NUMISMATIC NOTES AND MONOGRAPHS

168

ISSN 0078-2718
ISBN 978-0-89722-309-6

Library of Congress Cataloging-in-Publication Data

Fischer-Bossert, Wolfgang.
 The Athenian decadrachm / Wolfgang Fischer-Bossert.
 p. cm. -- (Numismatic notes and monographs, ISSN
0078-2718 ; 168)
 Includes bibliographical references.
 ISBN 978-0-89722-309-6 (hardcover)
 1. Decadrachma. 2. Coins, Greek--Greece--Athens--History.
3. Coin design--Greece--Athens--History. 4. Numismatics--
Greece--Athens. 5. Athens (Greece)--History. 6. Forgery of
antiquities--Case studies. I. Title.

 CJ359.F57 2009
 737.4938--dc22

 2008045450

Printed in China

Für Gudrun

THE ATHENIAN DECADRACHM

Wolfgang Fischer-Bossert

Numismatic Notes and Monographs

168

THE AMERICAN NUMISMATIC SOCIETY
NEW YORK
2008

Contents

List of Figures

Acknowledgments

Many friends and colleagues contributed to this investigation with data, feedback, and assistance. I am indebted to Peter van Alfen, Michel Amandry, Norman Ashton, Richard Ashton, Dieter Bellinger, Denyse Bérend, Eva Berger, Shanna Berk Schmidt, Françoise Berthelot, Christof Boehringer, François de Callataÿ, Frank Campbell, Felicity Cobbing, Karsten Dahmen, Günther Dembski, Basil Demetriadi, Uta Dirschedel, Richard G. Doty, Victor England, Despina Evgenidou, Nina Frolova, Haim Gitler, Hans Rupprecht Goette, Richard Grossmann, Thomas Heese, Robert W. Hoge, Silvia Hurter, Jonathan Kagan, Ulrich Klein, Frank Kovacs, Sergej Kovalenko, Hubert Lanz, Katerini Liampi, Catharine Lorber, Rodolfo Martini, Andrew Meadows, Marco Mignucci, Hélène Nicolet-Pierre, Eleni Papaefthymiou, Adrian Popescu, Efterpi Ralli, Elena Stolyarik, Melinda Torbágyi, Yannis Touratsoglou, Dimitra Tsangari, Massimiliano Tursi, Hans Voegtli, Reinhold Walburg, Alan Walker, Ute Wartenberg Kagan, Bernhard Weisser, Ulla Westermark, Richard Witschonke, and some others who want to remain anonymous.

I owe a special debt to the editor, Andrew Meadows, who posed important questions and whose τέχνη μαιευτική made the book so much better. Of course, all errors remain my own.

Finally I must thank Arnold-Peter Weiss, without whose generosity and enthusiasm this volume could not have reached the light of day.

Abbreviations

Beulé E. Beulé, *Les monnaies d'Athènes* (Paris: Rollin, 1858).

Brand A. Brand, *Het verboden Judas-evangelie en de schat van Carche-mish* (Soesterberg: Aspekt, 2006).

Carradice I. Carradice (ed.), *Coinage and Administration in the Athenian and Persian Empires*, BAR international series 343 (Oxford: BAR, 1987).

CH M. Price et al. (eds), *Coin Hoards, I–IX* (London: Royal Numismatic Society, 1975–2002).

Flament Ch. Flament, *Le monnayage en argent d'Athènes* (Louvain-la-Neuve: Association de numismatique Marcel Hoc, 2007).

Head, *HN²* B. V. Head, *Historia Numorum²* (London: Clarendon Press, 1911).

IGCH M. Thompson, C. M. Kraay, and O. Mørkholm, *An Inventory of Greek Coin Hoards* (New York: ANS, 1973).

Jongkees J. H. Jongkees, "Notes on the coinage of Athens," *Mnemosyne* III 12 (1945): 81–117.

Mainzer F. Mainzer, "Das Dekadrachmon von Athen. Eine kritische Skizze," *ZfN* 36 (1926): 37–54.

MJPP Martin Jessop Price papers, photograph files.

Seltman C. Seltman, *Athens, Its History and Coinage before the Persian Invasion* (Cambridge: Cambridge University Press, 1924).

Starr C. G. Starr, *Athenian Coinage 480–449 B.C.* (Oxford: Clarendon Press, 1970).

Studies Price R. Ashton and S. Hurter (eds), *Studies in Greek Numismatics in Memory of Martin Jessop Price* (London: Spink, 1998).

Svoronos J. N. Svoronos, *Les monnaies d'Athènes*, completed by B. Pick (Munich: Bruckmann, 1923–26). Reprinted with translated text as *Corpus of the Ancient Coins of Athens* (Chicago: Ares, 1975).

Traité E. Babelon, *Traité des monnaies grecques et romaines, I–IV* (Paris: Leroux, 1901–32).

1

Introduction

"To the ordinary collector, indeed, the coins of Athens offer
but little attraction."

E. Bunbury, *NC*[3] 1 (1881), p. 73.

The final Persian attempt to invade Balkan Greece was defeated at the Battle
of Plataea in 479 BC, but the war against Persia was not yet over. Athens had
played a prominent part in the great victories at Marathon in 490 BC, Salamis
in 480 and at Plataea. Now, under the leadership of Aristeides, the Athenians
joined an alliance of free Greeks. From its foundation this alliance was dedi-
cated to the ravaging of the Great King's land, and to the liberation of those
Greeks still subject to Persian control.

And it was then that the Athenians established the *Hellenotamiai,* the
treasurers of the Greeks, who received the *phoros* (for it was thus that the
contribution of money was known). The first *phoros* was assessed at 460
talents, and the treasury was established at Delos, where the meetings of
allies also took place.[1]

The history of the League's early campaigns is poorly recorded in the surviving
sources, but there was clearly considerable success. In 476, northern Greece
was freed following the capture of the Persian stronghold at Eion. During the
later 470s and the 460s the battle moved into Asia Minor and culminated in
the double victory—on land and sea—of the Athenian general Cimon over the
Persians at the River Eurymedon in what is today southern Turkey.

After a considerable struggle, the Athenians routed the Persians and
massacred them. They then captured the survivors along with their camp

1. Thuc. 1.96.2: καὶ Ἑλληνοταμίαι τότε πρῶτον Ἀθηναίοις κατέστη ἀρχή, οἳ ἐδέχοντο
τὸν φόρον· οὕτω γὰρ ὠνομάσθη τῶν χρημάτων ἡ φορά. ἦν δ᾽ ὁ πρῶτος φόρος ταχθεὶς
τετρακόσια τάλαντα καὶ ἑξήκοντα. ταμιεῖόν τε Δῆλος ἦν αὐτοῖς, καὶ αἱ ξύνοδοι ἐς τὸ
ἱερὸν ἐγίγνοντο.

1

which was stuffed with all kinds of treasure.[2]

This victory occurred some time between 469 and 465 BC. By this point the Persians had been firmly driven back out of the Aegean region, and some cities had begun to question the continued need for the League, or at least their continued contribution to it. Athens, with effective command of the Allied fleet, was becoming the enforcer of commitment to the League. In the 470s the Athenians had led a force to Carystus in Euboea to compel the city to join the League. Shortly thereafter the large island of Naxos attempted to secede from the League and was, in Thucydides' words, "the first allied city to be enslaved contrary to the established aims of the League."[3]

Following the battle of the Eurymedon the major and wealthy island state of Thasos, which controlled a mainland *peraea* rich in mineral resources (including silver), also rebelled. The Athenians were quick to respond militarily, by laying siege to the island, but also acquisitively, by sending a force of some 10,000 settlers to establish a colony at Nine Ways (*Ennea hodoi*), later the site of Amphipolis. This brazen attempt to appropriate the resources of Thasos' hinterland failed when the settlers were defeated in battle by the local Thracian peoples. Thasos, however, succumbed after a three-year siege, and in *c.* 463/2 BC the islanders

> pulled down their walls, handed over their ships and agreed with the Athenians to pay as much money as was necessary immediately and to pay tribute in the future, and to surrender their mainland *peraea* and mines.[4]

Fragmentary though our knowledge of the 460s BC is, there can be little doubt that this decade saw major military activity on the part of the Athenian state, significant expenditure on the fast growing fleet, but also a substantial influx in wealth from allied contributions to the treasury, booty won from the Persians, punitive reparations from the Thasians, and newly won silver sources in Thrace.

This, as we shall see, is the historical background against which we must place the Athenian decision to strike the decadrachm. Given the importance of Athens, and the fascinating historical circumstances of their issue, it must be considered odd that the Athenian decadrachms have received so little scholarly attention. While the discussion about the date and the occasion of the early classical decadrachms of Syracuse (Pl. 1.B) is invariably vivid, there has been

2. Plut. *Cim.* 13.2: πολλῷ δ' ἀγῶνι τρεψάμενοι τοὺς βαρβάρους ἔκτεινον, εἶτα ᾕρουν αὐτούς τε καὶ σκηνὰς παντοδαπῶν χρημάτων γεμούσας.

3. Thuc. 1.98.4: πρώτη τε αὕτη πόλις ξυμμαχὶς παρὰ τὸ καθεστηκὸς ἐδουλώθη.

4. Thuc. 1.101.3: ὡμολόγησαν Ἀθηναίοις τεῖχός τε καθελόντες καὶ ναῦς παραδόντες, χρήματά τε ὅσα ἔδει ἀποδοῦναι αὐτίκα ταξάμενοι καὶ τὸ λοιπὸν φέρειν, τήν τε ἤπειρον καὶ τὸ μέταλλον ἀφέντες.

almost complete silence concerning their Athenian counterparts. At first sight, this is a paradox. The number of specimens of the Syracusan issue is not much larger today than in the days when Erich Boehringer wrote his seminal study of the Syracusan coinage, whereas the number of Athenian decadrachms has grown from twelve to some forty specimens within the past 25 years. However, the new specimens have often caused problems. First, the massive Elmalı Hoard of 1984 (*CH VIII* 48) from which thirteen specimens derive became the object of a lawsuit finally leading to the transfer of the hoard to Turkish authorities before a definitive publication of its contents could be achieved; the majority of the decadrachms from that hoard remain unpublished. Secondly, several specimens appearing on the market thereafter raised suspicion. Although experts have done a good job in separating forgeries from genuine specimens, uneasiness has grown among dealers, collectors, and scholars.

The crisis became clear when a new specimen was discussed some years ago at a meeting of the International Bureau for the Suppression of Counterfeited Coins that I attended. Though the participants of the meeting had both the Prokesch-Osten coin and the huge collection of decadrachm casts kept by the Berlin Cabinet at their disposal, they did not come to a firm conclusion. Opinions differed as to the minutiae of both style and technique. The question was left open, but at least it was agreed that a die-study might solve the problem. It is true, the coin in question had but little in common with the specimens listed in Seltman's and Starr's die-studies of the Athenian coinage, but it must be said that the samples of decadrachms known to these authors (nine specimens and twelve respectively) display a wide range of varieties and have frustratingly few die-links (both authors were aware of one only, and even this die-link was to turn out in the course of the present investigation not to exist). In fact, some newcomers to the corpus have peculiarities. Sometimes there is a certain flatness to the reverse imprint that is far from the deep relief exhibited by longer-known specimens. Sometimes the figures of both sides, the head of Athena as well as the owl, appear to have strange proportions.

So it became clear that once again all specimens would have to be compared side by side, no matter if deemed genuine or counterfeit, in order to develop the criteria for distinguishing the ancient coins from modern forgeries. Arranging the series would be the second step, reconsidering the dating of it the third, and questioning the purpose of this extravagant issue the last one. Fortunately enough, a complete documentation of the thirteen specimens from the Elmalı Hoard was found soon after the meeting among the papers of the late Martin Price. Thanks to Price's far-sighted efforts, this study contains all Athenian decadrachms ever recorded.

2

Description

THE TYPES

The designs of the Athenian decadrachms differ in several respects from those of the contemporary tetradrachms. Chester Starr, whose study of the Athenian coinage is the standard reference, describes them as follows:

> The decadrachms have entirely new designs. On the obverse the helmet of Athena has three olive leaves and a very heavy spiral, which breaks into a unique palmette; the hanging earring is also unparalleled in Athenian coinage. The head of Athena is simply but strongly portrayed; the lips are full with limited modelling on the cheek. Generally the eye is oval, but on Nos. 55 and 59 it is composed of two lines with complex, unequal curves....
>
> The design of the reverse of the decadrachms is even more remarkable. The owl stands facing with outstretched wings; the alpha is to the right of the head, the theta and epsilon are on either side of the legs. The olive twig is in the upper left corner...; often its leaves are separated more than 90°. In a somewhat later group (Nos. 57 ff.), which is still within the same basic pattern, the leaves on the crest are not graduated, and the spiral and palmette come to point more at the first olive leaf. There is no moon.[1]

While Starr's internal arrangement of the series is no longer valid, his description is to the point. Due to the large size of the decadrachms, the engravers had to make some changes to the design of the tetradrachm images. The most obvious change is the frontal presentation of the owl; the position of the wings has lead to some sweeping interpretations. It should be said, however, that a strong pictorial difference between the two highest denominations of the Athenian

1. Starr, p. 32. Starr's nos. 55, 57, and 59 are nos. 5a, 8b, and 10a/11a in the catalogue below.

5

coinage was necessary for obvious reasons. The decadrachm owl is standing on the ground like that of the tetradrachms, with all six claws touching the ground-line. It is hard to say whether the owl is spreading its wings in order to start flying or flapping them while waking up or preening. Although ancient coin-engravers could be excellent in observing animal behavior, we should not expect too much characterization where a high degree of recognizability was as important as representational veracity. In any case, the rendering of the details is almost the same as with the tetradrachms. The short feathers over the owl's body are represented as small dots, those at the middle breast being a little bit larger than those on the flanks; only the "short trousers" around the hips have stripes instead of dots. The wings are divided into three sections: a) the mantle, the pennaceous feathers of which are represented as dots like those over the body, b) an upper row of short covert feathers, shown as short stripes, and c) a lower row of long covert feathers shown as long stripes. The two rows of covert feathers display different patterns: in some cases all the stripes point to the out-side, in other cases only the upper row points to the outside while the lower row has a complex, fan-shaped pattern pointing inwards. There is much variation here. The proportions of both body and wings can also vary in several ways. The head of the decadrachm owl is similar to that of the tetradrachm owls, but it has some features of its own. First, the position is different. The tetradrachm owl is rendered in profile and has the head turned around; in many cases the head is thrown back somewhat and the owl is looking at a point above the observer. The head of the decadrachm owl, however, is in a strictly frontal position, the eyes focusing on the observer. The circular eyes are divided into pupil and iris, the pupil covering about 80% of the eye. The eyes of the decadrachm owl appear to be larger than those of the tetradrachm owls, although there is no difference insofar that just one framing row of feathers forms the outline of the head. The feet of the owl are rendered in the same manner as those of the tetradrachm owls, except that they are placed side by side instead of one after another. The legs have two parallel muscles, the feet have three claws each.

Due to the posture of the owl there is not much room on either denomi-nation for symbols and letters. The contemporary tetradrachms have an olive sprig and a crescent in the upper left corner from which the owl is turning away, and a line of three letters running down at the right-hand side. The deca-drachms display a different arrangement of these elements. The olive sprig is in the same place but more spread out, the leaves often separated more than 90°. The fruit is hanging at 45°, pointing to the shoulder of the owl. There is no moon, perhaps because the crescent would have become too small. On the other hand, the relations of the figures are balanced with such care that the engraver might have considered the crescent troubling to the harmony of the design. The placing of the three letters of the legend clearly results from the re-arrangement of the owl and the olive. While the alpha keeps the position at the

upper right corner, thus corresponding to the angle of the olive sprig (hence often placed diagonally), the theta and the epsilon are put at the bottom in the center, flanking the legs of the owl. There is a subtle symmetry to the reverse image resulting from these changes.

Turning to the obverse image, the difference between decadrachms and tetradrachms is less easy to see. There is Athena's head in the form known from all the contemporary Athenian coins; she is wearing a crested helmet of the Attic type with all the details at their usual places. Even the split of the plume is depicted on the decadrachms as it is on the tetradrachms. Only the ornamental embellishment of the bowl of the decadrachms has an addition: the palmette has a "tendril" spreading downwards and sometimes touching the ear. The three olive leaves above the visor are exactly as with the tetradrachm Athena heads, the foremost leaf reaching to the top line of the bowl and sometimes beyond towards the plume. The coiffure is the same as well: the hair sweeps in long waves across the brow, with a large lock beside the ear. This "ear-lock" is sometimes rounded, as is the pattern of its inner strands. More often, however, it has a rectangular shape; in such cases the strands are arranged to form a V-shaped pattern. Sometimes it is clear that the hair waves above the forehead disappear behind the "ear-lock" (O 10); sometimes there is a small *taenia* holding waves and lock in place (O 3). Usually there is a single slim "cowlick" at the forehead. Athena is wearing her hair in an open fashion, that is to say, the hair is falling down behind the neckguard. Following archaic sculptural tradition, the hair is characterized in different ways according to its position. Around the face, the hair is shown in wavy, continuous strands, whereas the hair beside and beneath the neckguard is shown as small dots forming strands. The single strand beside the neckguard is just a line of dots joining the dotted strands beneath the neckguard. The bow-shaped pattern of these strands reveals that the hair is knotted at the back of the head, although concealed by the helmet. This is, in fact, no archaic coiffure but an early classical one.[2] Archaic taste, however, is reflected in the opulence of the jewels Athena is wearing. The double border of the neck truncation—a string above a dotted line—looks like a pearl necklace. The round ear-clip of the tetradrachm Athena has now changed into a tear-shaped pendant. Curiously enough, the pendant does not fall vertically but is swinging forward, thus accentuating the line of the chin.[3]

Lastly, there is the face. The archaic character of the Athena head on fifth-century Athenian coins has often been noted. It is an archaism without a certain

2. The Arethusa head of the "Damareteion" series has the same coiffure, see E. Boehringer, *Die Münzen von Syrakus* (Berlin: W. de Gruyter, 1929), pls. 15–16.

3. Cf. the alleged Nike head on a late fifth century Syracusan tetradrachm: A. J. Evans, "Syracusan 'Medallions' and Their Engravers", *NC* (1891), p. 351 f.; L. Tudeer, "Die Tetradrachmenprägung von Syrakus in der Periode der signierenden Künstler", *ZfN* 30 (1913), p. 160.

archaic model. The Athena heads of late sixth- and early fifth-century Athenian coins look entirely different in both typology and style. In fact, the Athena heads of Starr's Group II.A and beyond (the decadrachms belong to Group II.C) are modelled according to early classical taste rather than on archaic predecessors. Upon closer examination, there are three features only which may be called archaizing: the twofold pattern of the hair already mentioned, the frontal eye within a profile face, and the so-called archaic smile.[4] The proportions of the face, however, are early classical rather than archaic, though there are some long faces that look more archaizing than others.

As Starr has pointed out, the eye is always oval, but there is considerable variation. A few dies only have a perfectly oval eye. Much more often the eye is almond-shaped, that is to say, it has an asymmetrical curvature both above and below, arching above towards the front and below towards the back. These almond-shaped eyes generally have a clearly separated *caruncula lacrimalis* (an area in the corner of the eye containing accessory lacrimal glands), or a pointed inner tip at least. There is no pupil, but due to the facial expression the look is always attentive and never blind. The facial expression is, of course, dominated by the smile. Smiling is a complex interaction of movements all over the face. The corner of the mouth rises, thus pushing up the flesh of the cheek. As a result, the area behind the lips deepens, producing a vertical fold in the cheek that joins the nasolabial fold. The brow rises, the eye opens widely. All these features are to be seen here. It should be mentioned that, although the conventionalized archaic smile may be intended, both the delicacy of the surface transitions and the understanding of muscular interactions are classical style through and through. In fact, some engravers ignored their instructions and created heads of Athena that are almost avant-garde. Among the surviving specimens we find one die (O 13) that allows comparison with contemporary works of art; it will be argued that this die was made *c.* 460 BC (see below).

INTERNAL ARRANGEMENT OF THE SERIES

Starr knew twelve decadrachm specimens in 1970, the Bostonian lead trial piece not being figured in his catalogue.[5] As to die-links, he appears to have relied upon Seltman's study rather than checking the dies himself. In any case, he agreed with Seltman's opinion that the Delbeke and Rhousopoulos specimens (10a and 11a) derived from the same pair of dies.[6] This, however, is incorrect;

4. It must be said, however, that the profile eye replaced the frontal eye in sculpture much later than in vase-painting. The first profile eye attested is to be found on the Sosias cup, *c.* 500/490 BC: P. E. Arias and M. Hirmer, *A History of Greek Vase Painting*, translated and revised by B. Shefton (London: Thames & Hudson, 1962), pl. 118. The first profile eyes in low-relief sculpture can be found on votive and grave reliefs made *c.* 460/50 BC.

5. The piece (LT1) is mentioned by Starr, p. 38 n. 34.

6. Seltman, p. 211 no. 450 (A305/P385); Starr, p. 34 no. 59.

the two coins share neither obverse nor reverse die.[7] Both authors also missed the obverse link between the Rhousopoulos and Morgan coins (11a and 13b), and Starr overlooked that the specimen from the Malayer Hoard (8b) shares the obverse die with the Burgon coin in the British Museum (7a).

Yet it would be arrogant to blame the two scholars for blunders. The decadrachms known to them were in many cases quite worn, and the Burgon coin is defaced by a deep test-stroke through Athena's forehead. It is always easier to make a die-study dealing with a great many specimens (particularly if the majority of them are in good condition) than with a few ones. The Elmalı Hoard of 1984 (*CH VIII* 48) has improved the situation considerably.

Nevertheless, the decadrachms pose special problems due to their size. Plaster casts of the same piece prove to be different as to surface curvature and exactness of details. Photographs have a problem of their own: coins of so large a size and so high a relief cannot be photographed like smaller coins: the distance between camera and object has to be much greater than usual. Comparing pictures of the same piece reveals distortions varying according to the lenses used and to the distances applied. In one case, for example, the comparison of specimens is particularly troublesome because one coin was photographed from an angle that differed slightly from 90°, with the effect that Athena's face looked longer, her eye bigger, and the facial expression somehow different (30a). Fortunately, a distinctive die-break helped to attribute specimens to the die (O 17).

Forty decadrachms known to me may be regarded as genuine and valid for inclusion in a die-study. In addition, there are two lead trial pieces and two ancient forgeries (one of the latter is lost) which cannot be part of the die-study, even though one lead piece might stem from a die attested by valid specimens. The irregular specimens (trial pieces and forgeries) can be ignored without serious detriment to the study, for the relation between the numbers of specimens and dies is promising without them. Seltman knew nine specimens and he could have known one link between two specimens; Starr knew twelve specimens and could have known two links among four specimens, that is to say, Seltman had 22% of specimens interlinked, Starr had 33%. The new specimens have changed the figure entirely. The decadrachms included in the current die-study show more than 40 links among 35 specimens; that is to say, 87% of the 40 known specimens are interlinked. While the picture is clearer, there are still gaps. The sequence breaks into thirteen sections; just six die-combinations are attested by more than one specimen, and only one is attested by more than two specimens. We are still far from having the whole picture. In the future we may expect not only new die-links but new dies as well. Therefore we shall resist the temptation to go too far in interpreting the sequence that is proposed below.

7. This was pointed out by C. W. A. Carlson, "Rarities 5—the Missing Athenian Dekadrachm", *SAN* 5 (1973–74), p. 8.

The thirteen sections of the series are of varying lengths. There is one sec-
tion including as many as twelve die-combinations, but the other ones are
much shorter than that, seven including just one die-combination. Arranging
them into a sequence relies on interpretation of differences in pictorial typol-
ogy, technique and style, as small as they may be. Since the whole series might
cover a short time-span—less than a decade seems reasonable—we cannot ex-
pect a stylistic change in the true sense of the word, particularly since the coin-
age in question disclaims the mainstream style of its age. Yet there is a technical
feature that leads to a provisional arrangement where each section falls into one
of a few groups.

The specimens of the biggest section (22–33) display a feature that was only
noticed when a new specimen recently appeared on the market: the reverse
imprint is very flat, the edge of the coin barely rising above the background of
the *quadratum incusum*. Though the flatness was never conspicuous, each coin
of the section does show it in one way or another. A close examination of all 40
specimens revealed no clear point at which a change occurred; rather, there is
a gradual transition. There are specimens with a reverse imprint which looks
extremely deep because at least one side of the edge raises exuberantly (1a, 3a,
6a, 14a). When compared with other specimens of their respective sections it
turns out that "deepness" is a relative value and dependent on innumerable ac-
cidents of the minting procedure. In fact, there is a clear cause of imprints of so
variable a deepness: the size of the reverse die. Of course, we must not expect
that the power of the minting strokes was always the same. From the statistical
point of view, however, the rule holds true that the larger the die the flatter the
imprint. The measurements of reverse dies known to me are as follows:

1a	2.21 × 2.19 cm
5a	2.19 × 2.18 cm
21a	2.49 × 2.39 cm
23a	2.51 × 2.55 cm
29a	2.53 × >2.31 cm

The fact of a slight alteration does not by itself indicate whether the dies in-
creased in size or shrank. Among late archaic and early classical coinages there
is a general tendency for the size of the reverse image to increase, but there are
exceptions and counter-movements as well. We have to look for another clue.
On the one hand, one could argue that some obverse dies are more advanced
in style than others insofar as the palmette on Athena's helmet approaches the
first olive leaf, sometimes even touching its middle part. The tetradrachms of
Starr's Group III (i.e., following the decadrachms) have the palmette already
pointing downward along the leaf.[8] Obverse dies with "progressive" palmettes
occur more often within sections with deep reverse imprints (O 3, O 4, O 7,

8. Starr, pp. 43f.

O 8, O 10, O 11), while the big section with flat reverses contains obverses with "conservative" palmettes only (O 13–O 17). On the other hand, this typological trend is contradicted by another stylistic point. The one die mentioned above that is almost avant-garde (O 13) belongs to the big section with flat reverses. Since this die seems to have been made at the end of the series rather than at the starting point, the whole section has to be put near the end. Therefore it seems likely that the decadrachm reverse dies tended to increase in size. The need that the increasing die size would meet is not entirely clear. On the one hand, the deep reverse imprints corresponded with the traditional appearance of Athenian coins. On the other, decadrachms with flat reverses might have been introduced as easier to handle and more sturdy, too. Interestingly, the specimen from the Jordan Hoard (17a) was cut into halves diagonally, the cut running from one corner of the reverse imprint to the opposite. It may well be the Athenian mint-masters thought that deep reverses made coins of that large size too breakable and increased the die size accordingly.

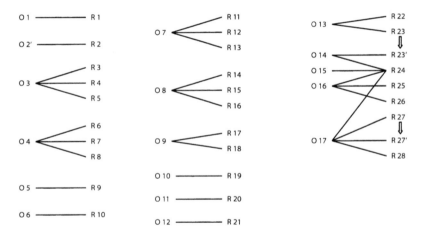

Figure 1. Die-link chart.

Unfortunately, there is no hoard evidence to suggest any arrangement of the series. The Elmalı Hoard contained specimens from both ends of the series (3a as well as 32a), and the relevant coins do not show wear of different grades. The other hoards are too late to be conclusive.

As a result, various details of the arrangement must remain hypothetical, particularly in the case of the smaller sections. It is not possible to say whether the Berlin coin (1a) or the recut Brussels specimen (2a) comes first, and the same is true with the Berry and Garrett coins (9a and 10a). It is a pity that Seltman and Starr did not discuss the reasons for their respective arrangements, for

both are similar in some ways to the one proposed here. If we disregard those specimens which have appeared after Starr's book the sequences are as follows:

Seltman		Starr		Fischer-Bossert	
445	Brussels	52	Berlin	1a	Berlin
446	Berlin	53	Brussels	2a	Brussels
447	Kunstfreund	54	Gulbenkian	5a	Kunstfreund
448	Gulbenkian	55	Kunstfreund	7a	London
449	London	56	Jordan Hoard	8b	Frankfurt
450a	Rhousopoulos	57	Frankfurt	9a	Berry
450b	Garrett	58	Berry	10a	Garrett
451	Morgan	59a	Rhousopoulos	11a	Rhousopoulos
452	Paris	59b	Garrett	13b	Morgan
		60	Morgan	17a	Jordan Hoard
		61	Paris	29a	Paris
		62	London	31a	Gulbenkian

There is some clear agreement. All authors concur that the Berlin and the Brussels coins are among the first ones and that the Paris coin has to be put near the end. The relative placings of the Kunstfreund and Rhousopoulos specimens are also similar to each other. Perhaps the disagreement as to some specimens—the London coin in particular—is even more interesting. At least in some cases the die-study has solved the problem; the London coin cannot be separated from the Frankfurt coin.

To conclude, I should again stress that the intrinsic structure of the series is by no means known. It would be hazardous to draw conclusions from forty specimens. The long die-chain at the very end of the series is more likely to be the result of accidents of discovery than indicative of a different pattern of production.

FABRIC

Large denominations require a much more sophisticated minting technique than the more common small ones. The Athenians took bigger risks than the other mints producing large silver denominations: the relief of the Athenian decadrachms is a good deal higher than those of the three Syracusan and the Akragantine decadrachm issues.[9] Hence the minting gaps which can be seen on several reverses, among them a remarkably big one (23a).[10] The slight change in the size of the reverse die over the course of the decadrachm series shows that the masters of the mint were experimenting.[11] Nonetheless, the high quality of all the decadrachms preserved is astonishing. The dies are always well centered on the flans. Granted, there are asymmetrical flans (for instance, 5a

9. Jongkees, p. 109.

10. I use this term here, and throughout the catalogue, to indicated places where, for whatever reason, part of the design on the die has not been transferred to the coin.

11. See above, p. 12.

and 19b), irregularities at the edge (the protuberance with 6b), edge cracks (1a, 6b, 7a, 32a) and doublestrikes (18a? 23a). The overall appearance is nevertheless excellent.

The rarity of both edge cracks and doublestrikes shows that the flans were red-hot when struck. Otherwise, no craftsman would have been able to deal with them. A minting device such as recently suggested for the Ptolemaic bronze coinage which would have produced standardized, circle-round coins is not likely to have been used.[12] There is too much variation of the flan shapes.

The high quality of mint practice applies to the weights, too. Eight specimens are heavier than 43 g, and sixteen more are heavier than 42 g. The halved specimen at 21.11 g (17a) might join them. Interestingly, the well-preserved specimens from the Elmalı Hoard have raised the peak. This is minting *al marco*. The flans were not meticulously adjusted, as is usual with gold coins (minting *al pezzo*), but the Athenians set great store in the reliability of their coinage, so much the more with large denominations.[13] The distribution of weights is shown in Figure 2, with the Elmalı Hoard highlighted; exact weights can be found in the Catalogue (below, pp. 33 ff.):

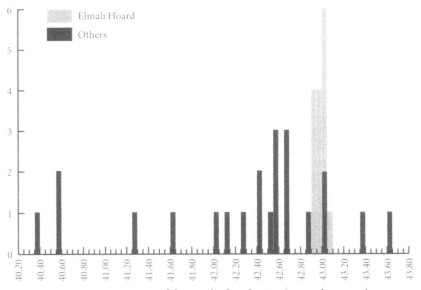

Figure 2. Histogram of the weight distribution (interval = 0.05 g).

12. Cf. B. Bouyon, G. Depeyrot, and J.-L. Desnier, *Systèmes et technologie des monnaies de bronze* (Wetteren: Moneta, 2000), pp. 52 ff.

13. On the metrology of the Athenian coinage see H. Nicolet-Pierre, "Metrologie des monnaies grecques. La Grèce centrale et l'Egée aux époques archaïque et classique (VIe-IVe s.)", *AIIN* 47 (2000), pp. 36 ff., especially p. 40 f. on the decadrachms.

3

Context

Some of the old decadrachm specimens have stories preserved about their find-spots, but such stories are often part of the commercial marketing of high-value coins and should not be trusted unquestioningly. Yet there may be some truth in them. Conspicuously, the first decadrachms to appear on the market were said to have been found in or near Attica. The majority, however, derive from hoards found in the Near East: Lycia, the Levant, Egypt, and Persia.

The first specimen to appear was the Paris coin from the Duc de Luynes and Lord Strangford collections (**29a**). Peter Oluf Brøndsted, who was, like Lord Strangford, a diplomat with an enthusiasm for ancient coins, makes the following claim of the coin's origin:

> La... grande médaille d'argent, est de la collection de Lord Strangford...,
> trouvée vers l'an 1817 auprès Mégare avec quelques autres semblables.[1]

The last point is of interest here. Whether or not the description of Megara as findspot is true, what can the remark "avec quelques autres semblables" tell us? Were more decadrachms offered to Lord Strangford? It is doubtful that false rumors would have circulated before the coin's sale, since these would have hurt the price. However, if the story was told to Lord Strangford only after he had bought the coin it could have been a trick in order to prepare the market for counterfeits still to be made. Strangford himself had another decadrachm which disappeared from the record in the course of the nineteenth century, pre-sumably because it was highly dubious (**F13**). We learn from Count Prokesch-Osten's notes that the Athens market of the 1840s offered several decadrachms that he regarded as forgeries.[2] Prior to that, Brøndsted had seen decadrachm

1. P.O. Brøndsted, *Voyages dans la Grèce accompagnés de recherches archéologiques*, $2^{ième}$ *livraison* (Paris: F. Didot, 1830), pp. 300 f.
2. See below, p. 81.

forgeries on the London market, probably the first specimens from Becker's production.[3] In any case, forgeries started to appear quickly. The story about a "Megara 1817 Hoard" may well be a deception.

But if Brøndsted's story is true, where have the "autres semblables" gone? The Berlin coin (1a) was seen by Count Prokesch-Osten in 1833 when the then owner settled at Nauplia. Soon thereafter, the London coin (7a) was bought somewhere in Greece (at that period, "Greece" meant the territories south of Thessaly) by the British consul at Patras. Another specimen that was said to have been found near Megara is the Lisbon coin from the Gulbenkian and Jameson collections (31a). This coin was published for the first time only in 1924. According to Sir George Hill, the Megarian provenance was a mistake, and the coin is said to have been found near Daphni instead, that is to say, half-way between Athens and Eleusis.[4] Intriguingly, Attic provenances recur. The Garrett coin, once in the Delbeke collection (10a), is said to have been found at Laurion before 1890. The Hunt coin from the Gillet, Seltman, and Kambanis collections (5a) is said to have been found near Spata, a town in Central Attica, in 1920. Lastly, there is the Rhousopoulos coin (11a) which does not have a findspot story, but is first heard of in an Athenian collection.[5]

The list of Attic findspots of single specimens is overshadowed by the much longer list of specimens from Near Eastern hoards. The first one discovered was the Malayer Hoard (Iran, c. 1934) that contained the coin now owned by the German Bundesbank, Frankfurt (8b).[6] The next was the Tell el-Maskhouta Hoard (Egypt, 1947-48)[7] though the Berry coin (9a) was published as being

3. Brøndsted, op. cit., p. 301 "J'ai vu ensuite, dans les collections de Londres, 3 ou 4 octodrachmes [i.e., decadrachms] contrefaites et évidemment fausses". On Becker, see below p. 54.

4. G. K. Jenkins and M. Castro Hipólito, *A Catalogue of the Calouste Gulbenkian Collection of Greek Coins, Part II: Greece to East* (Lisbon: Fundação Calouste Gulbenkian, 1989), p. 42 no. 515.

5. The first known owner Professor Athanasios Rhousopoulos was an Athens resident; cf. E. Langlotz in *Antiken aus dem Akademischen Kunstmuseum Bonn*[3] (Cologne: Rheinland-Verlag, 1983), p. 52 no. 59 "Aus Athen, Slg. Rhousopoulos".

6. IGCH 1790; J. Elayi and A. G. Elayi, *Trésors de monnaies phéniciennes et circulation monétaire (V^e-IV^e siècles avant J.-C.)*, Transeuphratène Suppl. 1 (Paris: Gabalda, 1993), pp. 277-279 no. LXVIII; N. Vismara, *Ripostigli d'epoca pre-ellenistica (VI-IV sec. a.C.) con monete della Lycia antica* (Milan: Ennerre, 1999), pp. 142 f.; K. Sheedy, *The Archaic and Early Classical Coinages of the Cyclades* (London: Royal Numismatic Society, 2006), p. 149; Flament, pp. 216 f.

7. IGCH 1649; Elayi and Elayi, op. cit., pp. 282-286 no. LXXI; B. Shefton, "The White Lotus, Rogozen and Colchis: the fate of a motif", in J. Chapman and P. Dolukhanov (eds), *Cultural Transformations and Interactions in Eastern Europe* (Aldershot: Avebury, 1993), p. 179 f.; Ch. Flament, "À propos des styles d'imitations athéniennes définis par T. V. Buttrey", *RBN* 147 (2001), pp. 40 f.; J. Kroll, "A Small Find of Silver Bullion from Egypt," *AJN* 13 (2001), p. 11 n. 14; P. van Alfen, "Two Unpublished Hoards and Other

derived from it only in 1971.[8] Rumors about a decadrachm in the Balkh Hoard (Bactriana, northern Afghanistan, 1966) cannot be corroborated, for the coin in question now turns out to be a forgery (**F31**).[9] The third certain instance was a Hacksilber hoard from Jordan (1967) that contained a halved specimen (17a).[10] The fourth is the massive Elmalı Hoard (Lycia, Turkey, 1984) producing no less than thirteen specimens (3a, 4a, 8a, 12a, 14a, 16a, 18a, 19a, 19b, 20a, 20b, 22a, and 32a).[11] Lastly, there are rumors afloat that some of the decadrachms that appeared on the market during the late 1990s derived from a hoard found in Syria *c.* 1994.[12] Unfortunately the rumors cannot be substantiated in any concrete way.

Turning back to the specimens found in Attica or in nearby Megaris, the problem is now obvious. On the one hand we have stories about findspots scattered all over the Attic countryside, and the relevant specimens appeared within a time-span of some hundred years. On the other hand the lion's share of specimens available today was found in Near Eastern hoards. Of course, we cannot say how much of the whole decadrachm issue was exported. A part at least may have remained in the treasure chests of Athenian citizens to be concealed in savings hoards and discovered during the nineteenth century. Yet it is strange that we do not learn of recent decadrachm discoveries in the countryside of Attica, although both archaeological and building activities have been intensified during the second half of the twentieth century. Perhaps, then, there is some truth in the story told by Brøndsted about a decadrachm hoard found near Megara *c.* 1817.

'Owls' from Egypt", *AJN* 14 (2002), pp. 64 f.; N. Hardwick, "Coin Hoards", *NC* 166 (2006), pp. 382–384; Flament, pp. 210–212.

8. B. Y. Berry, *A Numismatic Biography* (Lucerne: printed for the author, 1971), p. 66 no. 355; C. Starr, "New Specimens of Athenian Coinage, 480–449 B.C.", *NC* (1982), p. 130 n. 9.

9. *IGCH* 1820; Starr, *op. cit.*, p. 130 n. 10; Elayi and Elayi, *op. cit.*, pp. 279–281 no. LXIX; M. N. Smith, *The Mint of "Lete"* (Ann Arbor: University Microfilms, 1999), p. 105; M. Pfisterer, *Ein Silberschatz vom Schwarzen Meer* (Paris: AAEI, 2000), pp. 66, 90; Flament, pp. 217 f.

10. *IGCH* 1482; Elayi and Elayi, *op. cit.*, pp. 240 f. no. LIII; H. B. Mattingly, "A New Light on the Early Silver Coinage of Teos", *SNR* 73 (1994), p. 8; Smith, *op. cit.*, p. 105; Vismara, *op. cit.*, pp. 114–119; C. Augé, "La circulation des monnaies à l'est du Jourdain à l'époque perse", *Transeuphratène* 20 (2000), p. 167 f.; J. Spier, "Coin Hoards", *NC* 160 (2000), p. 371; G. Le Rider, *La naissance de la monnaie* (Paris: Presses universitaires de Frace, 2001), p. 171; H. Gitler and O. Tal, *The Coinage of Philistia of the Fifth and Fourth Centuries BC* (Milan: Ennerre, 2006), p. 65; Sheedy, *op. cit.*, p. 148; Flament, p. 198 f.

11. *CH VIII* 48; Mattingly, *op. cit.*, p. 8 n. 17; T. Figueira, *The Power of Money. Coinage and Politics in the Athenian Empire* (Philadelphia: University of Pennsylvania Press, 1998), p. 179 f.; Vismara, *op. cit.*, pp. 87–89; Sheedy, *op. cit.*, pp. 146; Flament, pp. 194 f.

12. Brand, pp. 96 ff., coined the nickname "Carchemish Hoard". The usual *nom de guerre* is Aleppo Hoard; see below, p. 26.

DATING THE SERIES

Although there is now, as we shall see, a general consensus concerning the absolute chronology of the Athenian decadrachm series which can be subject to minor modifications at most, it is instructive to review the former proposals for the date of the Athenian decadrachms. It is not now fashionable to regard decadrachms as "medallions", but the temptation to date them by historical considerations rather than by numismatic evidence is still fairly strong. On the one hand it is clear that an issue of large denominations must have met a financial need. On the other hand the Greek state was at war often and in the case of Athens it is not hard to find one or another appropriate historical background as soon as we have arrived at a dating to a certain decade.

Before we turn to earlier theories it should be said that the issues of didrachms and drachms[13] that accompanied the decadrachms do not suggest any specific circumstance of production, but rather are to be explained as a reaction within the denominational structure of the coinage to the production of the decadrachms. It would have been strange if the decadrachms had not been accompanied by didrachms that enabled the people to convert the large denomination into smaller ones. Without the supply of medium denominations the citizen would have needed two decadrachms in order to get tetradrachms. Small change—hemidrachms, obols and even smaller denominations—might not have been accepted by an owner of decadrachms because small denominations tend to be underweight due to the increased relative costs of production.[14]

When the first specimen of the Athenian decadrachms was found in 1817—the Lord Strangford coin that was to end up in the Paris Cabinet (29a)— it stirred up a debate about the authenticity of such coins. Mionnet's mistaken description of the coin as an octodrachm, and the immediate production of counterfeits along with the appearance of other (genuine) specimens occupied collectors and scholars for several decades. The first to raise the chronological question was Ernest Beulé in 1858.[15] His discussion of the matter is still worth reading, since he described almost all the points and considerations that have been taken into account in subsequent scholarship: Herodotus' account of a debate in the Athenian council about how to realize the revenues from the mines at Laurion where Themistocles succeeded in passing a bill to build up a fleet;[16] the problem of whether revenues had been paid to the Athenian citizens

13. Starr, pp. 36–38 nos. 73–90.
14. Cf. Jongkees, p. 96.
15. Beulé, pp. 47–50.
16. Hdt. 7.144: ἑτέρη τε Θεμιστοκλέï γνώμη ἔμπροσθε ταύτης ἐς καιρὸν ἠρίστευσε, ὅτε Ἀθηναίοισι γενομένων χρημάτων μεγάλων ἐν τῷ κοινῷ, τὰ ἐκ τῶν μετάλλων σφι προσῆλθε τῶν ἀπὸ Λαυρείου, ἔμελλον λάξεσθαι ὀρχηδὸν ἕκαστος δέκα δραχμάς· τότε Θεμιστοκλέης ἀνέγνωσε Ἀθηναίους τῆς διαιρέσιος ταύτης παυσαμένους νέας τούτων

at all before; and the question of whether the term δεκάδραχμον occurs in ancient writings. Although Beulé was aware that dating the decadrachms to the time of Themistocles fitted several facts, he was not seduced by the superficially attractive historical circumstances. In a time when a reliable chronology of classical Greek coins was very much in the future, Beulé had more confidence in his eye than in ancient writings:

> Cependant les décadrachmes qui ont été découverts jusqu'à ce jour ne remontent point jusqu'à Thémistocle; ils sont de ce grand style qui a voulu retenir les beautés propres à l'archaïsme, et qui me semble appartenir par excellence à l'art monétaire sous Périclès.[17]

The age of Pericles is the latest period to which the decadrachms have ever been dated. Beulé is not likely to have taken the early years of Pericles' career into consideration; rather he probably had in mind Pericles' prime, that is to say, the years when the Parthenon was built (447–432 BC).

Beulé's approach had no successors. His arguments were overshadowed by the comparison of the Athenian decadrachms with those produced by mints in Sicily. Since in the latter case these large denominations were thought to carry a commemorative function, memorable occasions were looked for in the case of the Athenian coins too.[18] Ernest Babelon argued in favor of the battle of Marathon (490 BC), interpreting the olive leaves at Athena's visor as an allusion to a major victory.[19] Barclay Head agreed with him on the general context of the

τῶν χρημάτων ποιήσασθαι διηκοσίας ἐς τὸν πόλεμον, τὸν πρὸς Αἰγινήτας λέγων. "Prior to that, Themistocles was successful with another bill. When the Athenians, having in the treasury much money that they got from the mines of Laurion, were about to share it, each man receiving ten drachms, then Themistocles persuaded them to give up this distribution and to build up two hundred ships with the money for the war, meaning the war against the Aeginetans". The story is repeated in Diod. 11.43.3: ἔπεισε δὲ τὸν δῆμον καθ᾽ ἕκαστον ἐνιαυτὸν πρὸς ταῖς ὑπαρχούσαις ναυσὶν εἴκοσι τριήρεις προσκατασκευάζειν.... "[Themistocles] persuaded the people each year to construct and add twenty triremes to the fleet they already possessed". Cf. Plut. *Them.* 4.1: Καὶ πρῶτον μὲν τὴν Λαυρεωτικὴν πρόσοδον ἀπὸ τῶν ἀργυρείων μετάλλων ἔθος ἐχόντων Ἀθηναίων διανέμεσθαι, μόνος εἰπεῖν ἐτόλμησε παρελθὼν εἰς τὸν δῆμον, ὡς χρὴ τὴν διανομὴν ἐάσαντας ἐκ τῶν χρημάτων τούτων κατασκευάσασθαι τριήρεις ἐπὶ τὸν πρὸς Αἰγινήτας πόλεμον. "When the Athenians were about to divide up among themselves the revenue from the silver mines of Laurion, he was the only one to dare to come before the people with the proposal that the distribution should be given up, and that triremes be constructed with the money for the war against the Aeginetans". Aristot. *Ath. Pol.* 22.7 was not yet known in Beulé's day (see below, pp. 20–21 n. 23).

17. Beulé, p. 49.
18. This view predominated until the 1960s, cf. J. Milne, "The History of Greek Medallions", in G. E. Mylonas and D. Raymond (eds), *Studies Presented to David Moore Robinson*, vol. II (St. Louis: Washington University Press, 1953), pp. 224–232.
19. *Traité* II 1, col. 769 ff.

decadrachm issue: he might have had in mind the medals of his own age when declaring that coins of so large a size could also have been issued for the personal gratification of tyrants or kings "and not for common currency".[20] However, he would date the decadrachms to the age of Hippias (527–510 BC), thus arriving at the earliest date ever proposed. Percy Gardner maintained Babelon's date of 490 even though he had recognized the contemporaneity of the Athenian and Syracusan decadrachms and identified the latter with the *Damareteia* mentioned by ancient sources and therefore dated to the aftermath of the battle of Himera (480 BC). Gardner confirmed the general view that "Decadrachms seem in Greece only to have been issued on the occasion of some great national triumph".[21]

Only Charles Seltman abandoned this view. His study of Athenian coinage laid the foundations for the scholarship in the field, although his chronology was strongly modified by his successors. Seltman was right in ascertaining that the Athenian coins issued around the years of Marathon were more primitive in appearance than the decadrachms. However, instead of taking seriously Gardner's idea which would have led to a date soon after the battle of Salamis (480 BC) he denied, to a limited extent at least, the commemorative character of the decadrachms: "There is reason to believe that the Athenians had no time immediately after Salamis to plan commemorative medallic issues."[22] Seltman had another kind of occasion in mind. Without quoting him, Seltman came back to the episode Beulé had noted (though rejected) of the alleged dividend of the revenues from the mines of Laurion. In the meantime, Herodotus' account of the controversy in the Athenian council and Themistocles' fleet bill had been supplemented by Aristotle's *Atheneion Politeia* discovered among the British Museum papyri in 1890.[23] Though the chapter in question was

20. Head, *HN²*, pp. 370f.

21. P. Gardner, *A History of Ancient Coinage 700–300 B.C.* (Oxford: Clarendon Press, 1918), p. 162.

22. Seltman, p. 106.

23. Aristot. *Ath. Pol.* 22.7: ἔτει δὲ τρίτῳ μετὰ ταῦτα Νικοδήμου ἄρχοντος, ὡς ἐφάνη τὰ μέταλλα τὰ ἐν Μαρωνείᾳ καὶ περιεγένετο τῇ πόλει τάλαντα ἑκατὸν ἐκ τῶν ἔργων, συμβουλευόντων τινῶν τῷ δήμῳ διανείμασθαι τὸ ἀργύριον Θεμιστοκλῆς ἐκώλυσεν, οὐ λέγων ὅ τι χρήσεται τοῖς χρήμασιν ἀλλὰ δανεῖσαι κελεύων τοῖς πλουσιωτάτοις Ἀθηναίων ἑκατὸν ἑκάστῳ τάλαντον, εἶτ᾽ ἐὰν μὲν ἀρέσκῃ τὸ ἀνάλωμα, τῆς πόλεως εἶναι τὴν δαπάνην, εἰ δὲ μή, κομίσασθαι τὰ χρήματα παρὰ τῶν δανεισαμένων. λαβὼν δ᾽ ἐπὶ τούτοις ἐναυπηγήσατο τριήρεις ἑκατόν, ἑκάστου ναυπηγουμένου τῶν ἑκατὸν μίαν, αἷς ἐναυμάχησαν ἐν Σαλαμῖνι πρὸς τοὺς βαρβάρους. "In the third year afterwards, in the archonship of Nicodemos, the veins of ore at Maroneia were discovered and the state had a profit of 100 talents from the mining, while some persons gave the advice to distribute the revenues among the people, Themistocles prevented them from doing so, not saying what use he would make of the money. He recommended that it should be lent to the hundred wealthiest Athenians, each thus receiving a talent, so that if they should spend it in a satisfactory manner, the state would have the profit, and if they did not, the state

inconsistent and might derive from Herodotus anyway, the story appeared to be sufficiently corroborated to confirm a numismatic hypothesis. From Seltman's point of view, the amount of the dividend paid to the Athenians was crucial: ten drachms each. Seltman claimed that the Athenians had started distributing the dividend among the citizens some years before Themistocles persuaded the council to use the revenues for financing a ship building program. Seltman's argument was simple and circular: the existence of the decadrachms proved the dividend to have been distributed. The accompanying didrachm issue would show that the amount was sometimes paid in smaller denominations. His calculation of the total number of decadrachms issued was equally fantastic: estimating that "for some three or four years before that date [when Themistocles passed his bill] each fortunate citizen of Athens had, instead of paying income-tax, received the bonus of ten drachmae once a year", he multiplied the three year term by the number of Athenian citizens (30,000), thus suggesting the figure of *c.* 900,000 drachms minted in addition to the ordinary tetradrachm issues, the decadrachms accounting for the lion's share of the sum.[24] Dating the series now was easy: Themistocles' fleet program was traditionally dated to 483 BC; accordingly, the decadrachms would have been issued during the years 486–484.[25]

Seltman's theory did not convince his reviewers. Both Stanley Robinson and Kurt Regling expressed doubt about details of the construction.[26] Adhering to the commemorative function of the decadrachms, Robinson was inclined to see the battle of Salamis as the occasion of the issue. He could offer no definitive argument, however. It was Friedrich Mainzer who tried to cut the Gordian knot by challenging both the approaches of Babelon and Seltman. Reconsidering the historical sources, Mainzer contested Seltman's view that the Athenians ever distributed their revenues among the citizens; Themistocles, he argued, would have dismissed the first petition to do so in 483 BC. Furthermore, Mainzer argued that the olive leaves at Athena's visor were not a victory wreath (actually, not a wreath at all) but just another element of embellishment. A certain series of hemidrachms from Arcadia would show exactly the same feature without refering to any historical event, much less to a victory on the battlefield. This hemidrachm issue of Cleitor was to become an important piece of evidence, although scholars agree today that the hemidrachms copy the Athenian model

should call in the money from the borrowers. On these terms the money was put at his disposal, and he used it to build up a fleet of hundred triremes, each of the borrowers having one ship built, and with these they fought the naval battle at Salamis against the barbarians".

24. Seltman, pp. 106 f. The figure of 30,000 citizens is given by Herodotus (5.97) as a round number at the time of the Ionian Revolt.

25. Seltman, p. 108.

26. E. S. G. Robinson, *NC* (1924), p. 338 f.; K. Regling, *Berliner Philologische Wochenschrift* (1925), pp. 219–224.

without reference to any particular historical event.[27] Curiously enough, while refuting Seltman's and Babelon's conclusions Mainzer was heading for a similar date; he thought the decadrachms might be a festival issue from soon after the battle of Marathon.

Others were less willing to abandon the search for a specific historical reference. If it was not Marathon, the next step was to consider the battle of Salamis instead. Soon after Gardner's publication, Kurt Regling had proposed to interpret the decadrachms as "Siegesmünze[n] von Salamis und Plataiai".[28] This was consonant with Seltman's overall chronology of the Athenian coinage, which had not yet been contested and easily accomodated a date in the late 480s. So rather than reopening the question of the overall chronology of the Athenian mint, scholars concentrated instead on elements of the design, particularly the reverse. Jan Hendrik Jongkees wondered whether the decadrachm owl with its opened wings was intended to depict the bird in flight; he thought of the good omen of a flying owl when the battle of Salamis was about to enter its crucial phase.[29] Hermann Sorge pondered the crescent that started to appear on tetradrachm reverses beneath the olive sprig some time before the decadrachm issue. While Barclay Head had related the moon to some Athenian religious rites, Sorge tried to prove that the moon on the coins of Athens represents exactly the phase it had entered during the battle of Salamis.[30] None of these proposals met universal acceptance.[31]

27. Mainzer, pp. 47 f.; cf. R. T. Williams, *The Confederate Coinage of the Arcadians in the Fifth Century B.C.*, NNM 155 (New York: American Numismatic Society, 1965), p. 39 nos. 45–53; W. P. Wallace, "The Early Coinages of Athens and Euboia", *NC* (1962), p. 35 n. 1; Starr, p. 19.

28. A. v. Sallet, *Die antiken Münzen*, revised by K. Regling (Berlin & Leipzig: W. de Gruyter, 1922), p. 9.

29. Jongkees, pp. 108–112. The omen is mentioned by Plut. *Them.* 12.1: Λέγεται δ᾽ ὑπό τινων τὸν μὲν Θεμιστοκλέα περὶ τούτων ἀπὸ τοῦ καταστρώματος [ἄνωθεν] τῆς νεὼς διαλέγεσθαι, γλαῦκα δ᾽ ὀφθῆναι διαπετομένην ἐπὶ δεξιᾶς τῶν νεῶν καὶ τοῖς καρχησίοις ἐπικαθίζουσαν· "Some tell the story that, while Themistocles was speaking from the deck, an owl was seen flying through the fleet from the right side, and settling on the rigging". Another interpretation of the owl's posture is now proposed by D. Metzler, "Der Adler als achämenidisches Herrschaftszeichen des Themistokles von Magnesia am Mäander (ca. 465–459 v. Chr.)", in E. Winter (ed.), *Vom Euphrat zum Bosporus. Festschrift für Elmar Schwertheim*, Asia Minor Studien 65, 2 (Bonn: Habelt, 2008), p. 464. Maintaining the idea that the decadrachm issue celebrated the victories over the Persians, Metzler argues that the "heraldic" posture might reflect the Achaemenid eagle standard.

30. Head suggested the Pannychis during the Panathenaic festivals (cf. L. Deubner, *Attische Feste* (Berlin: H. Keller, 1932), p. 24). H. Sorge, "Der Mond auf den Münzen von Athen", *JNG* 2 (1950/51), pp. 7–13. L. M. v. Lanckoroński, *Schönes Geld der alten Welt* (Munich: E. Heimeran, 1935), p. 50, made a similar suggestion, but took the occasion to be the battle of Marathon.

31. Jongkees was critized by Wallace, *op. cit.*, p. 34, and by Starr, p. 32 n. 30. Head's

Thus far, the debate about the chronology of the decadrachms was obviously lacking a firm numismatic basis. When Colin Kraay eventually wrote his pioneering study on the early Athenian coinage it inevitably had repercussions for the dating of the decadrachms. Paying attention to the hoard chronology he reconsidered, and substantially modified, the relative arrangement of Seltman's groups.[32] Although he was not able to establish the date when the Athenians switched from the so-called Wappenmünzen to the owl coinage—a problem that still remains controversial—it became quite clear that Seltman's dates were much too high. For instance, a series of early owls with extremely coarse style which Seltman had put in the middle of the sixth century was now shown to have been minted after the battle of Marathon.[33] A result to become decisive for the decadrachm issue was Kraay's dating of the first "wreathed" tetradrachm series: the hoard chronology suggests that this series cannot have started before the battle of Salamis.[34] Thus arriving at a date after 480 BC for the similarly "wreathed" decadrachms, Kraay set little store by the interpretations of moon and owl. Though considering occasions with commemorative aspects, he was inclined to turn to an economic explanation:

> Possible occasions seem to be (1) 479, after Plataea (parallel to the Syracusan Demareteion), (2) 478/7, the first payment of tribute and the victories at Cyprus and Byzantium ... and (3) the Eurymedon campaign of c. 467.[35]

Economic aspects had been neglected in the debate before this point. When discussing the matter again and again with sceptics, Kraay reminded them of very simple facts of distribution and output: decadrachms would not have been appropriate to pay out a ten-drachms dole; a currency mainly of tetradrachms would have needed to have been supplemented not by decadrachms but only by a supply of drachms.[36] Yet Kraay had trouble in convincing his critics. William Wallace tried to re-establish Seltman's theory and pre-Themistoclean date,

proposal was refuted by Mainzer, pp. 52 f. Sorge was critized by C. M. Kraay, "The Archaic Owls of Athens: Classification and Chronology", NC (1956), p. 55 n. 2, and by Starr, p. 11.

32. Kraay, op. cit., pp. 43–68.

33. Seltman's Group E, see Seltman, pp. 56–58; the attribution of this group to an Athenian "satellite mint" in northern Greece had been revoked by Seltman himself (C. Seltman, "On the style of early Athenian coins", NC (1946), pp. 105 f.).

34. Seltman's Group N, see Seltman, pp. 102–105; cf. Kraay, op. cit., p. 55–58. "Wreathed" is the terminus technicus for Athenian coins with the olive leaves above Athena's visor. Although I agree with Mainzer's view that this is not a wreath in the true sense of the word, the terms "wreathed" and "unwreathed" will be used here.

35. Kraay, op. cit., p. 58 n. 3.

36. C. M. Kraay, "The Early Coinage of Athens: A Reply", NC (1962), p. 418; id., Archaic and Classical Greek Coins (London: Methuen, 1976), pp. 66–68.

although he agreed with some of Kraay's late datings and even lowered the date of the earliest owls to the years when Kleisthenes reorganized the Athenian state (510–507 BC).[37] Herbert Cahn resisted Kraay's downdating for a long time.[38] Maria R. Alföldi maintained Seltman's date while changing the occasion of the issue. From her point of view, the decadrachms would have been used for paying for timber, that is to say, for financing Themistocles' fleet.[39] In doing so, she appreciated the Near Eastern provenance of new specimens from the Jordan and Malayer Hoards (17a, 8b) but ignored the facts established by Kraay and Chester Starr.

For in 1970 Starr had published his study of early classical Athenian coinage. Like Kraay, Starr based his chronology on hoards. As yet, the Pentekontaetia did not provide reasonably dated hoards containing Athenian coins, but Starr relied upon the *termini post quos* given by Kraay's hoard chronology and the *terminus ante* given by the traditional date of the Athenian Standards Decree, 449 BC. Starr was able to arrange the Athenian coins minted within this bracket into five groups, the decadrachms making up his Group II.C. Starr did not provide a corpus—and only a few die links were observed by him—but a mere typology that nevertheless convinced many of his reviewers.[40] He confirmed Kraay's date of the earliest "wreathed" owls soon after the battle of Salamis, whereby he referred to the hemidrachm series of Cleitor that had been brought into play by Mainzer.[41] The Cleitorian hemidrachms, he argued, would not copy Athenian coins of a much earlier date. Based on the relative order of his groups and an estimate of their output, Starr arrived at the latest date of the decadrachms that had been taken into consideration by Kraay: the battle near the river Eurymedon (c. 469/465 BC).[42] Not being an adherent of the idea that decadrachms must be commemorative, Starr sought a purely economic

37. Wallace, *op. cit.*, pp. 23–42.

38. H. A. Cahn, "Dating the Early Coinage of Athens" [lecture given at the American Numismatic Society, April 1971], in *Kleine Schriften zur Münzkunde und Archäologie* (Basel: Archäologischer Verlag, 1975), pp. 81–97; cf. Cahn's conservative date for the decadrachm from the Malayer Hoard (8b) in MMAG 37, 5 Dec. 1968, 191. See also: *id.*, "Asiut: Kritische Bemerkungen zu einer Schatzfundpublikation", *SNR* 56 (1977), pp. 279–287.

39. M. R. Alföldi, *Dekadrachmon. Ein forschungsgeschichtliches Problem*, Sitzungsberichte der Wissenschaftlichen Gesellschaft an der Johann Wolfgang Goethe-Universität Frankfurt am Main XIII, 4 (Wiesbaden: F. Steiner, 1976), pp. 90–103.

40. Cf. A. A. Kleeb, *SAN* 12, 2 (1971), pp. 29 f.; R. T. Williams, *Phoenix* 26 (1972), pp. 411 f.; C. M. Kraay, *NC* (1972), pp. 313–317; R. Göbl, *Anzeiger für die Altertumswissenschaft* 28 (1975), pp. 77–79.

41. See p. 22 n. 27.

42. Starr, pp. 38–42. The exact date of the battle is controversial, see A. W. Gomme, *A Historical Commentary on Thucydides*, I (Oxford: Clarendon Press, 1945), pp. 286 ff., 408; R. Meiggs, *The Athenian Empire* (Oxford: Clarendon Press, 1972), pp. 75–82; P. Briant, *L'histoire de l'empire perse* (Paris: Fayard, 1996), pp. 573 f.

stimulus and found it in the war booty that would have been minted soon after the battle. The decadrachms were now thought to span the mid 460s.

A few years later, Kraay's chronology of the early owls was corroborated by the Asyut Hoard (*IGCH* 1644).[43] The Asyut Hoard also proved that the decadrachms could not have been minted during the decade following the battle of Salamis, whether the hoard's burial is dated to *c.* 475 BC or even later. From this point onward Starr's date was generally accepted. The fact that the Syracusan decadrachms which had for long been thought to be the *"Damareteia"* of 480 BC were now dated to the early 460s perhaps contributed to this acceptance.[44] Although the images of the Syracusan decadrachms are not archaizing, their style is roughly at the same chronological level as that of their Athenian counterparts (compare Pl. 1.A and 1.B).

Eventually the hoard found near Elmalı (Lycia) in 1984 (*CH VIII* 48) confirmed the dating to the 460s. Comprising *c.* 1900 silver coins from numerous mints, this hoard contained 187 Athenian coins, among them 13 decadrachms. The tetradrachms ranged from early owls down to Starr's Group V.A, Series 1.[45] Accordingly, the decadrachms do not belong to the hoard's final group, although they did not show much wear. It was agreed that the burial can be dated to *c.* 460, but there is no closing coin nor a definitive clue to the precise circumstances of deposit. The Athenian campaigns in the eastern Mediterranean are, of course, the broad historical background.[46]

Including specimens from all major sections of the decadrachm issue, the Elmalı Hoard must have been buried some years after the series came to its end. Although the exact chronology of Starr's groups is far from being settled, the admixture of 32 coins of Group V indicates that the typology developed a good deal quicker than Starr had thought.[47] In any case, the basis for Starr's terminal date for his Group V was fading away since more and more scholars were inclined to date the Athenian Standards Decree down to 425 BC.[48] The shift from Group V to the conventionalized style and the mass striking of the third quarter of the century must have had another reason. It seems more likely today that

43. M. J. Price and N. M. Waggoner, *Archaic Greek Silver Coinage. The "Asyut" Hoard* (London: Vecchi, 1975), pp. 61–68.

44. Ch. Boehringer, "Hierons Aitna und das Hieroneion", *JNG* 18 (1968), pp. 67–98; C. M. Kraay, *Greek Coins and History. Some Current Problems* (London: Methuen, 1969), pp. 19–42. Cf. Starr, p. 41.

45. S. Fried, "The Decadrachm Hoard: an introduction", in Carradice, p. 5. More figures are given in *CH VIII* 48.

46. H. B. Mattingly, "A New Light," p. 8 n. 17, suggests the Athenian campaign to Cyprus in 460; cf. Gomme, *op. cit.*, pp. 305–307.

47. See J. H. Kagan, "The Decadrachm Hoard: Chronology and Consequences", in Carradice, pp. 21–28, esp. p. 22.

48. See H. B. Mattingly, *The Athenian Empire Restored. Epigraphic and Historical Studies* (Ann Arbor: University of Michigan Press, 1996), *passim*.

the removal of the Delian League treasury from Delos to Athens in 454 was the occasion, for it enabled the Athenians to dispose of the tribute much more easily than before.[49]All this suggests that the sequence of Starr's groups has to be pressed into a smaller time frame. Located near the middle of the sequence, the decadrachms seem to remain exactly where they were put by Starr, that is to say, soon after the battle of the Eurymedon, still in the first half of the 460s.[50]

In or before 1994 a second decadrachm hoard was found somewhere in the Levant. This hoard which has come to be known as the Aleppo Hoard purportedly contained four decadrachms at least. Unfortunately, only a small and perhaps contaminated sample without any decadrachm was recorded in London. It is by no means sure which of the decadrachms that appeared on the market since 1994 may be traced back to the Aleppo Hoard. These new specimens have little in common in their wear and preservation, and so they might derive from more than one source. As far as the Aleppo Hoard can be reconstructed, it covered a wide range of Macedonian, Aegean, Phoenician, and Cyrenaic mints. Although there is no publication yet it is known that some of its contents point to a burial date after 440 BC.[51] Although it extends the die-study somewhat, the Aleppo Hoard does not help in fixing the date of the decadrachm issue. The same is true for the somewhat earlier Jordan Hoard (*IGCH* 1482).[52]

Having reviewed the previous scholarship we have to ask whether Starr's date will stand or not. As in other cases, the date depends largely on historical considerations. Starr cited Plutarch's remark that the sale of the Eurymedon booty had contributed to the public building program of Athens.[53] However,

49. J. H. Kroll, *The Greek Coins,* The Athenian Agora XXVI (Princeton: American School of Classical Studies, 1993), p. 6. As long ago as 1910 Rudolf Weil arrived at the same date: R. Weil, "Das Münzrecht der Symmachoi im Ersten Attischen Seebund", *ZfN* 28 (1910), p. 356; cf. E. Babelon, "La politique monétaire d'Athènes au V. siècle avant notre ère", *RN* (1913), pp. 467 f.

50. Flament, pp. 51–54.

51. Brand, pp. 96 ff., reports some of the rumors. An overview of the available evidence is in preparation by A. Meadows and U. Wartenberg Kagan.

52. C. M. Kraay and P. R. S. Moorey, "Two Fifth Century Hoards from the Near East", *RN* (1968), pp. 181–210. Kagan, *op. cit.*, p. 22 has pointed out the circular argument that would emerge as soon as Kraay's date of the Jordan Hoard is used for modifying the Athenian coin chronology.

53. Starr, p. 40. Plut. *Cim.* 13.5 f.: Πραθέντων δὲ τῶν αἰχμαλώτων λαφύρων, εἴς τε τὰ ἄλλα χρήμασιν ὁ δῆμος ἐρρώσθη, καὶ τῇ ἀκροπόλει τὸ νότιον τεῖχος κατεσκεύασεν ἀπ' ἐκείνης εὐπορήσας τῆς στρατείας. Λέγεται δὲ καὶ τῶν μακρῶν τειχῶν, ἃ σκέλη καλοῦσι, συντελεσθῆναι μὲν ὕστερον τὴν οἰκοδομίαν, τὴν δὲ πρώτην θεμελίωσιν εἰς τόπους ἑλώδεις καὶ διαβρόχους τῶν ἔργων ἐμπεσόντων, ἐρεισθῆναι διὰ Κίμωνος ἀσφαλῶς, χάλικι πολλῇ καὶ λίθοις βαρέσι τῶν ἑλῶν πιεσθέντων, ἐκείνου χρήματα πορίζοντος καὶ διδόντος. "The people of Athens raised so much money from the spoils of war, which were publicly sold, that besides other expenses, and raising the south wall of the citadel, they laid the foundations of the long walls, not, indeed, finished till at a

this does not mean that the lion's share of the war revenues was spent at once. In line with the general finance policy of Athens, a considerable amount of silver might have been stored in the treasury for some time, particularly if the much disputed peace of Kallias which brought a cessation in hostilities between Athens and Persia, is a historical fact.[54] If so, it might have caused the Athenian war expenditure to diminish temporarily. Nonetheless, there remained the expense of the maintenance a fleet with which to police the Athenian empire, including Cimon's siege of Thasos in 465–463.

Metallurgical analyses will not help any further. Some years ago Hélène Nicolet-Pierre pointed out that the Paris decadrachm appears to be made of Laurion silver.[55] The silver of some other Athenian issues is distinguished by a high gold content, which suggests an admixture of foreign silver.[56] Since the sale of the Eurymedon booty might have caused the influx of foreign silver to increase, it might be suggested that the fact that the Paris coin was struck of pure Laurion silver suggests that it was minted before Eurymedon. Yet it is equally possible that in the case of such high-value pieces as the decadrachm that the Athenian mint took special care to use only unadulterated Laurion silver.

As things stand, the style of the issue should be reconsidered. It has often been said that the so-called *"Damareteion"* issue of Syracusan decadrachms (Pl. 1.B) is more or less contemporary with the Athenian decadrachms. The Arethusa head does indeed resemble that of Athena on the Berlin coin (1a: die O 1; Pl. 1.A) in the proportions of face and upper head as well as the internal proportions within the face. Unfortunately, scholars still disagree whether the Syracusan decadrachm issue has to be dated shortly before or soon after the

later time, which were called the Legs. And, the place where they built them being soft and marshy ground, they were forced to sink great weights of stone and rubble to secure the foundation, and did all this out of the money Cimon supplied them with".

54. See K. Meister, *Die Ungeschichtlichkeit des Kalliasfriedens und deren historische Folgen*, Palingenesia 18 (Wiesbaden: F. Steiner, 1982), and L. J. Samons II, "Kimon, Kallias and Peace with Persia", *Historia* 47 (1998), pp. 129–149.

55. H. Nicolet-Pierre, "Autour du décadrachme athénien conservé à Paris", in *Studies Price*, pp. 293–299.

56. A high gold percentage in silver objects from the Bronze and early Iron Ages points to Egyptian silver sources. See Z. A. Stos-Gale, "The Impact of Natural Sciences on Studies of Hacksilber and Early Silver Coinage", in M. S. Balmuth (ed.), *Hacksilber to Coinage. New Insights into the Monetary History of the Near East and Greece* (New York: American Numismatic Society, 2001), pp. 53–76. There are Greek coinages with similar high gold contents, see Y. L. Djukov, T. N. Smekalova, A. V. Melnikon, and N. M. Vecherukhin, "Studies of Silver Coins of Alexander of Macedon from the Collection of the State Hermitage", in Gh. Moucharte et al. (eds), *Liber amicorum Tony Hackens* (Louvain-la-Neuve: Association de numismatique Marcel Hoc, 2007), p. 92, on coins of Alexander the Great from Amphipolis. Persian war booty too?

fall of the Deinomenid dynasty in 466 BC.[57] It is nevertheless clear that the Arethusa head is still more conservative than the obverse die O 13 (22a–23a). The comparison between O 1 and O 13 reveals the stylistic spread of the series. Probably the Athenian issue lasted somewhat longer than its Syracusan counterpart. The question is, how long?

A close look at O 13 suggests a final point of the series deep in the second half of the 460s. It has already been mentioned that the die is not archaizing but strictly avant-garde. There is a touch of smile left around Athena's lips, and both hair and profile eye do submit to the archaizing tendency, but as a whole this is a Severe Style composition. Therefore it should be possible to come to a better dating by stylistic comparisons.

It must be said at the outset that none of the works of art to be compared can be dated exactly. They are all dated to "c. 460" by common opinion. The backbone of the chronology is the complex of sculptures from the temple of Zeus at Olympia which was built from 472 onwards and dedicated in 457 BC. It is not hard to say whether a work of art of the Severe Style (c. 480–c. 450 BC) was created before rather than after the Olympia sculptures. However difficult in details, the overall style chronology in the decades 480–450 is far from being controversial.[58]

The Athena head on O 13 with its compact proportions, notably the arched forehead, the heavy chin and the fleshy cheek, evidently belongs with the sculptures made "after" the Olympia complex, that is to say, c. 460 BC. The best comparisons are the heads of the seated woman on the relief from the island Ikaria (Pl. 3.F) and of the female flute-player on the side of the Ludovisi Throne (Pl. 4.G).[59] The Ikaria stele in particular shares the overall proportions of the heads, the flat features of the relief and the relaxed facial expression with O 13. The girls' heads on the stele fragment from Pharsalos look more conservative, but this might be due to the provincial style of Thessaly.[60]

57. The problem was recently discussed by G. Manganaro, "Dall'obolo alla litra e il problema del 'Damareteion'", in M. Amandry and S. Hurter (eds), *Travaux de numismatique grecque offerts à Georges Le Rider* (London: Spink, 1999), pp. 239–255, and by K. Rutter, *Greek Coinages of Southern Italy and Sicily* (London: Spink, 1997), pp. 121–132. Furthermore, see H.B. Mattingly, "The Damareteion Controversy: a New Approach", *Chiron* 22 (1992), pp. 1–12, and K. Rutter, "The Myth of the 'Damareteion'", *Chiron* 23 (1993), pp. 171–188.

58. See B.S. Ridgway, *The Severe Style in Greek Sculpture* (Princeton: Princeton University Press, 1970), and C. Rolley, *La sculpture grecque, 1. Des origines au milieu du V^e siècle* (Paris: Picard, 1994), pp. 318 ff.

59. Ikaria stele: H. Hiller, *Ionische Grabreliefs der 1. Hälfte des 5. Jahrhunderts v. Chr.*, Istanbuler Mitteilungen Beiheft 12 (Tübingen: Wasmuth, 1975), pp. 172–174, pl. 16. Ludovisi Throne: Rolley, *op. cit.*, p. 314 fig. 328.

60. H. Biesantz, *Die thessalischen Grabreliefs* (Mainz: von Zabern, 1965), pp. 22 f., pl. 17.

It is easy to specify comparanda from the decade 460/50 the stylistic level of which can be distinguished from the Athena head of O 13: the female head on the Melos Disc (Pl. 5.H), the girl's head on the Giustiniani Stele (Pl. 6.I), the "Mourning Athena" (Pl. 7.K) and the head of the seated woman on the banquet relief from Thasos (Pl. 8.L) all have different proportions. The lower part of the face has lost some volume, the chin is no longer heavy, the jawbone no longer protrudes.[61] Furthermore, the facial elements—eye, nose, mouth—are rendered in the right perspective, that is to say, they are shifted to the front of the head.

To sum up, the die O 13 must have been cut during the second half of the decade 470/60 and should actually be dated "*c.* 460". The same must be true for the die-chain 22–33, however archaizing Athena looks on O 14 and the following obverse dies. This is not to say that the decadrachm issue continued during the early 450s. If the battle at the river Eurymedon was its starting point (some date between 469 and 465), then the decadrachm issue did not conclude after one or two years, but lasted until the end of the decade.

Recently Hélène Nicolet-Pierre has pointed out that we do not yet know which one of the two decadrachm issues of Syracuse and Athens started first.[62] It is still controversial whether the Syracusan issue was the last display of tyranny or rather the celebration of liberty. At Athens, the political discrepancies were less harsh, but there was some turmoil as well. In 463/2 the Areopagus was deprived of its power; Ephialtes and his aspiring partisan Pericles introduced radical democracy to Athenian politics. A year later Cimon was ostracized and left Athens. It is hard to say whether the conclusion of the decadrachms has anything to do with the changes on the political stage. The decadrachm issue is likely, however, to have been a project of an "ancien regime".

THE PURPOSE OF THE ISSUE

A last question remains: the purpose of the decadrachm issue. Although we do not know the exact size of the issue we may suppose that it was much too large to have any other purpose than an economic one. The idea that large denominations were issued to celebrate victories on the battlefield stems from the

61. Melos disc: Ch. Karouzos, "An Early Classical Disc Relief from Melos", *JHS* 71 (1951), pp. 96–110. Giustiniani stele: Hiller, *op. cit.*, pp. 175 f., pl. 17, 2; R. Tölle-Kastenbein, *Frühklassische Peplosfiguren. Originale* (Mainz: von Zabern, 1980), p. 86 f., pl. 53. "Mourning Athena": Tölle-Kastenbein, *op. cit.*, p. 56 f., pl. 45. Banquet relief from Thasos: G. Neumann, *Probleme des griechischen Weihreliefs* (Tübingen: Wasmuth, 1979), p. 40, pl. 21.

62. H. Nicolet-Pierre, "Metrologie des monnaies grecques", p. 44: "Ainsi, l'initiative de la frappe des lourdes monnaies de 10 drachmes revient-elle à Athènes, ou celle-ci entre-t-elle alors en compétition avec Syracuse et ses 'démareteia'? Ni d'un côté ni de l'autre la chronologie de ces émissions de décadrachmes n'est absolument fixée et la question reste encore en suspens".

modern habit of issuing large-size medals on such occasions. Medals, however, are usually either produced of cheap material or issued in quite small numbers, and medals are not legal tender. Decadrachms must be compared with the highest banknote available rather than with prestigious but non-monetary medals.

Although it is now commonly held that the issue of decadrachms served a monetary purpose, the comparison with high-value banknotes has to be qualified. While the modern state cares about a permanent supply of high-value banknotes, the ancient state issued the high denominations quite sporadically. For that reason numismatists keep looking for the special need that such an issue could have met, a consideration that appears to shift the problem from one field of history to another. In the end, it is the same field, since economic history has always been a part of the history of power. In fact, the decadrachms have often been thought to have been issued for payments of the state, that is to say, for arms expenditure. The Near Eastern findspots have fueled the idea that the decadrachms were issued for buying timber for the Athenian fleet.[63] This is an explanation worth considering, but the pedigrees of some specimens reveal that a certain amount of the decadrachm issue remained in Greece.[64] The didrachm series that accompanied the decadrachms clearly shows that the decadrachms were expected to enter circulation. Obviously the high denominations met a need in the market: Athenian society of the 460s must have been monetized already at a fairly high level. The booty from the battles of Marathon, Salamis, Plataea, and Eurymedon was at least partly sold at Athens, thus leading to the repeated influx of sums rarely seen before. While fifth-century gold coins are often a symptom of crisis, the silver decadrachms are the symptom of a flourishing market.[65] From this point of view, the issue's drift to the East that is revealed in the Near Eastern provenances of the majority of the extant specimens might result from the lasting demand in the Levant for good silver, rather than from a sudden need of the Athenian state to import Oriental merchandise.[66]

63. See above, p. 24.
64. See above, p. 15 ff.
65. On the general interpretation of fifth-century gold coins, see C. M. Kraay, "Greek Coinage and War," in W. Heckel and R. Sullivan (eds), *Ancient Coins of the Graeco-Roman World*, The Nickle Numismatic Papers (Waterloo: Wilfrid Laurier University Press, 1984), pp. 3–18; W. E. Thompson, "The Functions of the Emergency Coinage of the Peloponnesian War", *Mnemosyne* 4, 19 (1966), pp. 337–343. See also M. Caccamo Caltabiano, *La monetazione di Messana*, AMuGS XIII (Berlin & New York: W. de Gruyter, 1993), pp. 73–75.
66. Beside the specimens found in Near Eastern hoards, the export of decadrachms to the Levant is also reflected in some copies of the decadrachm owl in Levantine coinages: see Y. Meshorer and Sh. Qedar, *Samarian Coinage* (Jerusalem: Israel Numismatic Society, 1999), p. 99, nos. 87–88; H. Gitler and O. Tal, *The Coinage of Philistia*, pp. 96–100,

Nevertheless, we must wonder why Athens never again minted deca-
drachms. The output of the Athenian mint grew rather than shrank after 460.
Although the conventionalized style of the Athenian tetradrachms minted dur-
ing the second half of the fifth century makes a die-count difficult, it is beyond
doubt that there was a real mass striking during the years of Pericles' prime,
and perhaps still during the early years of the Peloponnesian War (431–404).
But no decadrachms.

From the economic point of view, more decadrachm issues would have
made sense. Before the Peloponnesian War the Athenian economy flourished,
the properties of both citizens and metics grew, and the export of Attic silver
continued. The absence of the high denomination in the period of Pericles is
in fact a problem. Since a strictly economic explanation is not obvious, a socio-
logical one may be appropriate, particularly since it is valid for later times too.
The renunciation of the opportunity to supplement the vast tetradrachm coin-
age with decadrachms could in fact be due to a change of mentality in Athenian
society. The power of Pericles and his successors was based on the assembly
and on the council. While the poor, especially those located in the countryside,
could not afford to attend the assembly regularly, each citizen was enabled to
join the council by a daily wage of five obols that was instigated soon after the
introduction of radical democracy (463/2).[67] As a result, notable families which
did not adapt to the new situation soon lost their leading position in Athenian
politics. Wealth, of course, did not lose its political power, but it was no longer
regarded without mixed feelings. Wealthy citizens were forced to contribute to
both theater performances and armament expenses.[68] Unlike their ancestors,
they cared about concealing all provocative signs of a luxuriant life-style.[69] The
envy of the crowd was proverbial, and in the fourth century wealthy Athenians
often preferred to live their lifes abroad.[70] In short, the ideology of the radical

nos. III.1T–III.5O (Ashkelon).

67. M. H. Hansen, "Misthos for Magistrates in Classical Athens", *Symbolae Osloenses*
54 (1979), pp. 5–22; J. J. Buchanan, *Theorika. A Study of Monetary Distributions to the
Athenian Citizenry during the Fifth and Fourth Centuries B.C.* (Locust Valley, N.Y.: J. J.
Augustin, 1962), pp. 21 f.

68. M. A. Christ, "Liturgy Avoidance and Antidosis in Classical Athens", *TAPhA* 120
(1990), pp. 147–169.

69. Cf. N. Himmelmann, *Minima Archaeologica* (Mainz: von Zabern, 1996), pp. 41–45.
The indignation of those who despised the now-required self-denial can be felt in the
pamphlet of the so-called Old Oligarch (Ps.-Xen., *Ath. pol.*).

70. Corn. Nep. *Chabr.* 3.3 f.: *est enim hoc commune vitium in magnis liberisque civita-
tibus, ut invidia gloriae comes sit et libenter de iis detrahant, quos eminere videant al-
tius, neque animo aequo pauperes alienam [opulentium] intueantur fortunam. itaque
Chabrias, quoad ei licebat, plurimum aberat. neque vero solus ille aberat Athenis libenter,
sed omnes fere principes fecerunt idem, quod tantum se ab invidia putabant futuros, quan-
tum a conspectu suorum recesserint.* "It is a common fault of great states which enjoy
freedom that jealousy waits upon glory and that the people take pleasure in humbling

democracy placed a taboo on all symbols of individual superiority, and so it may well be that the concomitant change of mentality prevented further issues of denominations that only a few people would be able to use. In the second half of the fifth century an average day's wage was a drachm.[71] Paying for something with decadrachms or even storing them up must have been beyond the imagination of the majority of the Athenian citizens. Politicians like Pericles and his partisans might have avoided the resumption of decadrachm issues so as not to be charged with adherence to oligarchic ideas.

those whom they see rising above the level of their fellows. Those of moderate means cannot regard with patience the good fortune of others who are rich. For that reason Chabrias frequently absented himself, as long as he was able to do so. He was not the only one who preferred to leave Athens, almost all the leading men thought as he did, believing that the more they withdrew from the sight of their fellow citizens, the more they would escape envy".

71. The craftsmen of the Acropolis building sites obtained 1 drachm per day, a few specialists obtained 5 drachms; see B. Wesenberg, "Kunst und Lohn am Erechtheion", *Archäologischer Anzeiger* (1985), pp. 55–65. Jurors got ½ drachm per day (Aristoph. *Equ.* 51, 255, 798–800, cf. Buchanan, *op. cit.*, pp. 14–21). The same or less might be true for unqualified laborers. Soldiers got at least 1 drachm per day (Thuc. 3.17.3 f.; 5.47.6; Aristoph. *Ach.* 602).

4

Catalogue

Right and left are always from the point of view of the observer.

Obverse: Head of Athena facing right, wearing crested Attic helmet, ear-pendant, and necklace, the bowl decorated with three olive leaves and palmette.
Reverse: A-Θ-E. Owl standing facing, wings spread. Olive twig in the upper left field with two leaves and fruit. The whole within *quadratum incusum*.

1 O1 Almond-shaped eye with *caruncula lacrimalis*. Tiny, flat cowlick. The bunch of hair in front of the ear is thick and softly rounded. The right olive leaf does not touch the dotted line of the crest but ends at the bowl. The palmette does not touch the left olive leaf, and the tendril spreading downwards does not touch the ear. The pendant hangs to the left of the jaw line. A line (necklace?) above the dots at the shoulder. (A die-break running from the eyebrow to the upper lid.)

R1 The olive leaves spring from different points. Broad wings; the middle row of feathers is almost vertical, the lower row fan-shaped. Broad A with slightly slanting cross-bar, irregularly shaped Θ with eccentric point, �LJ with apparently uniform cross-bars. (A die-break beneath the right eye.)

a) 42.60 g, 4 h. Berlin, Prokesch-Osten (Flament, p. 51 fig.; B. Weisser in *Münzen und Medaillen. Die Ausstellung des Münzkabinetts im Bode-Museum* (Munich: Prestel, 2006), p. 46 fig.; A. Tzamalis, *Nomismatika Khronika* 17 (1998), pp. 123–126; H. D. Schultz, *Antike Münzen. Bildheft* (Berlin: Staatliche Museen zu Berlin, 1997), p. 19 no. 22; S. Schultz, *Antike Münzen. Griechische Prägung* (Berlin: Staatliche Museen zu Berlin, 1984), p. 24 fig. 12 (obv.); Starr, p. 33 no. 52; C. M. Kraay and M. Hirmer, *Greek Coins* (London: Thames & Hudson, 1966), p. 326 no. 357 pl. 118/XII; C. Seltman, *Masterpieces of Greek Coinage* (Oxford: Cassirer, 1949), pp. 38–41 figs. 11a-b; K. Lange, *Antike Münzen* (Berlin: Gebr. Mann, 1947), p. 11 fig. (obv.); Jongkees, p. 109 pl.

II; K. Lange, *Götter Griechenlands* (Berlin: Gebr. Mann, 1941), fig. 24 (obv.); Mainzer, pp. 37–54, pl. VI, 1; Svoronos, pl. 8, 15; K. Regling, *Die antike Münze als Kunstwerk* (Berlin: Schoetz & Parrhysius, 1924), p. 129 no. 331, pl. 14; Seltman, p. 211 no. 446, pl. 20 [A301/P381]; A. v. Sallet, *Die antiken Münzen*, p. 9 fig.; E. Babelon, *JIAN* 8 (1905), p. 47 fig. 14; *Traité* I 2, no. 1141, pl. 35, 8; J. Friedländer, *ZfN* 4 (1877), p. 2, 5; Beulé, p. 48 fig.; A. Prokesch von Osten, *Inedita meiner Sammlung autonomer altgriechischer Münzen* (Vienna: Hof- und Staatsdruckerei, 1854), p. 29, pl. 2, 76; W. S. W. Vaux, *NC* (1853), p. 30; BM electrotype; BM Cast 21; Berlin Cast 6 of obv.; ANS cast. Purchased at Athens from Michel Iatros c. 1853 but seen as early as 1833 at Nauplia. Obverse: two cracks, the first one at 4 o'clock, the second one at the neckguard. A deep cut almost splits the pendant. Reverse: minting-gap through the left eye. Deep scratch beneath the left wing.

~

2 O 2′ Though no earlier stage is known, the die might be recut: the eye is bigger than usual and wrongly placed within the eye socket, thus overlapping the eyebrow. The nose might be redone as well, coarse as it looks. Otherwise, the details can be described as usual. The cowlick is tiny if there is one at all. The bunch of hair in front of the ear is thick and softly rounded. The right olive leaf does not touch the dotted line of the crest but ends at the bowl. The middle leaf of the palmette is longer than usual and touches the olive leaf just at the tip, whereas the tendril spreading downwards does not touch the ear. The pendant hangs to the left of the jaw line. A thin line (necklace?) above the dots at the shoulder. (Small cracks at the crest. A die-break in the curl of the tendril of the palmette. Big die-break in the field, beneath Athena's chin.)[1]

R 2 Due to the condition of the only specimen extant, it cannot be said whether the olive leaves spring from the same point. Broad wings; the middle row of feathers is almost vertical, and the lower row as well. Narrow A with a slightly slanting cross-bar, irregularly shaped Θ, Ⅎ with a short upper cross-bar. (Big die-break at the hanging olive leaf).

a) 41.61 g, 12 h. Brussels, de Hirsch 1272 (Starr, p. 33 no. 53; P. Naster, *La collection Lucien de Hirsch* (Brussels: Bibliothèque royale, 1959), p. 211 no. 1272, bought "probablement chez Rollin-Feuardent, 23 août 1882, 1.200 F[rancs]"; Svoronos, pl. 8, 8; Seltman, p. 211 no. 445, pl. 20 [A300/P380]; Berlin Cast 7).

~

1. The Boston lead trial piece was erroneously said to have the same obverse die (see below, p. 51).

3 O 3 Almond-shaped eye without a separated *caruncula lacrimalis* but
with a pointed inner tip. Flat cowlick. The bunch of hair in front of
the ear is broadly rounded, has a triangular pattern at the center, and
is tied up by a narrow fillet. The right olive leaf does not touch the
dotted line of the crest but ends at the bowl. The middle leaf of the
palmette is longer than usual and touches the olive leaf just at the
middle, while the tendril spreading downwards touches the ear. The
pendant hangs to the left of the jaw line. (A die-break at the left tip of
the eye runs upwards to and crosses the eyebrow. All the three speci-
mens extant have two dents which must be due to the die: one at the
upper cheek, just beneath the eye, and another above the ear, between
the palmette's tendril and the left olive leaf. Thus the die has two pro-
tuberances which are not traces of rust.)

R 3 The olive leaves spring from different points. Broad wings; the middle
row of feathers is almost vertical, the lower row fan-shaped. Narrow A
with a "modern", horizontal cross-bar, round Θ, Ƌ with a short middle
cross-bar.

a) 42.91 g, 4 h. Current disposition unknown, from the Elmalı Hoard *CH VIII*
48, *MJPP* 10.063. Two traces of abrasion at the stomach of the owl.

4 O 3 As above.

R 4 The olive leaves spring from different points. Broad wings; the middle
row of feathers is vertical and the lower row as well. Broad A with a
slightly slanting cross-bar, round Θ, Ƌ with a long middle cross-bar.
The A is placed horizontally into the corner.

a) 43.05 g, 11 h. Current disposition unknown, from the Elmalı Hoard *CH VIII*
48, *MJPP* 10.070 (S. Fried in Carradice, p. 5, pl. 3, 21).

5 O 3 As above.

R 5 The olive leaves spring from almost the same point. Broad wings; the
middle row of feathers is diagonal, the lower row fan-shaped. Broad
A with an "archaic", slightly slanting cross-bar, irregularly shaped Θ,
Ƌ with a short upper cross-bar. (A die-crack above the right wing, i.e.
"beneath" the cross-bar of the A. Two edge cracks running over the
lower half of the right wing into the Θ. Die-break at the upper left
corner of the *quadratum incusum*, at the origin of the olive sprig.)

a) 42.90 g, 9 h. Sotheby's NY 19 June 1990, Nelson Bunker Hunt I, 66 (*Wealth
of the Ancient World*, Cat. Fort Worth, Beverly Hills: Kimbell Art Museum &
Summa Galleries 1983, p. 169 no. 66), *ex* Syd Weintraub Collection, Holly-
wood (B. McNall, *Fun While It Lasted* (New York: Hyperion, 2003), pp. 36–
39) = Leu-MMAG 28 May 1974, Kunstfreund 147, *ex* Boston, Museum of
Fine Arts (C. Seltman, NC (1946), p. 108 n. 35, pl. IX, 5 "in Boston"), *ex*
[E. P.] Warren Collection (*hors catalogue,* but see C. Seltman, *Greek Coins*

(London: Methuen, 1933), p. 94, 292 "Warren" pl. XIII, 2; Berlin Cast 2 (rev. splintered) with the notice "Kambanis 40 jetzt Warren" and the ticket "Kambanis 40 = Warren stgl.") = Charles Seltman Collection, Cambridge (Starr, p. 34 no. 55 "Seltman Collection"; Seltman, p. 211 no. 447, pl. 20 [A302/P382] "Seltman, Cambridge"; ANS Cast with two notices: a) "Cast from a coin in Athens [illegible] Guide (1922). Taken by Mr. Noe, while in Athens", b) "Seltman, Athens, no. 447, in known possession"), *ex* Michael L. Kambanis Collection, Athens (cf. the Berlin cast above), allegedly found at Spata (Central Attica), 1922. Obverse: scratches at the tip of the left olive leaf and above the ear, corrosion all over the neck. Reverse: some minting-gaps at the stomach and over the left wing of the owl. Both sides show traces of horn silver.

The various notes about the owners deserve some explanation: a) The owner at Athens, where Noe took the ANS cast, might have been M. L. Kambanis. b) No genuine specimen has ever been recorded as being in the E. P. Warren Collection before and after the collection was published in 1906, but the Berlin notice "jetzt Warren" was written by Warren's cataloguer Regling himself, and the name is corroborated by Seltman who sold the coin. c) The notice "Boston" corroborates the notes alluding to Warren who sold the lion's share of his collection to the Museum of Fine Arts. However, he did so in 1904, i.e. 20 years before Seltman's book appeared, where the coin is still said to be in Seltman's collection. Warren died in 1928.[2] Seltman would have sold the coin to him soon after finishing his study (1924). On the other hand, it is by no means clear whether any other coin bought by Warren after 1904 ever came to Boston. Agnes Baldwin Brett's foreword to the Boston catalogue and the concordance to accession numbers which is chronologically arranged provide no explanation.[3] There are numerous gifts, even of a certain Mrs. Samuel D. Warren in 1903, but none credited to E. P. Warren.

∼

6 O 4 Almond-shaped eye without a *caruncula lacrimalis*, but with a pointed inner tip. Cowlick. The bunch of hair in front of the ear is rounded, but its shape is long rather than broad; it forms a triangular pattern at the center. The hair at the temple touches the eyebrow. The right olive leaf slightly touches the dotted line of the crest. The palmette touches the left olive leaf at its tip with the upper leaflet, while the tendril spreading downwards does not touch the ear. The pendant hangs just

2. On Edward Perry Warren (1860-1928) see O. Burdett and E. H. Goddard, *Edward Perry Warren: The Biography of a Connoisseur* (London: Christophers, 1941); D. Sox, *Bachelors of Art: Edward Perry Warren and the Lewes House Brotherhood* (London: Fourth Estate, 1991).

3. A. B. Brett, *Museum of Fine Arts Boston. Catalogue of Greek Coins* (Boston: Museum of Fine Arts, 1955), pp. xiii, 329–337.

to the left of the jaw line. Line (necklace?) above the dotted border at the shoulder. (Two point-like die-cracks: one at Athena's cheek, just to the right of the bunch of hair in front of the ear, and another just to the right of the curl of the tendril. Two more die-cracks emerge in the last combination only: a thin one beneath the nostril, and another at the chin, just beneath the lower lip.)

R6 The olive leaves spring from almost the same point. Narrow wings; the middle row of feathers is diagonal, the lower row is almost vertical. Broad A with a slightly slanting cross-bar, irregularly shaped Θ, Ⴑ with a short upper cross-bar. (A die-crack at the right edge of the hanging olive leaf. Another die-crack at the point of the Θ.)

a) 43.03 g, die axis unknown. Private collection (*Connoisseur*, July 1988, p. 78 fig.; *Der Münzen- und Medaillensammler. Berichte* 27/159 (Jan. 1988), frontispiece and p. 348). Obverse: edge crack at 8 o'clock.

b) 42.67 g, 9 h. Private collection, allegedly from a Syrian hoard, found together with c. 10 Attic tetradrachms. Obverse: deep gash made by a chisel, at 11 o'clock; a crack in Athena's cheek. Reverse: crack (from the test-stroke), at 4 o'clock; some minor minting-gaps on the stomach of the owl.

7 O4 As above.

R7 The olive leaves spring from the same point. Narrow wings; the middle row of feathers is diagonal, the lower row fan-shaped and almost vertical. Broad A with a slightly slanting cross-bar, round Θ, Ⴑ with a short upper cross-bar.

a) 42.70 g, 7 h. London, *BMC Attica*, p. 6 no. 40, *ex* Thomas Burgon, 1841 (C. M. Kraay, *Archaic and Classical Greek Coins*, p. 66 no. 188, pl. 11; Starr, p. 34 no. 62; B. V. Head, *A Guide to the Principal Coins of the Greeks*[3] (London: British Museum, 1959), p. 22 no. 31, pl. 11, 32 [*sic*]; Svoronos, pl. 8, 16; Seltman, p. 211 no. 449, pl. 21 [A304/P384]; *Traité* I 2, col. 771 f. no. 1143 [a]; Head, *HN*[2], p. 371 fig. 208; W. S. W. Vaux, *NC* (1853), p. 30 "[the coin] in the Museum was procured in Greece by Mr. Green, late Her Majesty's consul at Patras, and passed into Mr. Burgon's collection, from whom it was purchased by the British Museum about twelve years ago"; Berlin Cast 5 "ein weiteres Dekadr.: Thomas (Kat. no. 1500) *ex* Strangford, abgeb. bei Brondsted voyages[2] p. 188, cf. p. 300 – dürfte aus Sotheby Kat. 14.VI.[18]87 'a gentleman' stammen, lot 381", added by another hand "Nein" (cf. below). Obverse: deep gash made by a chisel, at 2 o'clock; a long scratch on the neck-guard. Reverse: edge crack (from the test stroke), at 2 o'clock.

The disagreement documented on the Berlin Cast 5 deserves an explanation. The Berlin curator was wrong twice: a) The Strangford specimen mentioned is the de Luynes coin.[4] b) The Sotheby Sale of a gentleman

4. Cf. H. Nicolet-Pierre in *Studies Price*, pp. 293 f.

(who was, according to the BM copy, a certain "Hoffmann": the Paris deal-
er?) did not offer a decadrachm nor (more than) 381 items. So the curator
might have had in mind rather the Sotheby's 27 June 1887 sale "A Cabinet of
Select Greek Coins" [Thomas Jones Collection], where no. 381 is indeed an
Athenian decadrachm. Unfortunately, that specimen is lost (NA2; see below,
p. 49 f.).

8 O 4 As above.
 R 8 The olive leaves spring from almost the same point. Narrow wings;
 the middle row of feathers is diagonal, the lower row fan-shaped.
 Narrow A with a slightly slanting cross-bar, irregularly shaped Θ, Ⅎ
 with a short upper cross-bar.

 a) 42.93 g, 4 h. Private collection, from the Elmalı Hoard *CH VIII* 48, *MJPP*
 10.069. Reverse: deep minting gap on the stomach of the owl.
 b) 42.60 g, 3 h. Frankfurt, Geldmuseum der Deutschen Bundesbank 2194/68
 (M. R. Alföldi, *Dekadrachmon*, p. 91 pl. 1, 1) = MMAG 37, 5 Dec. 1968, 191 =
 "André Emmerich Gallery, *Art of the Ancients* (1968), 27" (Starr, p. 34 no. 57
 "Commerce"), from the Malayer Hoard *IGCH* 1790 (D. Schlumberger in R.
 Curiel and D. Schlumberger, *Trésors monétaires d'Afghanistan* (Paris: Impr. na-
 tionale, 1953), p. 53 "Godard"; BM Cast 12 "decadr. sur la Moretti [*sic*] (12.65),
 4 h, 42.61 gm" = M. J. Price, *BoC* 2, 4 (1977), p. 90 fig. 8 "shown 1965"). The
 coin is rather worn. Reverse: a deep gash in the right edge of the flan.
 The notes about the first owners are difficult to explain. Strangely enough,
 the coin (or a cast of it?) was shown to the BM authorities in 1965, and seems
 to have been regarded as fake, at least by Price in 1977. "Moretti" certainly
 means the late Swiss collector Athos Moretti. If so, he would have bought the
 coin from the director of the Antiquities Service of Iran, André Godard.[5]
 Interestingly enough, the coin was shown in 1965, the very year of Godard's
 death. However, Moretti is not known to have collected anything other than
 Sicilian coins during the 1960s. The matter remains a mystery.

 ∾

9 O 5 Almond-shaped eye; due to the condition of the only specimen extant
 it cannot be said whether it does or does not have a *caruncula lacri-
 malis*. No cowlick? The bunch of hair in front of the ear is rounded,
 its shape is long rather than broad. The right olive leaf rises above the
 dotted line of the crest. Due to the condition of the specimen extant,
 the shape of the palmette cannot be described. The pendant seems to
 hang exactly on the jaw line. A thin line (necklace?) runs above the
 dotted border at the shoulder. (A die-break runs downwards from the

5. On Athos Moretti (1907–1993) see the obituary in *NACQT* 23 (1994), pp. 9 f. On
André Godard (1881–1965) see A. Parrot, *Syria* 43 (1966), pp. 157 f.

forehead, crossing eyebrow and eye. Another die-break gives the nose an aquiline shape. A third big die-break enhances the earlobe.)

R 9 Due to the condition of the specimen extant it is impossible to say whether the olive leaves spring from the same point. Narrow wings; the middle row of feathers is slightly diagonal, the lower row is fan-shaped. Broad A with a slightly slanting cross-bar, irregularly shaped Θ, �糸 with a long middle cross-bar. (Two die-breaks cover the lower half of the right wing.)

a) 42.41 g, 9 h. New York, ANS 1968.34.16 = *SNG Berry* 641 (Starr, p. 34 no. 58), from the Tell el-Maskhouta Hoard *IGCH* 1649 (B. Y. Berry, *A Numismatic Biography*, p. 66 "the single decadrachm in the hoard" no. 355; C. Starr, *NC* (1982), p. 130 n. 9). Obverse: traces of corrosion. Two scratches at Athena's cheek.

∾

10 O 6 Almond-shaped eye without *caruncula lacrimalis*. Cowlick. The bunch of hair in front of the ear is rounded, its shape is long rather than broad. The right olive leaf touches the dotted line of the crest. Due to the condition of the specimen extant, the palmette cannot be described exactly; it does not seem to touch the olive leaf, and the tendril spreading downwards does not seem to touch the ear. The pendant seems to hang exactly on, or just slightly to the left of, the jaw line. There is a line (necklace?) above the dots at the shoulder.

R 10 Both olive leaves spring from the same point. Narrow wings; the middle row of feathers is diagonal, whereas the lower row seems to be almost vertical. Very broad A with a short, slightly slanting cross-bar, irregularly shaped Θ with eccentric point, Ⴧ with a short upper cross-bar.

a) 40.60 g, 7 h. Private collection = Leu-NFA 29 March 1985, Garrett III 52 = Leu-NFA 16 Oct. 1984, Garrett II 216, *ex* Johns Hopkins University, Baltimore (C. W. A. Carlson, *SAN* 5 (1973–74), p. 8), *ex* John Work Garrett Collection, *ex* J. Schulman, 1 Apr. 1927 = Sotheby's 24 Apr. 1907, Delbeke 139 (Starr, p. 34 no. 59b; Seltman, p. 211 no. 450b; A. Delbeke, *RBN* 48 (1892), p. 428 fig.; BM Cast 22) = Hoffmann 19 May 1890, Photiadès Pacha 532 (W. Froehner, *Monnaies grecques de la collection Photiadès Pacha* (Paris: H. Hoffmann, 1890), no. 532), allegedly found at Laurion. Although claimed by both Seltman and Starr, the die-link to the Rhousopoulos coin (11a) does not exist. "Our specimen…was heavily cleaned before the 1907 Sotheby's sale; I suspect it has been worked on further since then. Some metal has been removed from the lower rear of the helmet, which accounts for the disparity between the line of the helmet and the line of the crest. The weight must have been affected somewhat by this removal of metal" (Carlson, *op. cit.*, p. 8).

~

11 O 7 Almond-shaped eye with *caruncula lacrimalis*. Cowlick. The bunch
of hair in front of the ear is rounded, but its shape is long rather than
broad. The right olive leaf rises above the dotted line of the crest.
The palmette does not touch the olive leaf, while a tendril spreading
downwards almost touches the ear. The pendant hangs to the left of
the jaw line. (A die-crack runs down from the forehead to the cheek
by crossing the eye. Another die-break in the center of the auricle.)

R 11 Both olive leaves spring from the same point. Narrow wings; the mid-
dle row of feathers is vertical, the lower row fan-shaped. Narrow A
with a slightly slanting cross-bar, irregularly shaped Θ with eccentric
point, Ǝ with a short upper cross-bar.

a) 40.40 g, 4 h. Seen on the Paris market, Feb. 2007 = Vinchon 14 Apr. 1984,
Comtesse de Béhague 123 = Hirsch 13, 15 May 1905, [Rhousopoulos] 1965
(Starr, p. 34 no. 59a; Svoronos, pl. 8, 13; Seltman, p. 221 no. 450a, pl. 21
[A305/P385]; *Traité* I 2, col. 771 f. no. 1143 [b]; Berlin Cast 1).

12 O 7 As above.

R 12 Both olive leaves spring from the same point. Narrow wings; the
middle row of feathers in a slightly diagonal fashion, the lower row
fan-shaped. Narrow A with a slightly slanting cross-bar, irregularly
shaped Θ, Ǝ with uniform cross-bars. The left bar of the A keeps al-
most to the horizonal line.

a) 42.99 g, 1 h. Ankara, from the Elmalı Hoard *CH VIII* 48, *MJPP* 10.061.

13 O 7 As above.

R 13 The olive leaves spring from different points. Narrow wings; the mid-
dle row of feathers is short and slightly diagonal. A with a slanting
cross-bar, round Θ, Ǝ with a short upper cross-bar. The left bar of the
A keeps to the horizonal line.

a) Weight and die axis unknown. Current disposition unknown, stolen from
Nino Savoca, Munich, 31 Jan. 1996, allegedly from one of the Decadrachm
Hoards (Brand, p. 120 ff., 130, fig. 10).

b) 39.00 g, 7 h. New York, ANS 1949.119.1 *ex* Wayte Raymond (Starr, p. 34
no. 60; H. L. Adelson, *The American Numismatic Society, 1858–1958* (New
York: American Numismatic Society, 1958), pp. 280 f., plate facing p. 188) =
J. Pierpont Morgan Collection (W. Raymond, *The J. Pierpont Morgan Collec-
tion* (New York: Wayte Raymond, 1953), no. 178; Seltman, p. 212 no. 451, pl.
21 [A306/P386]) = Hirsch 21, 16 Nov. 1908, Consul Weber 1645 (Svoronos,
pl. 8, 17; Berlin Cast 8). Two test cuts on the reverse, at 10 o'clock.

~

14 O 8 Almond-shaped eye without a separated *caruncula lacrimalis*. Cow-
lick. The bunch of hair in front of the ear is broadly rounded and has
a triangular pattern at the center. The hair at the temple touches the
eyebrow. The right olive leaf touches the dotted line of the crest. The
middle leaf of the palmette touches the olive leaf just above its middle
part, while the tendril spreading downwards does not touch the ear.
The pendant hangs to the left of the jaw line. (A die-break above the
point where the hair touches the eyebrow.)

 R 14 The olive leaves spring from different points. Stout owl with narrow
wings; the middle row of feathers is diagonal, the lower row almost
vertical. Narrow A with a "modern", horizontal cross-bar, irregularly
shaped Θ, Ⴈ with uniform cross-bars.

 a) 43.05 g, 7 h. Private collection, from the Elmalı Hoard *CH VIII* 48, *MJPP*
10.066. Edge-crack (obverse at 7 o'clock, reverse at 10 o'clock)

15 O 8 As above.

 R 15 The olive leaves spring from different points. The owl as stout as be-
fore, but with a long neck. Extremely narrow wings; the middle row
of feathers is diagonal, the lower both fan-shaped (left) and vertical
(right). Broad A with a slightly slanting cross-bar, round Θ, Ⴈ with a
short upper cross-bar. The left bar of the A keeps almost to the hori-
zontal line. (Tiny die-cracks in the right upper corner of the *quadra-
tum incusum*.)

 a) 41.264 g, 3 h. Athens, Numismatic Museum BE 746 [130/1999] (J. Touratso-
glou, *Archaiologikon Deltion* 54 (1999 [2005]), p. 19 fig. 1, 1; *id.*, *Nomisma-
tika Khronika* 18 (1999), pp. 17-19; *id.*, Ιλίου Μέλαθρον *2000* (Athens: n.p.,
2001), pp. 103–105 with fig. [reverse the wrong way round]), allegedly from
one of the Decadrachm Hoards (Brand, p. 113 f.). Obverse: minting gap at
the middle olive leaf, and a scratch (?) beneath Athena's eye.

16 O 8 As above.

 R 16 The olive leaves spring from almost the same point. Broad wings; the
middle row of feathers is slightly diagonal, the lower row fan-shaped.
Broad A with a slanting cross-bar, round Θ, Ⴈ with a short upper
cross-bar.

 a) 43.00 g, 6 h. Ankara, from the Elmalı Hoard *CH VIII* 48, *MJPP* 10.062.
Scratch in Athena's eye.

<div align="center">～</div>

17 O 9 Almond-shaped eye with *caruncula lacrimalis*. Cowlick. The bunch of
hair in front of the ear has a round shape, but a triangular pattern at
the center. The right olive leaf touches the dotted line of the crest; this
dotted line has some tiny breaks just left of the leaf's tip. The middle

leaf of the palmette touches the left olive leaf at its top. (Several die-cracks along the line of forehead and nose. A large die-break above the visor's top and to the right of the right olive leaf is to be seen on 18a only.)

R 17 The short row of feathers above legs and tail is almost horizontal. Middle row of wing feathers is diagonal. Irregularly shaped Ⓞ. Big Ⴈ with uniform cross-bars.

a) 21.11 g, 7 h. Private collection = CNG 76/2, 12 Sept. 2007, 3049, *ex* John A. Seeger Collection, *ex* P.M. Heinmiller Collection, Pasadena (Starr, p. 34 no. 56 "American collection"), from the Jordan Hoard *IGCH* 1482 (C. M. Kraay and P. R. S. Moorey, *RN* (1968), p. 185, no. 41, pl. 20). Fragmented, i.e. cut down to a half. Some traces of verdigris at the reverse. The reverse has some flatness at the left and lower edge of the flan, like 5a.

18 O 9 As before.

R 18 Middle row of wing feathers is diagonal, the lower row goes in the opposite direction, somewhat fan-shaped. Broad A with an "archaic" slanting cross-bar, irregularly shaped Ⓞ, big Ⴈ with short lower cross-bar. The left bar of the A keeps to the horizonal line.

a) 42.92 g, 1 h. Ankara, *ex* NFA (rev. on flyer reprinted in *Der Münzen- und Medaillensammler. Berichte* 27/159 (Jan. 1988), frontispiece and p. 348), from the Elmalı Hoard *CH VIII* 48, *MJPP* 10.067. The dotted line of the crest appears to be broken above the palmette, but a shadow of its original position is still to be seen. The phenomenon might be explained by a doublestrike rather than by a recutting of the die.

~

19 O 10 Almond-shaped eye with *caruncula lacrimalis*. Cowlick. The bunch of hair in front of the ear has a broad oval shape. The right olive leaf rises above the dotted line of the crest. The palmette touches the left olive leaf below its middle. A tendril of the palmette spreading towards the ear ends in a dot. The pendant hangs exactly on the jaw line. (A point-shaped die-crack like a beauty-spot below the lower lip.)

R 19 Large olive sprig, whose leaves spring from different points. Narrow wings, the middle row of feathers is diagonal. Narrow A with a slightly slanting cross-bar, round Ⓞ, big Ⴈ with uniform bars.

a) 43.06 g, 4 h. Ankara, from the Elmalı Hoard *CH VIII* 48, *MJPP* 10.072 (S. Fried in Carradice, p. 5, pl. 3, 22)

b) 42.99 g, 11 h. Ankara, from the Elmalı Hoard *CH VIII* 48, *MJPP* 10.068

c) Weight and die axis unknown. Private collection. A crack in the flan that is visible at 5 o'clock on the obverse. Small dent at the left edge of the reverse.

~

20 O 11 Almond-shaped eye without *caruncula lacrimalis*. Cowlick. The bunch of hair in front of the ear is broadly rounded. The right olive leaf touches the dotted line of the crest. The palmette approaches the left olive leaf but does not touch it; also the tendril spreading downwards does not touch the ear. The pendant hangs left from the jaw line. A line (necklace?) runs above the dotted border at the shoulder. (A die-break at the eyebrow, another jagged crack beneath the cowlick.)

R 20 The olive leaves spring from different points. Narrow wings; the middle row of feathers is diagonal, the lower row fan-shaped. Broad A with a slightly slanting cross-bar, round O with an eccentric point, Ǝ with a short upper cross-bar. The left bar of A keeps to the horizontal line.

 a) 43.05 g, 1 h. Ankara, from the Elmalı Hoard *CH VIII* 48, *MJPP* 10.064. Obverse: traces of horn silver. Reverse: minting-gaps in the hanging olive leaf, the right eye, and on the stomach of the owl.

 b) 42.91 g, 1 h. Ankara, from the Elmalı Hoard *CH VIII* 48, *MJPP* 10.065. Reverse: minting-gaps on the stomach of the owl; furthermore, some traces of corrosion.

<center>∼</center>

21 O 12 Almond-shaped eye with a *caruncula lacrimalis*. Tiny flat cowlick. The bunch of hair in front of the ear is broad and softly rounded and has a triangular pattern at the center. The right olive leaf just touches the dotted line of the crest. The palmette touches the left olive leaf at the middle with its lower leaflet; the tendril spreading downwards does not touch the ear. The peg of the pendant is not visible; the pendant hangs exactly on the jaw line. A line (necklace?) runs above the dotted border at the shoulder.

R 21 Due to the condition of the one specimen extant, it is not yet clear whether the olive leaves spring from the same point. Broad wings; the middle row of feathers is almost vertical, the lower row as well but leaning slightly inwards. Both the mantles of the wings and the tail have extraordinarily many dots. Broad A with a horizontal cross-bar, irregularly shaped O, big Ǝ with uniform cross-bars.

 a) 43.61 g, 2 h. Private collection. Several air bubbles ("lunkers") at the edge of the flan. Obverse: tiny lunkers (rather than minting-gaps) at the bunch of hair. Reverse: scratch in the field left from the A.

<center>∼</center>

22 O 13 Almond-shaped eye without *caruncula lacrimalis*. Flat cowlick. The bunch of hair in front of the ear is broadly rounded. The hair at the

temple touches the eyebrow. The right olive leaf almost touches the dotted line of the crest. The palmette has one leaflet only; it is far from approaching the left olive leaf, while the tendril spreading downwards almost touches the ear. The peg of the pendant is visible at the right side of the earlobe; the pendant hangs to the left of the jaw line. A line (necklace?) above the dotted border at the shoulder. (Die-crack at the left end of the eyebrow, running into the hair. Two die-cracks at the lower lid.)

R 22　Due to the condition of the one specimen extant, it is not yet clear whether the olive leaves spring from the same point. Broad, compact wings; the middle row of feathers is almost vertical, the lower row as well. The tail looks "combed" and fills the whole space between the legs. Narrow A with a slightly slanting cross-bar, irregularly shaped Θ, Ɛ with a short middle cross-bar.

a)　42.98 g, 9 h. Ankara, from the Elmalı Hoard *CH VIII* 48, *MJPP* 10.071. Obverse: scratch in the field below chin; some traces of horn silver. Reverse: traces of horn silver, at the upper edge in particular.

23　O 13　As above.

R 23　The olive leaves spring from almost the same point. Broad but slim wings; the middle row of feathers has an arched outline; the feathers of both the middle and the lower rows are vertical. The bushy tail fills the space between the legs. Broad A with a slightly slanting cross-bar, "triangular" Θ, crooked Ɛ with uniform cross-bars. The A is placed horizontally into the corner. (Die-cracks around the Θ; a flaw in the field in front of the right foot; small cracks left from the A.)

a)　42.52 g, 1 h. Baldwin's 50, 24 Apr. 2007, 21 (E. Papaefthymiou, *The Celator* 21.4 (2007), pp. 33–39). Reverse: doublestrike (to be seen at the feet of the owl). The big "gash" at the chest of the owl, the two small strikes beneath, and the "cuts" through both the eyes are not test-strokes but minting-gaps, perhaps the remnants of an overstrike. The edges of the big "gash" might have been cleaned up by a tool.

24　O 14　Almond-shaped eye without a *caruncula lacrimalis* but with a pointed inner tip. Tiny cowlick. The bunch of hair in front of the ear is softly rounded. The right olive leaf touches the dotted line of the crest. Gap between visor and the hair. The palmette touches the left olive leaf with its lower leaflet; the tendril spreading downwards does not touch the ear. The peg of the pendant is not visible; the pendant hangs a little bit to the left of the jaw line. No line above the dotted border at the shoulder. (A flame-shaped die-break runs above the visor, right from the right olive leaf; another flaw at the left end of the eyebrow.)

R 23′ Recut: the field of the die has been reduced at the upper part (cf. the small cracks left from the A, which are nearer to the edge than before). The hanging leaf of the olive-sprig is slightly lengthened, its tip is now moving outwards. The background around the letters is reworked, thus reducing the flaws around the Θ. The dots on body, wings, and tail of the owl are reworked, enhanced, and reduced in number. The head of the owl is redone as well. (The die-cracks around the Θ are flatter, but longer. A new crack at the right edge of the *quadratum incusum* runs to the right wing. The flaw at the right foot is bigger now.)

 a) 43.38 g, 2 h. Private collection = Triton 10, 9 Jan. 2007, 230, "from a North American Collection of Numismatic Masterpieces". Minting gaps at the stomach of the owl.

25 O 14 As before.
 R 24 The olive leaves spring from the same point. Broad, "angular" wings; the middle row of feathers is diagonal, as is the lower row but moving in the opposite direction. Tail smaller than before. Broad A with a slightly slanting cross-bar, round Θ, big Ǝ with a short upper cross-bar. (Wave-like protrusions on the lower row of feathers of the right wing; a bow-shaped die-break between the left wing of the owl and the olive-sprig.)

 a) 42.69 g, 8 h. Private collection (A. Meadows and R. W. Kan, *History Restored. Ancient Greek Coins from the Zhuyuetang Collection* (Hong Kong: Zhuyuetang, 2004), p. 90 no. 31) = CNG Review 26 (Summer 2001), 52, allegedly from one of the Decadrachm Hoards (Brand, p. 112, fig. 8). Flan edge with several gaps.

26 O 15 Almond-shaped eye without a *caruncula lacrimalis*. Tiny cowlick. The bunch of hair in front of the ear is rounded, but long rather than broad. The right olive leaf touches the dotted line of the crest. The palmette touches the left olive leaf with its lower leaflet, the tendril spreading downwards does not touch the ear; the ringlet looks weak. The peg of the pendant is not visible; the pendant hangs exactly on the jaw-line. A line runs above the dotted border at the shoulder. (A die-break beneath the throat can be seen on **26**b only.)

 R 24 As before.
 a) 40.59 g, 1 h. Leu 77, 11 May 2000, 206. Traces of corrosion all over the coin.
 b) 42.30 g, 11 h. Gemini 3, 9 Jan. 2007, 133. Scratches on the bunch of hair in front of the ear. A dent at the jaw-bone, just beneath the bunch. Another dent at the chin. This specimen poses some questions. After having performed autopsy two times, I believe that it is genuine and derives from the same dies as the preceding specimen. However, this coin has been treated very badly.

The comparison reveals that all of the dots on the body of the owl are due to a recent recutting of the coin. There exist pictures of the coin with a dark brown patina, the coin must have been repatinated at some stage. Thereafter, it was cleaned a second time before being offered for sale at auction. Traces of recutting can be observed elsewhere as well: on the obverse the right olive leaf is like a sculpture projecting in front of a background, i.e., some material "behind" the leaf has been removed. A feature to be seen on the reverse is even more bewildering. The die-break running from the tip of the hanging olive leaf into the left wing of the owl is not an ordinary crack: it forms something like a step instead of an edge. If this is due to the die (which might have been damaged by a blow from a hammer, thus producing a step in the background of the image), the specimen must be the latest minted among those extant having this reverse die; if so, the wave-like die-breaks at the right wing of the owl must have been removed completely from the coin.

27 O 16 Almond-shaped eye without a *caruncula lacrimalis*. Flat cowlick. The bunch of hair in front of the ear has an almost rectangular shape. The right olive leaf touches the dotted line of the crest. The palmette approaches the left olive leaf with its long middle leaflet, the tendril spreading downwards does not touch the auricle. The ear pendant hangs a little bit to the right of the jaw line. Probably there is no line above the dotted border at the shoulder. (A die-crack running from the tip of the left olive leaf into the middle leaf. Another crack at the edge of the neck-guard. A large die-break at chin and throat. Another large die-break at the crest, above the palmette.)

R 25 Due to the condition of the one specimen extant, it is not yet clear whether the olive leaves spring from the same point. Broad wings; the middle row of feathers is vertical, the lower row as well. Tail smaller than before. Broad A with a horizontal cross-bar, small round Θ, Ⅎ with uniform cross-bars. (Some flaws at the right side of the Θ.)

a) 36.93 g, 4 h. Seen in commerce, *c.* 1995. Small minting gap at the right chest of the owl. Traces of horn silver all over the coin, and upon that many spots of cuprous oxide.

28 O 16 As before.

R 26 The olive leaves spring from almost the same point. Broad wings; the middle row of feathers is slightly diagonal, the lower row as well but moving in the opposite direction. Narrow A with a slightly slanting cross-bar, round Θ with an eccentric point, Ⅎ with "hanging" cross-bars.

a) 42.01 g, 1 h. NAC 39, 16 May 2007, 41, *ex* Barry Feirstein Collection = Berk 109, 20 July 1999, 191. Obverse: small fissure at the eyebrow. Flan crack at 2 o'clock. Reverse: small minting gaps in the owl's right eye and chest.

29 O 16 As above.
 R 24 As above.

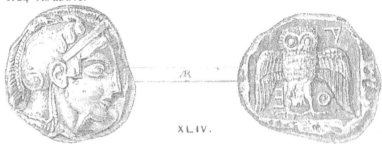

Figure 3. Brøndsted's drawing.

a) 43.04 g, 3 h. Paris, de Luynes 2037 (H. Nicolet-Pierre in *Studies Price*, pp.
 293–299, pl. 63, 1–2; Starr, p. 34 no. 61; C. M. Kraay and M. Hirmer, *Greek
 Coins*, p. 326 no. 358, pl. 118; J. Babelon in P. R. Roland-Marcel (ed.), *Bib-
 liothèque Nationale. Cabinet des Médailles et Antiques. Les Monnaies. Guide
 du Visiteur* (Paris: Leroux, 1929), p. 29 f. no. 679, pl. VII; Svoronos, pl. 8,
 14; J. Babelon, *Catalogue de la Collection de Luynes, II* (Paris: Florange &
 Ciani, 1925), p. 94 no. 2037 "Traité 1141" [wrong]; Seltman, p. 212 no. 452,
 pl. 21 [A307/P387]; N. Mushmov, Античнитъ Монети (Sofia: Gavazov,
 1912), p. 478 no. 7429, pl. LXII, 16; *Traité* I 2, col. 771 f. no. 1142, pl. 35, 11;
 ANS cast) = Sotheby 29 July 1844, Thomas W. Thomas 1500 a = Sotheby
 4 Aug. 1831, The property of a nobleman principally collected during his
 residence at Constantinople [Lord Strangford], 177 ("octo-drachm, 664 grs,
 see Mionett's Supplement III, p. 537, no. 7", bought by a certain Mr. Young),
 ex Lord Strangford Collection[6] (T. E. Mionnet, *Description de médailles an-
 tiques grecques et romaines. Supplément III* (Paris: Testu, 1824), p. 537 no. 7
 "Octodrachme. Du portefeuille de M. le chevalier de Brondsted, agent de
 la cour du roi de Danemarck près le saint Siége";[7] D. Sestini, *Descrizione di
 molte medaglie antiche greche esistenti in più musei* (Florence: Piatti, 1828),
 p. 76 pl. X, 13; P. O. Brøndsted, *Voyages dans la Grèce*, p. 188 fig. xliv (Fig.
 3 above), pp. 300 f. "Trois médailles d'Athènes; ... la seconde, grande mé-

6. On Percy Clinton Sydney Smythe, 6th Viscount Strangford (1780–1855) see E. B.
de Fonblanque, *Lives of the Lords Strangford, with Their Ancestors and Contemporaries
through Ten Generations* (London: Cassell, 1877). Strangford was British ambassador to
Constantinople 1820-1824, and to the Russian court 1825.

7. Mionnet appears to have misunderstood the information given to him. The coin was
never in the Brøndsted collection. Brøndsted had seen it in Lord Strangford's collection.
On Peter Oluf Brøndsted (1780–1842) see O. Mørkholm in *id.* (ed.), *Den kongelige Mønt-
og Medaillesamling, 1781–1981* (Copenhagen: Nationalmuseet, 1981), pp. 140–142; J. S.
Jensen, *Christian VIII & The National Museum* (Copenhagen: National Museum, 2000),
pp. 45 ff. Brøndsted was Danish ambassador to the Holy See 1818–1826.

daille d'argent, est de la collection de Lord Strangford..., trouvée vers l'an
1817 auprès Mégare avec quelques autres semblables, est probablement une
octodrachme; elle était inédite, autant que je sache, avant que M. Mionnet,
à qui j'ai communiqué le présent dessin très-fidèle, le publiât.... J'ai vu en-
suite, dans les collections de Londres, 3 ou 4 octodrachmes contrefaites et
évidemment fausses; mais quant à la médaille en question, que j'ai dans la
suite souvent examinée chez Lord Strangford, je n'ai pu y découvrir le moin-
dre indice de falsification"). Allegedly found at Megara 1817 "avec quelques
autres semblables".

30 O 17 Almond-shaped eye without a *caruncula lacrimalis* but with a pointed
inner tip. No cowlick. The bunch of hair in front of the ear is softly
rounded. The tip of the right olive leaf does not rise above the bowl
of the helmet. The palmette swings to a higher point than usual, thus
approaching the left olive leaf with its lower leaflet only, while the
tendril spreading downwards almost touches the auricle. The ear pen-
dant hangs clearly to the left of the jaw line. A line (necklace?) runs
above the dotted border at the shoulder. (A small die-crack at the left
end of the eyebrow. Another, bow-shaped die-crack between earlobe
and the stem of the palmette.)

R 27 The olive leaves spring from different points. Stout owl with broad
wings; the middle row of feathers is almost vertical, the lower row
moves slightly inwards. Narrow **A** with a horizontal cross-bar, irregu-
larly shaped **Θ**, **Ǝ** with uniform cross-bars.

a) 42.13 g, 3 h. Athens, Alpha Bank 10407 (D. I. Tsangari, *Hellenic Coinage. The
Alpha Bank Collection* (Athens: Alpha Bank, 2007), pp. 182–183; ead., *No-
mismatika Khronika* 24 (2005), pp. 12–13) = NAC 29, 11 May 2005, 183 =
Goldberg 7 June 2000, 3125, *ex* Dr. Jon Kardatzke Collection. Reverse: mint-
ing gaps at the right eye and the right side of the chest.

31 O 17 As above.
R 27′ Recut: the hanging olive leaf is broader.

a) 42.57 g, 3 h. Lisbon, Museu Gulbenkian 515 (J. Theodorou, "Athenian Silver
Coins: 6th–3rd centuries BC; the current interpretation", in A. P. Tzamalis and
M. Tzamali (eds), *Μνήμη Martin Jessop Price* (Athens: Hellenic Numismatic
Society, 1996), p. 73 no. 32; G. K. Jenkins and M. Castro Hipólito, *A Cata-
logue of the Calouste Gulbenkian Collection of Greek Coins, Part II*, p. 42 no.
515; Starr, p. 33 no. 54) = Robert Jameson Collection, Paris (Seltman, p. 211
no. 448, pl. 21 [A303/P383]; [R. Jameson], *Collection R. Jameson, III* (Paris:
Feuardent, 1924), p. 72 no. 2080). Allegedly found at Megara or, according
to G. F. Hill, near Daphni. Reverse: minting gaps beneath the bill. To judge
from to the Gulbenkian catalogue picture, the "cracks" to the left of the left
wing of the owl to be seen on the BM cast are not on the coin (BM Cast 23).

32 O 17 As above.

 R 28 The olive leaves spring from different points. Broad wings; the middle row of feathers is almost vertical, the lower row fan-shaped. Broad A with a clearly slanting cross-bar, small and round Θ, Ⅎ with short upper cross-bar. The A is placed horizontally into the corner.

 a) 43.01 g, 3 h. Tkalec-Rauch 16 Nov. 1987, 88, from the Elmalı Hoard *CH VIII* 48, *MJPP* 10.060. One major and two minor edge-cracks. Reverse: the scratch at the stomach of the owl could be a minting gap.

33 O 17 As above.

 R 24 As above.

 a) 42.41 g, 8 h. Private collection. Reverse: edge crack at 4–5 o'clock, running into the right wing.

OLD SPECIMENS WITHOUT KNOWN AFTERLIFE

NA1) 42.00 g, die axis unknown. F. Lenormant, *Description de médailles et antiquités composant le cabinet de M. le baron Behr*[8] (Paris: Hoffman, 1857), no. 201, no illustration. "Nous ne connaissons que cinq exemplaires authentiques du décadrachme d'Athènes : un dans la collection de M. le duc de Luynes, un autre au Musée Britannique, un troisième encore à Athènes [Jameson? Rhousopoulos?], un chez M. de Prokesch-Osten, et enfin celui de M. le baron Behr. Dans le lot des pièces fausses à la fin de la vente, on trouvera un des exemplaires faux qui se fabriquent aujourd'hui en très-grand nombre en Grèce, et on pourra juger des différences qui les distinguent des exemplaires authentiques". E. Babelon, *JIAN* 8 (1905), p. 46 n. 2 "J'en ai vu un certain nombre d'exemplaires faux très habilement exécutés, dans le commerce. Cf. Lenormant, *Catal. Behr*, p. 37, no 201" seems to have suspicions, while he cites the piece along with several genuine specimens in *Traité* I 2, col. 771 n. 3; G. F. Hill, *NC* (1921), p. 170. If this is not a fake (F92), it could be the specimen that Lucien de Hirsch bought in 1882 (2a).

NA2) 43.15 g, die axis unknown. Sotheby's 27 June 1887, 381 "Decadrachm. AR 9, Head of Pallas, r., *rev.* ƎOA. Owl, facing, wings open, sprig of olive (two leaves and a berry) in *f. l.*, within deep square *wt.* 666 *grs.* 1. The obverse is injured by a deep cut which does not affect the reverse" [I found this hitherto unknown reference in the erroneous notice attached to Berlin Cast 5 of the BM specimen. The collector of "A Cabinet of Select Greek Silver Coins" sold by Sotheby's is called "Thomas Jones" by the BM copy and "Mr. Jones" by the ANS copy of the sale catalogue. There are no plates. The description leads to the assumption that

8. On Count Désiré Behr (1793–1869) see A. de Smet, *Voyageurs Belges aux États-Unis du XVIIᵉ siècle à 1900* (Brussels: Bibliothèque royale, 1959), p. 25 f.; *Traité* I, col. 332; J. W., *RN* (1856), pp. 432–434. Count Behr was Belgian ambassador to Constantinople from 1839 onwards.

it was not a genuine specimen but an electrotype of the BM coin (7a), cf. B. V. Head, *A Guide to the Principal Coins of the Greeks*[2] (London: British Museum, 1932), p. 22 no. 31 pl. 11, 32 (*sic*)]. On the muddle documented by Berlin Cast 5, see above p. 37 f.

LEAD TRIAL PIECES

Like their modern counterparts, ancient trial pieces are in most cases made of lead. They had no value and no monetary function either. However, in those cases where pieces are coined on both sides, it can be difficult to distinguish them from emergency coinages. As a rule of thumb, the existence of any coinage must be ascertained by a sample of remnants. On the other hand, we know several ancient coinages from but a single specimen.[9] Thus the question is sometimes a matter of discretion.[10] If the lead piece has an irregular flan which is coined on one side only, there can be no doubt about interpreting it as a trial piece that was made for checking the die before or during the minting process. This holds true for the first piece below, now in the Boston Museum. The second piece, once in private hands, has a round flan and is coined on both sides. The small size of the second piece and its blurred images lead to the assumption that we should regard it as a forger's *anima* rather than as a trial piece. The

9. For instance, the Brussels tetradrachm of Dankle (P. Naster, *La Collection Lucien de Hirsch*, p. 95 no. 466), the tetradrachm of the Tean (?) *technitai* (C. Lorber and O. Hoover, "An unpublished tetradrachm issued by the artists of Dionysos", *NC* 163 (2003), pp. 59–68), and the tetradrachm of the satrap Tissaphernes (E. S. G. Robinson, "Greek Coins Acquired by the British Museum", *NC* (1948), pp. 48–56).

10. The literature on this problem has recently grown considerably: A. Houghton, C. Lorber, and O. Hoover, *Seleucid Coins: A Comprehensive Catalogue, Part 2* (New York & Lancaster: American Numismatic Society & Classical Numismatic Group, 2008), pp. 237–239; O. Hoover, *Coins of the Seleucid Empire from the Collection of Arthur Houghton, Part II*, ACNAC 9 (New York: American Numismatic Society, 2007), pp. 154 f.; D. Hendin, "A Bronze Test-Strike from the Bar Kokhba Revolt", *Israel Numismatic Research* 1 (2006), pp. 111–116; O. Hoover, "A Late Hellenistic Lead Coinage from Gaza", *Israel Numismatic Research* 1 (2006), pp. 25–36; *id.*, "A Reassessment of Nabatean Lead Coinage in the Light of New Discoveries", *NC* 166 (2006), pp. 105–120; C. Meyer, "A Lead Test-Piece from Histria in the Ashmolean", *NC* 166 (2006), p. 25 f.; E. Krengel and C. Sode, "Griechische zweiseitige Bleisiegel aus dem 4. Jahrhundert v. Chr.", *JNG* 55/56 (2005–06), pp. 69–73; D. Gricourt and D. Hollard, "Plomb et faux-monnayage en Gaule romaine: épreuves de coins et empreintes monétaires inédites", *RBN* 149 (2003), pp. 11–42; P. Pensabene, "Su alcune tessere plumbee di uso commerciale", *Scienze di Antichità* 11 (2001–03), pp. 479–510; W. Fischer-Bossert, "A Lead Test-Piece of a Syracusan Tetradrachm by the Engravers Euth... and Eum...", *NC* 162 (2002), pp. 1–9; S. Kovalenko, "Struck Lead Pieces from Tauric Chersonnesos: Coins or Tesserae?", *NC* 162 (2002), pp. 33–58; H. Ihl, "Eine neue Bleimünze des Polykrates. Falschgeld oder Notgeld?", in P. Berghaus (ed.), *Westfalia Numismatica 2001* (Münster: Münzfreunde Minden, 2001), pp. 15–19; W. Fischer-Bossert, "Zwei sizilische Bleimünzen in Münster", *Boreas* 23–24 (2000–01), pp. 195–206.

present whereabouts of the second piece are unknown and I have not been able to examine it or to judge whether it is ancient or not.

The Bostonian piece has another problem. In the Boston catalogue the piece was said to share its obverse die with the Brussels coin (2a), but this is not the case. Having compared the relevant casts side by side, I am sure that it has the same obverse die as the Kunstfreund specimen (5a), that is to say O 3. Unfortunately, there is a series of modern forgeries the dies of which were taken from the coin in question (see the "Ars Classica" fake below). Due to the somewhat blurred features of the Boston piece (unusual in ancient lead strikes), it is difficult to say whether the die used was the ancient one or its modern copy. As far as the condition of the die can be established, there is nothing that would lead to a firm conclusion. There is no break at Athena's eye, but it is impossible to say whether this is due to the fresh state of the original die or the redone copy. The minor cracks exhibited by O 3 in its later stage would not necessarily be visible anyway. There are minting-gaps at the bowl and the crest of the helmet, but this does not help. Even the strange "collar" around the circle of the die finds a parallel in the raised border of another test-piece.[11] Potentially, a metallurgical analysis of the Boston piece would prove its authenticity.

Provided that the Boston piece is genuine, its purported findspot is intriguing. The piece is said to have been found on the Acropolis of Athens. This may be just another story told in order to force up the value, but it could be true. If so, the piece is not likely to have been stored like the dies used for the gold issue at the end of the Peloponnesian War which are attested among the treasures kept in the Parthenon.[12] Being almost valueless in intrinsic terms and useless for coin production, the trial piece might rather have been dedicated. Trial pieces could be used not only for intermediary checks of the dies during the minting process but also as models for other dies and as master copies of the engraver's work when he was seeking his next employment. Thus the trial pieces might have been regarded as tools like hammer and tongs rather than as works of art, and in ancient times tools were certainly worth dedicating.[13] In fact, two pierced trial pieces remind one of the well-known habit of hanging offerings on temple-walls.[14]

11. Cf. W. Fischer-Bossert, "A Lead Test-Piece", p. 2 pl. 1, 1.

12. *IG II*[2] 1408, 11–12. 1409, 5; E. Kosmetatou, "A numismatic commentary of the inventory lists of the Athenian Acropolis", *RBN* 147 (2001), pp. 35 f.; D. Harris, *The Treasures of the Parthenon and Erechtheion* (Oxford: Oxford University Press, 1995), p. 119, no. 34; E. S. G. Robinson, "Some problems in the later fifth century coinage of Athens", *ANSMN* 9 (1960), pp. 12 f.

13. See I. Kilian-Dirlmeier, *Kleinfunde aus dem Itonia-Heiligtum bei Philia (Thessalien)* (Mainz: Römisch-Germanisches Zentralmuseum, 2002), pp. 151 ff. Tools hanging in the temple of Athena at Metapontum were said to have been offered by Epeios who made the Trojan horse (Iustin. 20.2.1).

14. Fischer-Bossert, "A Lead Test Piece", pp. 6 f., nos. 2 (Acragas) and 9 (Gela).

LT1) Weight unknown, no die axis. Boston, MFA 58.1187. One-sided lead trial piece, allegedly found on the Acropolis of Athens (W. Fischer-Bossert, *NC* 162 (2002), p. 6 no.1; *id.*, Boreas 23–24 (2000–01), p. 196 n. 14; Starr, p. 38 n. 34; M. Comstock and C. C. Vermeule, *Greek Coins, 1950 to 1963* (Boston: Museum of Fine Arts, 1963), p. 28 no. 98 "the die is [that of] the Brussels specimen"). The mirror of the die is encompassed by a collar-shaped border.

LT2) 11.2 g, die axis unknown. Current disposition unknown, formerly R. Argyropoulos [Rena Evelpidis] Collection, Athens (C. Conophagos et al., *Nomismatika Khronika* 4 (1976), p. 26 no. 11). Allegedly made from decadrachm dies. The figures are almost unrecognizable.

5

Forgeries

ANCIENT FORGERIES

Ancient forgeries are usually plated, that is to say, a thin foil of silver, gold, or electrum that bears the imprints of the dies conceals a core consisting of bronze, iron, or lead. Pre-Roman cast forgeries are rare, since it was difficult to imitate pure metals by using inferior alloys.[1] Since the Athenian silver coins were appreciated, and examined, for their metal purity, cast forgeries were not an option. There is a vast series of plated Athenian tetradrachms and drachms that is usually dated to the last years of the Peloponnesian War (*c.* 406–404); based on a joke made by Aristophanes, this series is thought to have been minted as an emergency coinage by the Athenian authorities.[2] This is, of course, an exception. Plated forgeries are usually products of irregular mints, and this might be true for the two following coins, although I have had no chance to examine them.

AF1) 36.67 g, 4 h. Athens, Alpha Bank 1195 = R. Argyropoulos [Rena Evelpidis] Collection, Athens (C. Conophagos et al., *Nomismatika Khronika* 4 (1976), p. 26 no. 10). Bronze, silver-plated. Surface, with many cracks and fissures, looks like crumpled paper.

AF2) Weight and die axis unknown. Lost? Once Palestine Exploration Fund, found at Tell Zakarīya (Tel 'Azekah), Northern Shefelah Plain, 1898/99 (H. Gitler and O. Tal, *The Coinage of Philistia*, p. 16 "lost after the excavation"; R. Barkay, *INJ*

1. The impression of the reverse of an Athenian tetradrachm on a piece of lead plate discovered in an ancient house in Himera might have been the first step for producing casting moulds in order to make cast forgeries: A. Tusa Cutroni in *Himera II. Campagne di scavo 1966–1973* (Rome: L'Erma di Bretscheider, 1976), p. 750 no. 345, pl. 118, 6.

2. Aristoph. *Ran.* 725 f. J.H. Kroll, "The Piraeus 1902 Hoard of Plated Drachms and Tetradrachms (*IGCH* 64)", in *XAPAKTHP. Αφιέρωμα στη Μάντω Οικονομίδου* (Athens: Archaeological Resource Fund, 1996), pp. 139–146. Another view is held by W. Weiser, "Die Eulen von Kyros dem Jüngeren", *Zeitschrift für Papyrologie und Epigraphik* 76 (1989), p. 275 n. 48.

8 (1984-85), p. 5 no. 5; F. J. Bliss and R. A. S. Macalister, *Excavations in Palestine during the Years 1898-1900* (London: Palestine Exploration Fund, 1902), p. 26 "The earliest coin was an Athenian piece of 10 drachmas, coated with silver. Obverse: Archaic helmeted head of Athena. Reverse: Owl with olive branch and Persian counter-sign. Date, 526-430 B.C."; cf. F. J. Bliss, *Palestine Exploration Quarterly* 31 (1899), p. 24 "three coins, one Jewish, found at the depth of about 5 feet; the other two are much corroded, one found on the surface, the second at a slight depth. The general absence of coins is significant". No coins mentioned in the other preliminary reports). This cannot be the Evelpidis piece (LT2 above), for that one does not have a countermark.

MODERN FAKES AND SUSPECTED SPECIMENS

Modern forgeries of the decadrachms started to appear very early, soon after the first genuine specimen, the Strangford coin (**29a**), became known. Due to the fact that Athenian decadrachms are extremely rare and accordingly much sought-after to the present day, decadrachm forgeries have appeared on a regular basis. Fortunately, the majority of them are easy to recognize, although some of them were dangerous when they were new. The only one that might remain dangerous is the "Ars Classica fake" (below, pp. 68 ff.). Thus far, the most sophisticated counterfeiters of ancient coins, who are located in Greece and Italy, seem not to have tried to create a forgery of the Athenian decadrachms. It should be said that the controversial Gemini coin (**26b**) does not correspond to the œuvre of any known master counterfeiter.

a. Becker's fake, before 2 October 1827

A renowned antiquarian at Offenburg, Geheimrat Karl Wilhelm Becker (1772–1832) was one of the most notorious counterfeiters of the early nineteenth century. Although he claimed to have made and distributed imitations just for educational reasons, many people were deceived by his products, whether it was he himself who sold them as genuine, or other dealers. Since his decadrachm fake was produced on 2 October 1827 by a certain W. Zindel, a seal-engraver who was Becker's collaborator only from 1826, it may well be that the dies of this fake are among the latest of Becker's works.[3]

From today's point of view, the style of Becker's fake is poor and the details are crude. The absence of the olive sprig strikes the eye in particular. According to Hill, Becker and Zindel worked after a model which failed to show the olive sprig.[4] The de Luynes coin (**29a**) is the only specimen known before 1827, and so it is likely to have been Becker's model. Here the olive sprig is indeed almost off flan; just the lower edge of the upper leaf and tiny traces of the olive fruit can

3. M. Pinder, *Die Beckerschen falschen Münzen* (Berlin: Nicolai, 1843), no. 68; G. F. Hill, *Becker the Counterfeiter, part I* (London: Spink, 1924), p. 67 no. 63.

4. Hill, *op. cit.*, p. 67, comparing the de Luynes coin.

be seen. Becker might have studied a drawing of the de Luynes coin,[5] and by so doing taken note of the absent crescent, but failed to observe the remnants of the olive sprig.

The majority of the Becker fakes are not made of silver and will not have been deceptive at any time. Perhaps some of them were not even sold by Becker himself. They could well derive from the parcel which Count Piccolomini bought from Becker's widow.[6] On the other hand, the forgeries seen in London before 1830 by Brøndsted may well have come from Becker's stock.[7]

Becker's dies are kept by the Berlin Cabinet (Pl. 1.C).[8]

O The tip of the first (i.e., upper) olive leaf touches the base of the helmet's crest. Eye with *caruncula lacrimalis*. Auricle with rectangular antihelix and a button-shaped ear-drop. The lips do not touch each other at the corner of the mouth. Hair at the neck without any dots.

R No olive sprig nor crescent. The owl is designed in a symmetrical fashion in all details (note the dots on body and tail). A with a "modern", horizontal cross-bar, small and round Ο, big Ⅎ. The left bar of the A keeps to the horizonal line.

F1) 71.99 g, 7 h. London, Baldwin's Forgery Archive (3). Unlabeled. Lead.

F2) 64.78 g, 10 h. London, BM Forgery Archive (G.F. Hill, *Becker the Counterfeiter, part I*, p. 67 no. 63 pl. 4; M.J. Price, *BoC* 2, 4 (1977), p. 89 fig. 3). Unlabeled. Lead.

F3) 45.08 g, 8 h. London, Baldwin's Forgery Archive (4). Unlabeled. Tin.

F4) 44.69 g, 11 h. London, Baldwin's Forgery Archive (2). Unlabeled. Lead.

F5) 42.82 g, 10 h. New York, ANS Forgery Archive (2), *ex* A.M. Huntington.

F6) 41.87 g, 12 h. Berlin, acc. 1923/24.580. Bronze.

F7) 39.10 g, 12 h. London, Baldwin's Forgery Archive (1). Unlabeled. Silver.

F8) 32.68 g, 11 h. Munich, Lanz Forgery Archive (acquired 2008), *ex* Vogel. Lead.

F9) Weight and die axis unknown. Current location unknown (H. Nicolet-Pierre in *Studies Price*, p. 294 pl. 63, 5).

F10) Weight and die axis unknown. Current location unknown (H. Nicolet-Pierre in *Studies Price*, p. 294 pl. 63, 6).

F11) Weight and die axis unknown. Triton 10, 9 Jan. 2007, 1481, pl. no. 7. Lead; obv. doublestrike.

F12) Weight and die axis unknown. eBay, Jan. 2007, *ex* D. Markov, New York.

5. The only source known to us is the drawing sent by Brøndsted to Mionnet before 1824. Since this drawing was published only in 1830, Becker must have seen it before, unless he had another source, such as a sulfur imprint or something similar.

6. Cf. the note in S. Leigh Sotheby, auction catalogue 23 July 1846, p. 188.

7. Brøndsted, *Voyages dans la Grèce*, p. 301: "J'ai vu ensuite, dans les collections de Londres, 3 ou 4 octodrachmes contrefaites et évidemment fausses".

8. The obverse die (acc. 1911/191) is figured in *Münzen und Medaillen. Die Ausstellung des Münzkabinetts im Bode-Museum*, p. 25.

b. The second Strangford coin, before 1828

We know from various sources that Lord Strangford's collection contained two decadrachms. The first one, which was erroneously called an octodrachm by Mionnet, came into the possession of the Duc de Luynes and eventually the Paris Cabinet (29a). The other one was said to be a modern forgery, and so it soon disappeared. It is by mere chance that we have a drawing of it, or at least a drawing of its obverse.

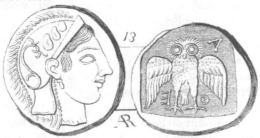

Figure 4. Sestini's drawing.

In 1828 Domenico Sestini published a drawing composed of two different coins, both of which were then in the Strangford collection. Though possessing embellishments typical of the epoque, the drawing obviously depicts the reverse of the piece that later entered the de Luynes Collection. The coin obverse is less easy to judge. In Sestini's own words,

> il disegno di questa medaglia che pesa 10 dramme mi fu rimesso da Trieste levato da due medaglie, perchè la parte dove è la testa di Pallade non corrisponde alla parte dove è la civetta. Lord Strangfort [*sic*] portò due medaglioni simili, uno del peso di 10. dramme, e l'altro d'otto, onde il rovescio della nostra appartiene a quello d'otto dramme. Io non posso giudicare di questi due medaglioni, per non averli veduti, e che la fortuna dovesse, dopo tanti secoli, favorire il genio di detto personaggio: dirò peraltro, che essendo egli a Pietroburgo, furono da uomini ben conoscitori, creduti genuini. Ma noi li crediamo opera dei falsificatori di Smirne, non essendo possibile, che Atene avesse voluto fare coniare due medaglioni uno di 10. dramme, e l'altro di otto.[9]

It is clear that the drawing does not depend on the drawing sent by Brøndsted to Mionnet some years earlier (see Figure 3, p. 47). Interestingly, Sestini was able to identify the coin that was called an octodrachm by Mionnet. Either Sestini had seen Brøndsted's drawing, or the correspondent from Trieste who was himself baffled by the discrepancy had told him.

In any case, the obverse depicts a specimen other than the de Luynes coin. Although we cannot check the source, it is possible that it depicts the second

9. Sestini, *Descrizione di molte medaglie*, p. 76.

Strangford coin, which disappeared before photography came into use. This second coin, then already suspected to be a product of the Smyrna forgers,[10] was sold along with the (genuine) first specimen in 1831 at the Strangford Sale,[11] and perhaps once more in 1844 at the Thomas Sale, then again along with the genuine specimen. It must be noted that the latter sale catalogue offers not a coin but "an imprint" of what is described as a fake. In any case, ten years later Count Prokesch-Osten mentioned the "second" coin as once having been in the Thomas Collection:

> In der Sammlung Thomas befand sich eine zweite, zu 810.6 Par. Gran Gewicht. Ich habe sie nicht gesehen, kann also über ihre Echtheit nicht urtheilen.[12]

The second Strangford decadrachm disappeared in 1844 at the latest. Unfortunately, the drawing of the obverse is not specific enough to single out the coin from the specimens known today, genuine or false. The different details of Athena's helmet suggest that it is not likely to be a Becker fake, and from its general appearance, it does not belong to another known group of fakes either.

> F13) 37.51 g, die axis unknown. Sotheby 29 July 1844, Thomas W. Thomas 1500b (not a second coin but an imprint of a fake). Sotheby 4 Aug. 1831, [Lord Strangford] 178: "Another, similar to the last, weighing only 579 grs. This has the appearance of an imitation of the last curious piece, probably from the Smyrna manufactory, from whence our continental neighbours have been supplied, and who, never having seen the original, have condemned all of this type as spurious".

c. "Hoffmann", before 1866, or even before 1857

While Becker's fake does not have the olive sprig, the specimens of this group have both sprig and crescent, the latter being an element not seen on the genuine decadrachms. The group takes its *nom de guerre* from a specimen once in the forgeries archive of the Paris dealer Jean-Henri Hoffmann (F24), a plaster cast of which is kept by the Cabinet des Médailles, Paris.

The group consists of both minted and cast coins. The von Gansauge specimen (F20) was the model for at least three casts, among them the "Hoffmann" specimen (F19, F23, F24). These casts are much thicker than the von Gansauge coin, and of reddish color.

A *terminus ante quem* for the group can be gleaned from the Woodhouse specimen (F17) which entered the British Museum in 1866. An even earlier

10. On the Smyrna workshop see further below, pp. 61 f.
11. According to the ANS copy of the sale catalogue, both coins were bought by a certain Mr. Young (see above). Ironically, the second coin which was always called a decadrachm turned out to be much lighter than the so-called octodrachm!
12. A. Prokesch von Osten, *Inedita meiner Sammlung*, p. 29; cf. the appendix.

date could perhaps be provided by the fact that another specimen published by Svoronos is said to have been in Osnabrück (F22). Here we must think of the old collection of Christian Schledehaus, a doctor once accredited to the Alexandrian court, who donated his collection of coins to his home city in 1857.[13] Unfortunately, the coin in question cannot now be found among the holdings of the Kulturgeschichtliches Museum Osnabrück, perhaps due to war losses. However, if the Osnabrück specimen did belong to the Schledehaus Collection, the "Hoffmann" fake might well have been produced some years before Schledehaus relinquished collecting (he died in 1858). If so, we may wonder whether the specimen seen at Athens and condemned by both Count Prokesch-Osten and Henry Borrell in 1851 was a "Hoffmann" fake.[14]

O 1 The tip of the first olive leaf touches the base of the helmet's crest. Eye with open corners. Auricle with empty cavity. Triple pendant like that of the genuine coins. The lips do not touch each other at the corner of the mouth. No cowlick; the bunch of hair in front of the ear is in plaited waves; the hair beneath the neck guard is cut off in straight fashion.

R 1 Olive sprig and crescent. Many ornate details, such as the comma-shaped wing-feathers of the upper row, the scroll of the wings' tips, and the dotted bars of the letters. A with "archaic", slightly slanting cross-bar, irregularly shaped Θ, big Ǝ with graduated long bars. (A die-break (oval protrusion) in the upper right edge, above the A.)

> F14) 45.49 g, 11 h. New York, ANS Forgery Archive (3), G. Clapp gift, ex E.P. Robinson
>
> F15) Weight and die axis unknown. Current location unknown. "von Zotos in Cpl. [Constantinople] eingesandt 26.6.[19]07". Berlin Paper Imprint.

O 1′ Recut; cowlick added.
R 1 As before.

> F16) 48.50 g, die axis unknown. Current location unknown. "Milan" (Svoronos, pl. 114, 5). According to R. Martini, the coin is not in the Milan cabinet.
>
> F17) 48.25 g, 12 h. London, Inv. 1866-12-1 (M.J. Price, BoC 2, 4 (1977), p. 90 fig. 7A; ANS cast with notice "B.M. Forgery") ex Woodhouse.
>
> F18) 47.90 g, die axis unknown. Marseille (Svoronos, pl. 114, 6).
>
> F19) 47.71 g, 12 h. London, Baldwin's Forgery Archive. Unlabeled. Cast copy of the von Gansauge specimen.
>
> F20) 45.89 g, 12 h. Berlin, von Gansauge (1873).
>
> F21) 42.07 g, 6 h. Moscow, National Museum 1651 (A.N. Zograph, Sovetskaja

13. Cf. A. Savio, *Catalogo delle monete alessandrine della collezione dott. Christian Friedrich August Schledehaus nel Kulturgeschichtliches Museum Osnabrück* (Bramsche: Rasch, 1997), p. 17.

14. See Appendix.

Arheologija (1940), p. 304; J. S. Kruskol, *Sbornik Statej po Arheologii SSSR* (1938), p. 179).

F22) Weight and die axis unknown. Current location unknown. "Osnabrück" (Svoronos, pl. 114, 7). Not in the Osnabrück cabinet.

F23) Weight and die axis unknown. Turin ([S. Pennestri], *Museo Civico di Numismatica, Etnografia, Arti Orientali* (Turin: n.p., *c.* 1990), p. 15 fig. 1; A. S. Fava, *Il medagliere delle raccolte numismatiche torinesi* (Turin: Museo Civico d'Arte Antica, 1964), p. 34 no. 179 "Reale Torino", pl. 4, 1; 9, 9). Cast copy of the von Gansauge specimen.

F24) Weight and die axis unknown. Current location unknown. Paris, plaster cast (Anonymous, *Médailles fausses recueillies par H. Hoffmann pour servir a l'étude de l'authenticité des monnaies antiques* (Paris: n.p., 1902), p. 15 no. 72; H. Nicolet-Pierre in *Studies Price*, p. 294, pl. 63, 4). The lost original was a cast copy of the von Gansauge specimen.

F25) Weight and die axis unknown. Current location unknown, documented by a photograph in the BM Forgery Archive (3[4]) beneath the Woodhouse fake (F17), annotated "Martin Stieger, Graz – Austria, Postfach 116", together with the ticket "Another specimen submitted from Austria 1956"; M. J. Price, *BoC* 2, 4 (1977), p. 90 no. 7B.

The following specimens are extremely poor. They cannot be anything but old tourist fakes. As to style and proportions, however, they are close enough to the preceding specimens to attribute them to the "Hoffmann" workshop.

O 2 As before, but the palmette on the helmet-bowl is reduced to one single branch. The edge of the neck guard is more rounded.

R 2 Olive sprig, but no crescent. Narrow wings. Broad, coarse A (the position of the cross-bar cannot be discerned), round Θ, big Ƨ with uniform bars. (Die cracks at the left side of the Ƨ?)

F26) 24.49 g, 6 h. Colorado Springs, American Numismatic Association. Unlabeled copper fake.

F27) 21.91 g, die axis unknown. Artemide Aste, Milan, website Aug. 2007, no. 2268.

F28) 20.84 g, 12 h. New York, ANS. Unlabeled copper fake.

F29) 16.77 g, 6 h. Berlin. Unlabeled lead fake. Holes in front of Athena's nose and in the ear.

The following specimen is likely to belong to the "Hoffmann" group.

O 3 As before. The bunch of hair in front of the ear is not plaited but combed.

R 3 Olive sprig but no crescent. Straight feathers in both rows. Narrow A with horizontal cross-bar, round Θ, lop-sided Ƨ.

F30) Weight and die axis unknown. Current location unknown. "Greece, shown III/1984" (Photograph in Spink's Forgery Archive, London).

d. "De Luynes", before 1891

The three following specimens in Washington, Moscow, and once in the von Molthein Collection are obviously copies of the de Luynes coin (**29a**). The reverse with all its peculiarities is the same; note the small dent in the left wing of the owl and the hollow in the right edge. While the von Molthein and Moscow specimens just repeat the reverse of the de Luynes coin, the Smithsonian specimen (**F31**) has been altered by the addition of the upper left corner, and the whole outline is different from the *madre*. The result appears not to have been convincing to the forger, and so he concealed his addition with a test cut. This turned out to be even worse; the cut looks as if it was made by the anxious use of a bread knife. The small dent in the owl's left wing was filled up with no better success.

The obverses have been altered in various ways. The von Molthein coin (**F33**) has the de Luynes obverse in a bloated version, thus giving the impression of extreme wear. The Moscow coin (**F32**) has the same obverse in a version both refined and blundered. The big die-break between chin and throat has been removed, but several details have become coarser. The obverse of the Smithsonian coin (**F31**) is worn in the extreme (more precisely, it is ground off, while the reverse shows much less wear), and one can say only that it seems to be derived from a different die than the Moscow specimen.

The style of the Moscow obverse is reminiscent of the "Hoffmann" fakes above. However, both specimens were recorded only during the early 1890s, and perhaps were made not much earlier. If so, the "Hoffmann" counterfeiter, who was apparently active earlier than 1860, is not very likely to be responsible for the "de Luynes" copies as well.

Two more sources must also be taken into account. The first one is a ticket without a coin. Beneath the Berlin cast of the Weight forgery (**F43**) there is a sheet of paper with a notice in Friedländer's hand-writing:

> AR 42.2 Grm. Von Louis Naudmann aus Perth mit mehreren anderen falschen Münzen 17 Dec. 1866 vorgelegt. Das Stück hatte eine Blei-Patina, halb bräunlich halb schwarz, abspringend. Es ist nicht von Becker, die vorhandene von Prokesch weicht ab.

Obviously the sheet does not belong to the cast: the Weight coin was produced by Christodoulou at least thirty years later than 1866. The original fake kept by the Berlin Cabinet, the von Gansauge coin (**F20**), is no better candidate, because it has a ticket of its own, and is much heavier than 42 g. Nonetheless, the notice cannot have been written before the von Gansauge forgery entered the Berlin Cabinet in 1873, since the Prokesch-Osten coin mentioned by the sheet notice (**1a**) was acquired two years later, in 1875.[15] According to a third

15. A. von Sallet, "Die berühmte Sammlung des Grafen Prokesch-Osten", *ZfN* 3 (1876), p. 104.

source, however, the forgery described by this sheet cannot have been owned by the Berlin Cabinet at any time, for the notice matches a fake that was "seen" by Julius Friedländer, and mentioned by him some years later:

> Das Dekadrachmon hat Becker gemacht, aber außerdem auch ein anderer Fälscher. Ein Exemplar von richtigem Gewicht (42,3 Gramm) habe ich gesehen, es ist vortrefflich gemacht, dem bei Beulé abgebildeten sehr ähnlich, es hatte einen halb bräunlichen, halb schwarzen Oxyd-Überzug, der theilweise abgesprungen war. Der Mann, der es verkaufen wollte, führte eine Anzahl Falschmünzen aus der Smyrnaer Fabrik.[16]

The other decadrachm forgeries documented by casts, paper, and silver foil imprints in the Berlin Cabinet are products of the twentieth century. Neither the coin described by both Friedländer and the misplaced sheet of paper nor a cast of it are now in the Berlin Cabinet. So we must ask whether we are able to identify the forgery among the fakes known to us. We have a date (before 1866), a weight (42.3 g), a description (oxidized), and a comparison (similar to the coin figured by Beulé). The description resembles von Renner's of the von Molthein coin (F33): "l'avers a souffert par une forte oxydation", but the comparison is truly bewildering, because the specimen illustrated by Beulé is the Prokesch-Osten coin.[17] Since Friedländer himself wrote the notice on the sheet, how could he fail to observe that Beulé's drawing shows the Prokesch-Osten coin? On the other hand, since the specimen was shown to him in 1866, and he did not keep it nor take a cast or an silver foil imprint of it, how could he make the comparison to the Prokesch-Osten coin which was not yet "vorhanden" (present) in the museum?[18] This notice remains a mystery.

A few words about Friedländer's remark on the Smyrna forgeries are necessary. When the first decadrachms came to light, collectors were afraid of being deceived by the products of the notorious Smyrna counterfeiters. In fact, the genuine de Luynes specimen was initially suspected.[19] Some years later,

16. J. Friedländer, *Ein Verzeichnis von Griechischen falschen Münzen welche aus modernen Stempeln geprägt sind* (Berlin: Weber, 1883), p. 29 no. 3.

17. Beulé, p. 48 fig. The drawing is likely to have been copied from Prokesch von Osten, *Inedita meiner Sammlung*, pl. 2, 76.

18. According to D. Bertsch, *Anton Prokesch von Osten* (Munich: Oldenbourg, 2005), p. 482 n. 175, Friedländer is not likely to have started negotiations with Count Prokesch-Osten earlier than 1874. At that point the collection was in Prokesch's home at Graz, Austria (see Bertsch, *op. cit.*, p. 484).

19. Sestini, *Descrizione di molte medaglie*, p. 76. When the coin was bought by the Duc de Luynes at the Lord Strangford sale, a second specimen (F13) was offered with an ironic comment: Sotheby 4 Aug. 1831, 178 "Another, similar to the last, weighing only 579 grs. [37.52 g]. This has the appearance of an imitation of the last curious piece, probably from the Smyrna manufactory, from whence our continental neighbours have been supplied, and who, never having seen the original, have condemned all of this type as spurious".

when four or five other decadrachms appeared on the Athens market, it was Henry Borrell, a Smyrna resident for many years and thus familiar with the Smyrna forgeries, who condemned them and confirmed the authenticity of the Prokesch-Osten coin.[20] Unfortunately, there is no way to determine whether the decadrachm forgeries exposed by him had anything to do with the Smyrna workshops. It is a pity that Friedländer does not tell whether the forgery he saw was in any way similar to the Smyrna forgeries offered to him at the same time. So we can only speculate. With the exception of Caprara who started his career in Smyrna, the Smyrna forgers have not yet caught the attention they deserve.[21] Neither the "Hoffmann" fake nor the "de Luynes" fake have any clear affinity to the forgeries attributed to Caprara.[22] We shall let the question rest.

Last but not least, a modern reverse die taken from the de Luynes coin is extant (Pl. 2.D).[23] The die-mirror is confined to the *quadratum incusum*, but without the upper left edge which is off the flan as it is on the de Luynes coin. Not having the areas beyond, this die cannot have been used for minting the von Molthein and Moscow specimens, nor the Smithsonian specimen. Therefore we should be aware that forgeries might exist that reproduce the de Luynes reverse and similarly lack the upper left corner.

> F31) 39.84 g, 1 h. Washington, Smithsonian Institution Inv. 71.305.1 (C. Starr, *NC* (1982), p. 130 no. 7, pl. 35), *ex* William Spengler. Allegedly found in Afghanistan, 1961: "apparently from the Balkh Hoard" *IGCH* 1820. Rather worn. Heavy stroke on the reverse. According to a story told by Spengler, he found a ridiculous fake of the decadrachms in the suq of Kabul. By accusing

20. On Borrell (1795–1851) see D. Whitehead, "From Smyrna to Stewartstown: A numismatist's epigraphic notebook", *Proceedings of the Royal Irish Academy* 99 (1999), pp. 73–113, and Bertsch, *op. cit.*, pp. 465 f. The story about Borrell's expertise was told by Prokesch-Osten several times; see Appendix.

21. An exception is Sestini's anonymously published pamphlet *Sopra i moderni falsificatori* (Florence: Tofani, 1826). A remark added in his *Descrizione*, p. vi "Questi falsificatori si stabilirono non ha molto in Smirne, e dopo in Sira isola dell' Arcipelago", matches the career of Caprara; cf. P. Kinns, *The Caprara Forgeries* (London: Royal Numismatic Society, 1984), p. 3. Maybe the "Smyrna forgers" should be reduced to just one workshop.

22. On Caprara, see Kinns, *op. cit.* Furthermore, S. Hurter, "A new Caprara counterfeit", *BoC* 10, 2 (1985), p. 4; D. Gerin, "Illustration de quelques faux de Caprara conservées au Cabinet de Médailles de Paris", *BNumParis* 41 (1986), pp. 1–4; S. Hurter, "Two possible new Caprara counterfeits", *BoC* 16, 1 (1991), p. 30; R. Ashton, "Forgeries of Rhodian Didrachms", in *Florilegium Numismaticum. Studia in honorem U. Westermark edita* (Stockholm: Svenska numismatisk föreningen, 1992), p. 30; S. Hurter, "Perseus/Gortyna: A new Caprara die-link", *BoC* 22, 2 (1997), p. 14; *ead.*, "More Caprara Forgeries: a Chalcidic League Problem Solved", *NC* 159 (1999), pp. 290–292; F. de Callataÿ, "Un faux 'tétradrachme en or' de Mithridate Eupator", *SM* 57 (2007), pp. 4 f.

23. Owned by an American coin dealer.

the dealer of being a counterfeiter and threatening him with the police, Spengler managed to obtain the piece which had served as the model. This he bought, smuggled out of the country (Spengler was a US diplomat), and presented to the Smithsonian Institution. The provenance of an Afghanistan Hoard was clearly false.

F32) 35.51 g, 3 h. Moscow, Pushkin Museum 2284, *ex* Moscow University (A. V. Oreshnikov, *Collection des monnaies grecques de l'Institut archéologique de l'Université de Moscou* (Moscow: Gerbek, 1891), p. 287 no. 2273).

F33) 30.75 g, die axis unknown. V. von Renner, *Catalogue de la collection des médailles grecques de M. le chevalier Léopold Walcher de Molthein* (Paris & Vienna: Rollin & Feuardent, 1895), p. 115 no. 1432 pl. 11 "L'avers a souffert par une forte oxydation", and in tiny letters underneath, "Cette décadrachme a perdu beaucoup de son poids normal par une forte oxydation de l'avers et par un nettoyage exagéré" (annotated in the copy of the Berlin Cabinet "falsch"); G. F. Hill, *NC* (1921), p. 170 "false". According to the sale list Ad. E. Cahn 25 Feb. 1901, no. 1432 was withdrawn. The coin is not in the Vienna Cabinet.

e. "Alexandria", before 1900

It is clear at first sight that the following forgeries copy the Prokesch-Osten coin in Berlin (1a). The outline of the flan, the position, and the axis of the dies are the same, as well as the details of both the owl and Athena's head (note the shape of the bunch of hair in front of the ear). The weights, however, are clearly wrong. The forgeries are casts, two of them showing signs of cold work. It is not clear whether the forger had a plaster cast of the Prokesch-Osten coin at his disposal. In any case, he made a worse job than his rival of the "de Luynes" fake. One of the forgeries can be traced back to late nineteenth-century Alexandria. According to Dutilh's research, the piece "found" near Alexandria is the work of a local who also made copies of Hellenistic (i.e., Seleucid and Ptolemaic) coins. Another specimen was included in Jacob Hirsch's archive of forgeries. Unfortunately, the famous dealer left not a single line about where and when he obtained it.

F34) 36.96 g, 4 h. LHS Numismatik AG, Zurich, Forgery Archive, *ex* Jacob Hirsch's archive (before 1955).

F35) 27.875 g, die axis unknown. Moscow, Historical Museum 84209; acquired *c.* 1950. Lead.

F36) 25.06 g, 4 h. New York, ANS 0000.999.53699, *ex* E. D. J. Dutilh (*id.*, "Vestiges de faux monnayages antiques à Alexandrie ou ses environs", *JIAN* 5 (1902), pp. 93–97, p. 95 no. 12 "Un décadrachme d'Athènes 525-430 av. J.C. au type de celui décrit dans Head-Svoronos Vol. I, p. 464 et pl. IΘ′ no. 6. Poids gr. 24,2, de même provenance, de même métal et de même fabrique que les

précédents"), *ex* Gen[eral] Lane (ANS ticket: "Found on sea shore near Alexandria Tuesday 22nd May 1900"). Much incrustation, hence surely made some years before it was found.

F37) 24.89 g, 4 h. New York, ANS Forgery Archive (4).

F38) 23.45 g, 4 h. Moscow, Pushkin Museum 18211. Provenance unknown. Brass or copper plated with silver. Heavy cold work. Hair at the ear partly removed.

f. Christodoulou's fake, at least partly before 1903[24]

Next to Becker's fake, the decadrachm forgeries made by Konstantinos Christodoulou are the most famous. This is in part due to the fact that the British Museum authorities were deceived by a specimen they bought in 1920. Christodoulou had already been exposed in 1914, but J. Svoronos published his first report on the affair only in 1921.[25] Sir George Francis Hill, then Keeper of Coins and Medals at the British Museum, had not yet learnt the news from Athens.[26]

Though Christodoulou's œuvre is well known, his life and career is still shrouded in mystery. Svoronos in his first article on the subject announced a second and more extensive report, but his untimely death soon afterwards prevented him from fulfilling his promise. All that could be gleaned from his notes was the second part of the list of Christodoulou's forgeries, based on the dies confiscated by the Greek authorities (Pl. 2.E).[27]

Opinions differ as to the year of Christodoulou's death. It is often said he died in the year of his exposure, 1914.[28] On the other hand there are rumors that he continued counterfeiting and died in 1955.[29] It is clear anyway that Svoronos got only a portion of Christodoulou's dies. Samples of hitherto unknown dies were discovered some years ago.[30] It is quite possible that more Christodoulou

24. The correct form of the name is Christodoulou, not Christodoulos. It is true that Svoronos used the nominative, but he relied upon the version prevailing in Greece. Christodoulou was born in Cyprus, where only the genitive form is in use.

25. J. N. Svoronos, "C. Christodoulos et les faussaires d'Athènes", *JIAN* 20 (1920 [1922]), pp. 97–107. On Christodoulou's technique, see G. Cornaggia, *RIN* 37 (1924), p. 38 f.

26. The story of how Hill's professional skepticism was overruled by the way the coin came to his attention is told by M. J. Price in M. Jones (ed.), *Fake? The Art of Deception* (Berkeley: Univ. of California Press, 1990), p. 171 f.; cf. N. Penny, "Exhibition Reviews: London, British Museum", *The Burlington Magazine* 132/1048 (July 1990), p. 505.

27. J. N. Svoronos, "Synopsis de coins faux de Christodoulos (suite)", *JIAN* 21 (1927), pp. 141–146.

28. For instance, O. H. Dodson, "Counterfeits I have known", *Coinage* 3, 4 (April 1967), p. 20.

29. P. Tazedakis, "The Medals of Christodoulou", *Nomismatika Khronika* 10 (1991), p. 99.

30. Ch. Moulakis, "Christodoulou the Forger – More Dies", *Nomismatika Khronika* 13 (1994), pp. 45-54, cf. *BoC* 20, 1 (1995), pp. 2–7; *id.*, "Christodoulou the Forger: Twenty more Fakes?", *Nomismatika Khronika* 14 (1995), pp. 71–75; *id.*, "Christodoulou yet again", in A. P. Tzamalis and M. Tzamali (eds), *Μνήμη Martin Jessop Price* (Athens:

dies are still to be found in the back rooms of Athenian workshops. If rumors are correct, even some of the confiscated dies could have been in use again. As Admiral O. H. Dodson discovered, the nephew and assistant of Christodoulou, a certain Nicholas Garyphallakis, won a lawsuit against the Greek state in early 1939 and regained 101 of his uncle's dies along with a large number of the confiscated forgeries.[31]

The case of Christodoulou's decadrachm forgeries is a special one. In an article listing the decadrachm forgeries shown to him and to his predecessors, Martin Price mentioned a specimen from the collection of Grigorios Empedokles; Price thought that this specimen shared dies with both the Christodoulou fake in the British Museum and another fake that was shown to him in 1976 (F75). He did not illustrate the Empedokles specimen, but the cast he relied on is preserved in the collection of the British Museum, and can thus be identified (F45).[32] Price was right insofar as its reverse die is that of the known Christodoulou forgery. The obverse die, however, has nothing to do with F75 and the remainder of the "Burgon" group (see below). So there is no reason to posit a link between the Christodoulou fake and a later group. According to the sequence of dies suggested here, Christodoulou is not even likely to have produced a decadrachm fake after his exposure. It is true that two obverse dies and one reverse die were not known to Svoronos, and they were never confiscated. However, all specimens but one of the Christodoulou group share the reverse die published by Svoronos.[33] One of them (F43) is attested as early as 1903, while the only specimen combining dies not known to Svoronos (F46) has an obverse die which was in use before Christodoulou's exposure in 1914. The specimen was recorded for the first time in 1927, thus leaving room for speculation. We will turn to the problem again when dealing with the "Ars Classica" fake (see below).

Hellenic Numismatic Society, 1996), pp. 157–160; id., "Inexhaustible Christodoulou", *Nomismatika Khronika* 19 (2000), pp. 131–134.

31. Dodson, *op. cit.*, pp. 20-23, 66; repeated by J. M. Balcer, "The Archaic Coinage of Skyros and the Forgeries of Konstantinos Christodoulos", *SNR* 57 (1978), p. 70 f. Dodson met Garyphallakis in 1956. The records of the lawsuit are said to have been destroyed in December 1944 when a mob burnt down the police building holding the courthouse archives.

32. M. J. Price, "More Forgeries from the British Museum Archives", *BoC* 2, 4 (1977), p. 89 no. 5. While two decadrachm forgeries from the Empedokles Collection are still extant among the holdings of the Athens Museum (F45 and F49), a third one is lost (F46). On the fate of the Empedokles Collection see M. Oikonomidou and J. Touratsoglou, *Coins & Numismatics* (Athens: Numismatic Museum, 1996), p. 42 f. See also S. Karusu, *Athenische Mitteilungen* 69–70 (1954–55), p. 67, and U. Hausmann, *Gnomon* 68 (1996), pp. 476–479.

33. All the decadrachm dies confiscated, and published by Svoronos, remain in the Numismatic Museum of Athens.

A story about a Christodoulou decadrachm told by a late Athenian coin dealer cannot be verified:

> Mr. Iliades tells how, immediately after the German occupation (1945) an English officer who happened to be a numismatist discovered in his shop an Athenian decadrachm forged by Christodoulou. He recognized it and, because this particular specimen was not in the British Museum collection, insisted on buying it. He did not have enough money with him, however, and paid Mr. Iliades with various items from the British military canteen, at that time hard to come by in Greece.[34]

It will suffice to note that this forgery is not to be found in the British Museum.

O 1 Small olive leaves. Small palmette ending to the left of the first leaf. Cowlick. The lips are pursed. The bunch of hair in front of the ear is triangular.

 F39) Weight and die axis unknown. Imprint from the first obverse die preserved in the Athens Cabinet (J.N. Svoronos, *JIAN* 21 (1927), p. 141 nos. 295, pl. J [obv. only]).

O 2 The dotted base of the crest has breaks and small gaps. Olive leaves larger than before. The palmette is spreading towards the ear. Cowlick. The bunch of hair in front of the ear in even more pronounced triangular fashion. Pursed lips as before, but the lips are smaller.

R 1 Big olive sprig, no crescent. Curved bearing of the owl. The upper rows of the wing-feathers have a slight shifting downwards near the outer end. Narrow A with "archaic", slightly slanting cross-bar, small Ө, lop-sided Ⴈ with long upper bar. Both A and Ⴈ have pointed bars.

 F40) 42.80 g, 1 h. London 1920-3-18-1 (A. Burnett, *CINCR* 46 (1999), p. 67; M.J. Price in M. Jones (ed.), *Fake? The Art of Deception*, pp. 171 f. no. 177; M.J. Price, *BoC* 2, 4 (1977), p. 89 fig. 4; Seltman p. 107 n. 4; Svoronos, pl. 114, 2 "commerce"; G.F. Hill, *NC* (1921), pp. 169–171 no. 16, pl. 5; BM Cast 4 of rev. & Imprint 5 & Cast 6), *ex* Michel Ghinis.

 F41) Weight and die axis unknown. Current location unknown, documented by BM Wax Imprints 7 & 8.

 F42) Weight and die axis unknown. Imprint from the second obverse die and the reverse die preserved in the Athens Cabinet (J.N. Svoronos, *JIAN* 21 (1927), p. 141 no. 294, pl. J).

O 3 The face more compact: heavy chin, large aquiline nose, swelling lips. The palmette spreading towards the ear. The bunch of hair in front of the ear softly rounded. Several pellets (two upon the neck-guard, one at the upper lip, one beneath the eye-brow) appear to be die-breaks.

34. Tazedakis, *op. cit.*, p. 101.

R 1 As above.

F43) 43.04 g, 11 h. Current location unknown, documented by a photograph in
the BM Forgery Files (2a[3] = 3[3]) (BM Cast 20 "Weight Coll. 664.3 [grs]";
M. J. Price, *BoC* 2, 4 (1977), p. 90 fig. 15; Berlin Cast 4 "Weight in Brighton
1903". A certain W. O. Weight Collection in Brighton is attested by F. & E.
Gnecchi, *Guida Numismatica Universale* (Milan: Cogliati, 1903), p. 250 no.
2728.

F44) Weight and die axis unknown. Current location unknown (Svoronos,
pl. 114, 1 "commerce").

O 4 Face harmonized, lips smiling, straight nose, almond-shaped eye. The
bunch of hair in front of the ear even more rounded.

R 1 As above.

F45) 42.795 g, 5 h. Athens, NM. Empedokles Collection 1 (BM Cast 9 "Embedo
660.5 [grs] 5 h"; M. J. Price, *BoC* 2, 4 (1977), p. 89 no. 5 [no fig.] "same reverse
as 4 [F40], same obverse as 16 [F75]").

O 4 As above.

R 2 As before, with slightly differing proportions.

F46) 42.64 g, die axis unknown. Current location unknown (M. J. Price, *BoC* 2, 4
(1977), p. 89 fig. 6 "Athens, Empedokles Collection"; Berlin Cast 11 "Empe-
dokles 1927 wohl falsch", with ticket "Empedokles 1929"; BM Cast 10 "Em-
pedokles 658.0 [grs]"). This coin is not to be found among the coins from the
Empedokles Collection kept in the Numismatic Museum of Athens.

g. "Schulman", before 1922

Svoronos' publication of two specimens of this group (F52, F56) gives a *ter-
minus ante quem*. In 1923 a third specimen was offered to the British Museum
(F57). The specimen that appeared in Hans Schulman's auction in 1956 (F50)
is said to have been bought in 1926, and in 1933 a photograph of another speci-
men was sent from Triente to the British Museum (F59). All evidence points
to the assumption that the forgeries were made not very long before Svoronos
died in 1922. However, the unlabeled Berlin silver foil imprint could be much
older than that. The lion's share of the silver foil imprints in the Berlin Cabinet
were made by J. Friedländer, hence dating back to the 1870s.[35] Nevertheless, the
style of the "Schulman" fake might corroborate a dating to the time soon after
the First World War.

The fabric of these specimens is quite uniform. The flan is larger than the
reverse die, hence arching up around the *quadratum incusum*. There is almost
never an edge crack or anything of the kind, and the surface looks like steel.
After the obverse die was recut, the results became even worse.

35. On the use of silver foil imprints during the 1860s, see J. Warren, *The Bronze Coin-
age of the Achaian Koinon* (London: Royal Numismatic Society, 2007), p. 194 n. 559.

O 1 The bunch of hair in front of the ear is well-rounded. Lunar-shaped pendant. Lips do not touch each other in the corner of the mouth.

R 1 Olive sprig, no crescent. Compact owl with stripes rather than feathers. Horizontal A, small Θ, Ǝ with graduated long bars (like that of the "Hoffman" fake).

> F47) 43.09 g, 12 h. Current location unknown, documented by a cast (1) in Vinchon's Forgery Archive, Paris (H. Nicolet-Pierre in *Studies Price*, p. 299, pl. 63, 7).
>
> F48) 40.88 g, 7 h. New York, ANS, Forgery Archive (1) "Athens". Traces of an overstrike at the owl's eyes.
>
> F49) 38.47 g, 12 h. Athens, NM. Empedokles Collection (private notes by H. Nicolet-Pierre: "1 exc. parmi les faux de la coll. Empedoclès, vu Athènes 19.3.85; poids : 38,48 g, axes 1; patine noire à reflets bleus; faux grossier, aspect neuf").
>
> F50) 37.7 g, 12 h. H. Schulman (New York) 23 March 1956 (Charles A. Kays Collection), 649, pl. 3 (M. J. Price, *BoC* 2, 4 (1977), p. 89 fig. 1b; BM Cast 1 "37 gm 12 h"), *ex* Henry Chapman, 1926.
>
> F51) 37.33 g, 12 h. Current location unknown, documented by a cast (2) in Vinchon's Forgery Archive, Paris (unpublished): the original could be the Empedokles specimen above.
>
> F52) 34.40 g, die axis unknown. Current location unknown (Svoronos, pl. 114, 4 "commerce. 34,4 g").
>
> F53) Weight and die axis unknown. Current location unknown, documented by an unlabeled aluminum foil imprint with wax underneath, Berlin.
>
> F54) Weight unknown, 12 h. Current location unknown. "Boulogne Collection, 1985; Again seen 1991" (BM Cast 2).
>
> F55) Weight and die axis unknown. Current location unknown (M. J. Price, *BoC* 2, 4 (1977), p. 89 fig. 2).
>
> F56) Weight and die axis unknown. Current location unknown (Svoronos, pl. 114, 3 "commerce").
>
> F57) Weight and die axis unknown. Current location unknown. "offered from Alexandria 1/[19]23" (BM Cast 19; M. J. Price, *BoC* 2, 4 (1977), p. 90 fig. 14).

O 1' Recut; Athena has Aphrodite's neck folds.

R 1 As above.

> F58) 40.64 g, 11 h. Current location unknown. "Shown 1991" (Photograph in the BM Forgery Files (2a[4])). Traces of an overstrike at the olive's leaf.
>
> F59) Weight and die axis unknown. Current location unknown. "Offered from Triente 24/VIII/33" (Photograph in the BM Forgery Files (3[6]); M. J. Price, *BoC* 2, 4 (1977), p. 89 no. 1a).

h. "Ars Classica", before 1928

The "Ars Classica" fake has its *nom de guerre* from the first auction sale it en-

tered. Like the "de Luynes" fake above and the "Burgon" fake below, the "Ars Classica" fake can be traced back to a genuine specimen: the "Kunstfreund" decadrachm (5a). Unlike these other two groups of forgeries, however, the "Ars Classica" fake proved to be so dangerous as to bring its *madre* under a certain suspicion, if without discussion in the literature. Before turning to details, it should be said that the suspicion was unfounded. The "Kunstfreund" coin is genuine, as the traces of horn silver (never mentioned in the sale catalogues) prove sufficiently. Furthermore, the sequence of dies reveals the artistic limits of the counterfeiter, and the step-by-step alterations of the dies clearly make his forgeries withdraw from the *madre* (if it were a forgery, the "Kunstfreund" coin would have had to be the final product, but never the prototype, since it exhibits several die-cracks).[36] Last but not least, the "Kunstfreund" coin shares its obverse die with two specimens from the Elmalı Hoard, all of them having exactly the same die-cracks. The authenticity of the "Kunstfreund" coin is above all suspicion.

The example consigned to Ars Classica Sale 13 (F60) was withdrawn from the auction. Its character became obvious at the latest in 1930, when Jacob Hirsch brought a second piece (F63) to the attention of the British Museum authorities. After having dealt with other works of the same forger, Oscar Ravel condemned the Ars Classica specimen in 1946:

Le décadramme d'Athènes de la vente de Lucerne 1928 présentait ces grains de sulfure sur les bords et sur la tête d'Athéna, le restant de la pièce était propre, on aurait dit qu'elle avait été nettoyée. Nous avions reconnu à première vue, qu'il s'agissait d'un faux de X, qui, pendant quelque temps, après la mort de Christodoulos [1914 (?)], a suivi les systèmes de son patron et parent. Pourtant cette pièce, d'un style remarquable, avait été vendue par un expert [Jacob Hirsch], et personne ne la suspectait, elle était passée par les experts de Berlin et Londres, qui la considéraient comme authentique. Très probablement le faussaire avait patiné entièrement la pièce, mais le résultat n'étant pas satisfaisant, il l'avait nettoyée, une petite partie était restée, mais elle avait suffi pour nous permettre d'en déceler l'origine.

En définitive la pièce fut retirée de la vente, mais on nous reprocha d'avoir condamné la pièce sans raisons suffisantes. Récemment à Athènes nous avions eu le plaisir d'avoir la confirmation que nous avions juste; non seulement la pièce était fausse, mais c'était bien X qui l'avait fabriquée.[37]

36. It can be added that the "Kunstfreund" coin is attested some years earlier than the earliest specimen of the "Ars Classica" Group.
37. O. Ravel, *Falsifications* (London: Spink, 1946), pp. 36–37; cf. *id.*, "Notes techniques pour reconnaitre les monnaies grecques fausses", *RN* (1933), pp. 9–12.

Ravel placed weight on the spurious patina, because he did not know the evidence of the die-links. Today it is clear that six specimens reproduce the obverse die of the "Kunstfreund" coin (F60–F65), and three of them reproduce the reverse die also (F60–F62). One of the six specimens, the Robinson piece kept by the ANS (F65), is of such poor metal that the whole string of coins, including three specimens connected by an altered reverse die (F66–F68), must be false.

A closer look reveals that the *madre* was reproduced down to small peculiarities. Of course, the forger did his best to remove troubling particulars, such as the die-break at Athena's eyebrow, the corroded surface of her neck, or the fissure to the left of, and the dent above, her ear (the Elmalı die-link eventually proved that the dent was not due to damage to the "Kunstfreund" coin but to the ancient die). He was more careless with the reverse: there are the fissures beneath, and to the right of, the A; there are the two thin cracks running over the right wing towards the Ο; there is the flatness of the flan's right and lower edge. The forger interfered with the reverse only if there was no other option. He had to fill in the lower right corner of the *quadratum incusum*, which is off the flan of the "Kunstfreund coin"; the edge of the *madre* was transformed into a worm-shaped crack beneath the tip of the right wing.

Among the specimens extant, the Ars Classica specimen (F60) was most certainly the first one minted. Its small flan concealed some treacherous elements but did not look very convincing. The following specimens were better done: the flans' outlines now look much more persuasive. A small crack at the right edge of the *quadratum incusum* had been removed, and the forger took pains in dealing with the cracks around the A and Ο. Another reverse die, which appears to be a revised version of the first one, was soon brought into use (F63, F64), and then two more variants (F65, F68). Another obverse die, based upon both the "Jameson" and the "Kunstfreund" coins (31a, 5a) but altered in many ways, was to follow (F66–F68). This die compares badly with the first obverse, thus laying bare the limited artistic skills of the counterfeiter.

The name of the counterfeiter remains a mystery. It is clear that Ravel had in mind a protégé or assistant of Christodoulou, and so his "X" could be the man Nicholas Garyphallakis mentioned above.[38] Unfortunately, Ravel did not tell precisely what had happened at Athens that confirmed his suspicion. The word "récemment", however, should probably be read as "shortly before the war". If so, Garyphallakis' lawsuit of 1939 to regain the tools of his uncle could have been the crucial experience.

Another witness of what was going on in the Athens scene of the 1930s was Willy Schwabacher. Being Jewish, he spent the years 1933–1938 at Athens, then joining the excavation teams at the Kerameikos and the Agora, before he took

38. See above, p. 65.

refuge in England, Denmark, and eventually Sweden.[39] He might have made the acquaintance of Michael Kambanis, once the owner of the "Kunstfreund" coin, and have learnt the rumors afloat in Athenian collectors' circles.[40] We shall never learn how the *madre* itself became suspected, although Christodoulou and his congenial successor were known to be skillful enough to create dies from plaster casts.[41] Unfortunately, a proud collector would provide casts to almost everybody even after Svoronos had exposed Christodoulou. In any case, if Schwabacher himself was not the first to suspect the "Kunstfreund" coin, he was to fuel such suspicions. Some time after the war, Kenneth Jenkins made a note in the British Museum copy of Seltman's book at no. 447 (i.e., the "Kunstfreund" coin): "Now Boston. ? false cf. similar style N.[aville] XIII 745."

Later on, he added the following note (using another pencil): "Schwabacher says he knows the man who made it!"

If the notice was written before the Kunstfreund sale, Jenkins cannot have been impressed by the hard bidding for, and the staggeringly high price of, the famous coin. According to Hélène Nicolet-Pierre's recollection, he had not changed his mind ten years later:

> C'est de cet exemplaire [i.e. the "Kunstfreund" coin] que W. Schwabacher avait mauvais opinion (I know the man who did it) d'apres Jenkins en visite à Paris, Cab.[inet des] Méd.[ailles], avec U. Westermark, en 1984.[42]

Among Nicolet-Pierre's notes on the same page the name "Nicholas Garyphallakis" is to be found. Since that name was notorious at least since the article published by J. Balcer six years earlier, it cannot be certain if Schwabacher had brought it to Jenkins' attention.[43] It should be mentioned that the same name (or at least a transmogrified version of it) turns up in still another context: the counterfeiter Orphanides is said to have appeared under the alias "Garyphallides" when dealing with Peloponnesian collectors.[44] Perhaps this is insignificant, for there was a sinister custom among Greek collectors and coin dealers of those days to use the names of rivals in order to bewilder both their business partners and the state authorities. On the other hand, Orphanides was by far the most successful follower of Christodoulou, and I would not put the "Ars

39. Ch. Boehringer, "Wilhelm Schwabacher (1897–1972)", *SNR* 52 (1973), p. 157. Schwabacher was the "Athenian correspondent" who added 21 entries to S. Noe's *Bibliography of Greek Coin Hoards*[2], NNM 78 (New York: American Numismatic Society, 1937).

40. On Kambanis see W. Fischer-Bossert, "Der Hortfund vom Dipylon 1875 (*IGCH* 339)", *Athenische Mitteilungen* 114 (1999), pp. 240f., with further references. Kambanis died after 1936.

41. Cf. Svoronos' first article on Christodoulou (above, p. 64 n. 25).

42. Quoted from H. Nicolet-Pierre's private decadrachm files.

43. See above, p. 65 n. 31.

44. B. Demetriadis, personal communication.

Classica" fake past him.[45] The time-span of Orphanides' activity is not exactly known. An old man, he died in 1966, but it is not known whether he started his career as early as the early 1920s. Born in 1887, Garyphallakis was of the same generation at any rate.

O 1 Taken from the genuine O 3 (see above). The scratch above the first olive leaf is removed as are both of the dents to left and right of the tendril spreading towards the ear; however, the right dent is still recognizable. Furthermore, the divided die-break at the eyebrow is removed. The lips might be reworked. The whole neck is smoothed.

R 1 Taken from the genuine R 5 (see above). The dots on the owl's body are redone, the flaws are removed. Still visible, however, are all the die-breaks: the crack beneath the A, and the crack running over the right wing of the owl towards the Θ. New fissures can be seen along the right edge of the *quadratum incusum*.

F60) 42.93 g, 12 h? Ars Classica 13, 27 June 1928, 745 (Leu index card "retour", BM Cast 24 "false", Berlin Cast 9, ANS Cast "Kambanis Cast – also Hirsch 1927"; M. J. Price, *BoC* 2, 4 (1977), p. 89), *ex* Zinser Collection, Stuttgart (Berlin Cast 10 "G[aebler] falsch, R[egling] echt"). The Zinser Collection is not known to Gnecchi's *Manuale Hoepli*. According to U. Klein, retired keeper of the Stuttgart Cabinet, there was a certain Richard Zinser, member of the local coin collectors' society from 28 Oct 1927 until 1938. The date suggests that he was Jewish and left Germany just in time; if so, he is likely to be the art dealer Richard H. Zinser (*c.* 1880–*c.* 1965) who had his business in New York during the 1940/50s.

F61) 42.37 g, die axis unknown. Current location unknown (BM Cast 18 "Warren 42.37"; M. J. Price, *BoC* 2, 4 (1977), p. 90 fig. 14). The owner might be Edward Perry Warren who died in 1928. If it is true that he bought the "Kunstfreund" coin (5a) from Seltman soon after 1924, he should have become thoughtful when comparing his two decadrachms.

F62) Weight and die axis unknown. Current location unknown (BM Cast 13 "offered to the Budapest Museum 1969, cf. Seltman 9C XIII. 2 [?] – False!" [offered by a late Hungarian collector] = BM Cast 14 "1966"; M. J. Price, *BoC* 2, 4 (1977), p. 90 fig. 9a [9b is another cast, but not another specimen]). Traces of an overstrike in the owl's eye.

O 1 As above.

R 2 More space between the olive and the owl's shoulder. Die-crack at the upper right edge of the right wing.

F63) 42.54 g, die axis unknown. Current location unknown (BM Cast 15 "Hirsch

45. On Orphanides see H. H. Kricheldorf, *Der Münzen- und Medaillensammler. Berichte* 8/43 (Feb. 1968), p. 382 f., and more recently Sheedy, *Archaic and Early Classical Coinages*, p. 45.

Feb. 1930, 656.5 grs"; ANS cast "Kambanis Cast"; Berlin Cast 3 "Kambanis 41"; M.J. Price, *BoC* 2, 4 (1977), p. 90 fig. 10)

F64) Weight and die axis unknown. Current location unknown (BM Cast 16 "Zoumboulakis 1967"; M. J. Price, *BoC* 2, 4 (1977), p. 90 fig. 11). The man who showed the piece might be Byron Zoumboulakis, a Greek resident of Geneva who sold some coins to the British Museum during the 1950/60s. He was the son of Theodore Zoumboulakis, an Athens coin dealer of the 1930s, cf. B. Y. Berry, *Near Eastern Excursions* (private publication [Zurich?] *c.* 1989), p. 72, 81.

O 1 As above.

R 3 The middle rows of feathers of the owl's wings have straight lower edges running downwards. Dot-shaped rust point beneath the A. A die-crack runs from the right edge of the die over the right wing to the ⊙.

F65) 41.85 g, 10 h. New York, ANS Forgery Archive (5), *ex* D. M. Robinson. Doublestrike on the reverse. Poor metal.

O 2 The palmette rising higher than usual, but without having the usual tendril touching Athena's auricle. Hair at the temple straight and broader. String above the dotted line at the neck.

R 2'? Identity with Reverse 2 cannot entirely be ascertained. If the dies are one and the same, the recutting goes as follows. The olive is slightly enhanced. The die-crack at the upper right edge of the owl's right wing has been removed. A secondary die-break runs from the olive leaf to the head of the owl (to be seen on **F67** only).

F66) 40.07 g, 4 h. Vinchon 13 Apr. 1985, Pflieger 285 (BM Cast 17 "Seen iii/ [19]52"; M. J. Price, *BoC* 2, 4 (1977), p. 90 fig. 12). Big hole in the reverse, at the owl's legs.

F67) Weight and die axis unknown. Private collection, South Africa; shown to a European coin dealer, Oct. 2007. Two star-shaped punch-holes on the hair and cheek of Athena.

O 2 As above.

R 4 Like Reverse 3, but there are differences in the proportions and the distribution of dots. Lowest bar of the Ǝ fairly short, A with horizontal left bar, small and irregularly shaped ⊙. Flaw at the left olive leaf.

F68) Weight and die axis unknown. Current location unknown. Burton Y. Berry Collection (ANS cast "B. Y. Berry. Found Keratea Valatori near Laurion, Apr. '46", ANS card "Formerly B. Y Berry Collection (1960). 2nd specimen, other in ANS"), cf. B. Y. Berry, *Out of the Past* (New York: Arco, 1977), p. 166: "I owned two decadrachms...."

i. "Burgon", before 1970

Like the "de Luynes" and "Ars Classica" fakes, this group of forgeries derives

from a genuine specimen: the Burgon coin of the British Museum (7a). Presumably an electrotype copy (galvano) sold by the Museum itself was used to create the dies.[46] Since both sides of the Burgon coin are heavily damaged by a gash across Athena's eye, the counterfeiter has done a good job in reconstructing an earlier condition of the coin. On the obverse, the whole area of forehead, eye, and hair around the upper face is redone, and the lips seem to be slightly retouched. Other parts, however, do not show any signs of a recutting, the helmet in particular. The palmette looks even more worn than on the Burgon coin, and the scratch running over the neck-guard has not been removed. On the reverse, the area around the A which is affected by the obverse test-stroke has been retouched, and both body and wings of the owl have been redone as well. An unintentional addition occurring on some specimens is a die-break running across the Ǝ.

At first sight, the result is persuasive. The forger did not reproduce the flan edge, thus giving his products outlines of their own. All the forgeries are minted on small, dumpy flans with edge cracks and ruptures, although cold minting is not typical of the ancient mint of Athens. By using small flans, the forger avoided revealing the outline of the Burgon obverse, where the crest and the neck hair are partly off flan.

Nevertheless, these forgeries can be recognized easily without reference to the Burgon coin. The difference between the fresh and worn areas is striking, especially on the obverse, and there is the exaggerated eye with the raised eyebrow. Although Martin Price had published a condemnation in 1977, he did not realize that the Burgon coin is the *madre* of the forgeries, and he would suggest a die-link to the Christodoulou Group that does not exist.[47]

No specimen has ever been offered at auction. The first one was recorded in 1970, and since then there have been periodical reappearances, the last one in 2007. In four cases the people showing the coins were said to be from Sicily, in another case to be Italians. As to the use of British Museum electrotypes there is a correspondence to a notorious series of forgeries, known as the products of the "Galvano boys".[48] However, this appears not to be the same source. The forgeries of the "Galvano boys" are much more sophisticated and dangerous than the "Burgon" fake, and the "Galvano boys" are active in Greece, whereas the Burgon fake workshop might be located in Sicily.

46. B. Head, *A Guide to the Principal Coins of the Greeks*[3], p. 22 no. 31 pl. 11, 32 [sic]. On the electrotype series sold by the British Museum, see J. Duncan, "R. Ready Electrotypist", *CNG Review* 17, 3 (1992), pp. 4 f.

47. M. J. Price, *BoC* 2, 4 (1977), p. 89 no. 5 (F45, see the discussion on p. 65 above).

48. S. Hurter and A. Walker, "The British Museum Forgers or 'Costodoulos' and 'Gulyás'", *BoC* 17, 1 (1992), pp. 2–49; S. Hurter, "The Galvano Boys – Part II", *BoC* 17, 2 (1992/93), pp. 2–10; *ead.*, "The 'Galvano Boys' Again", *BoC* 20, 2 (1995/96), pp. 2–9; *ead.*, "A Tetradrachm of Sura by the 'Galvano Boys'", *BoC* 23, 1–2 (1998), p. 10.

F69) 42.97 g, 6 h. Current location unknown. "Handel USA 1976" (Photo in LHS Forgery Archive, Zurich).

F70) 42.92 g, 7 h. Current location unknown. "Shown 12/11/98 by two Italians" (Polaroid in the BM Forgery Files (2a[1], 3[1])).

F71) 42.85 g, 6 h. Current location unknown. "Sotheby 1989" (Polaroid photo in the BM Forgery Files (1a[4])).

F72) 42.58 g, 7 h. Current location unknown, offered to a European coin dealer, March 2007, by Sicilians.

F73) 42.52 g, 8 h. Current location unknown. "Perito Gerbi Adolfo, Piazzetta Tavarone 2/3, 16123 Genova" (Photograph in the BM Forgery Files (1a[1], 1b[sheet]). No date).

F74) 42.41 g, 6 h. Private collection (Polaroid photo in the BM Forgery Files (1a[3]) "Mm. Sicily").

F75) 42.26 g, die axis unknown. Current location unknown. "Shown 1976" (M. J. Price, *BoC* 2, 4 (1977), p. 91 fig. 16).

F76) 41.75 g, die axis unknown. Current location unknown. "based on BM specimen; shown at Ashmolean from Sicilians, 1970" (Polaroid photo in the BM Forgery Files (2a[5], 3[5])).

F76a) Weight and die axis unknown. Current location unknown. "Handel 1977" (Photo in LHS Forgery Archive).

k. *"Phoenician style", before 1985*

These two fakes derive from the same reverse die. According to a story told when the coins were offered, the engraver tried to benefit from the rumors about the Elmalı Hoard.

F77) Weight and die axis unknown. Paris, Forgery Archive of the Bibliothèque Nationale (H. Nicolet-Pierre in *Studies Price*, p. 299 pl. 63, 9); the provenance "Elmalı Hoard" is false (offered to the Bibliothèque Nationale in 1985).

F78) Weight and die axis unknown. Paris, Forgery Archive of the Bibliothèque Nationale. Deep stroke on obv. (H. Nicolet-Pierre in *Studies Price*, p. 299 pl. 63, 10); the provenance "Elmalı Hoard" is false (offered to the Bibliothèque Nationale in 1985).

l. *Origin unknown, before 1992*

It cannot be proven that the following two die-combinations are the work of one and the same engraver. Yet they share some stylistic peculiarities such as the flatness of the relief and the precision (if not pedantry) of the engraving: note the regular waves of the hairdo. The fabric, however, is different; the specimen from the second die-pair is much more convincing than the previous ones with regard to the shape of the flan.

While a specimen of the first die-pair appeared in 1992, the specimen of the second pair could be some decades older. There are similarities to the

"Schulman" fake but these are typological rather than stylistic (note the shape of the palmette), and are perhaps coincidental.

O 1 Olive leaves widely positioned. The palmette similar to that of the "Schulman" fake above. Small eye.

R 1 Owl with big head but tiny tail; the bearing unlifelike. Large olive sprig, no crescent. Horizontal A; Θ and Ǝ are small and close to the legs.

 F79) Weight and die axis unknown. Current location unknown. "Seen in 1992" (BM Cast 3). Dent upon Athena's cheek.

 F80) 40 g, die axis unknown. eBay, Dec. 2006.

O 2 As above, but the proportions more compact. Almond-shaped eye, clear smile.

R 2 As above, but olive sprig smaller; no crescent. Diagonal A, Θ, and Ǝ are small and close to the legs.

 F81) 42.34 g, 4 h. Paris, Cast in the Vinchon Forgery Archive 3 (H. Nicolet-Pierre in *Studies Price*, p. 299 pl. 63, 8).

m. Tourist fakes from Turkey and Syria, before 1993

Without sharing any dies, the following specimens are homogenous in style. All but one appeared recently, and as far as is known, their origin is said to be the Turkish coast or the northern Levant. They might well be the products of one and the same workshop. In some instances they were said to be made of sterling silver.

 F82) 39.9 g, die axis unknown. Seen in Kaş, Lycia, in 1993.

 F83) 42 g, die axis unknown. eBay 3973958279, May 2005.

 F84) Weight and die axis unknown. Seen in commerce, 2005.

 F85) Weight and die axis unknown. Seen in commerce, 2005. Obv. "test cut" at 4 o'clock.

 F86) Weight and die axis unknown. eBay, January 2006.

n. From Syria, 2008

This new forgery was offered from Syria. The reverse is similar to the previous group, while the obverse has some features of its own. Athena's melancholic look is reminiscent of some Levantine imitations of Attic coinage.[49]

 F87) 39.01 g, die axis unknown. Offered to a European coin dealer, July 2008.

o. Still more fakes

The following pieces have nothing in common except the fact that they cannot be attributed to any one of the previous groups.

49. See, for instance, P. van Alfen, "The 'Owls' from the 1989 Syria Hoard", *AJN* 14 (2002), p. 14 no. 112, pl. 6; *SNG München (14). Attika, Megaris, Ägina* 53.

F88) 42.43 g, 6 h. Current location unknown. "Shown Jan. '99" (Polaroid in the BM Forgery Files (2a[2], 3[2])).

F89) 43.63 g, 6 h. Jerusalem, Israel Museum 24896, *ex* Shraga Qedar, *ex* local private collection "30 or 40 years ago". Crude.

F90) 42.7 g, die axis unknown. Shown in Paris, Aug. 2007. Similar to the Schulman fake, but much poorer.

F91) 36.6 g, die axis unknown. Seen on the Internet. Reverse with a small crescent right of the A. Style is similar to the Turkish-Syrian group above, but not from the same workshop.

F92) Weight and die axis unknown. Lenormant, *Description de médailles et antiquités… Behr*, no. 1188 "Lots de monnaies diverses qui n'ont pas trouvé place dans ce catalogue", cf. ibid. no. 201 "Nous ne connaissons que cinq exemplaires authentiques du décadrachme d'Athènes.… Dans le lot des pièces fausses à la fin de la vente, on trouvera un des exemplaires faux qui se fabriquent aujourd'hui en très-grand nombre en Grèce, et on pourra juger des différences qui les distinguent des exemplaires authentiques"; E. Babelon, "Les origines de la monnaie à Athènes", *JIAN* 8 (1905), p. 46 n. 2 "J'en ai vu un certain nombre d'exemplaires faux très habilement exécutés, dans le commerce. Cf. Lenormant, Catal. Behr, p. 37, no 201."

F93) Weight and die axis unknown. Current location unknown (Anonymous, *Médailles fausses recueillies par H. Hoffmann*, p. 15 no. 71 "Tête de Minerve d'ancien style, le casque orné de rinceaux et de feuilles d'olivier. Rv. Dans un carré creux: AOⱻ rétrograde. Chouette éployée de face. – Décadrachme. Arg.10, flan épais".

Appendix:
The Acquisition of the Prokesch-Osten Specimen

The search by the British Museum for another decadrachm that led Sir George Francis Hill to purchase the Christodoulou fake (**F40**) has a prehistory with an air of irony.[1] Correspondence in 1851 between George Finlay, an English resident at Athens, and Edward Hawkins, keeper of antiquities of the British Museum, reveals that the British Museum had had the opportunity to acquire the coin which eventually ended up in the Berlin Cabinet (1a).

The correspondence is known to me from a typescript copy in the Fitzwilliam Museum.[2] The copy has two pages. The text runs as follows:

Letter bound in a copy of Numismatica Hellenica, presented to George Finlay by the author, and now in the library of the British School of Archaeology, Athens.

Revd. Josiah Forshall, British Museum. Athens, 16 December 1856 [sic].

Sir,

I have met with a medal here which I think is of such rarity that it would be a great acquisition to the British Museum. It is a silver piece of ten drachmae wanting little more than 12 grains of the full weight. The ancient type of Athens.

The coin has every appearance in its favour; but I have not sufficient experience in the matter to give any opinion. I am informed however of Mr Postolakas who assisted Baron Prokesch von Asten[3] [sic] in his

1. Hill did not deal with the Athenian decadrachms in his *Historical Greek Coins* (London: Constable, 1906), nor in his *Select Greek Coins* (Paris & Brussels: Vanoest, 1927). He (and P. Gardner in his *History of Ancient Coinage*, as well) most certainly would have done so, and proudly have figured a specimen, if the Burgon coin (7a) had satisfied him.

2. I am grateful to Adrian Popescu for bringing this source to my attention.

3. Finlay made Prokesch's acquaintance in 1850 or early 1851, cf. Bertsch, *Anton Prokesch von Osten*, p. 474.

numismatic researches here, and who is the only person now in Athens combining scientific knowledge with practical experience, that it is indubitably genuine. I send a cast Mr Postolakas was so good as to make for me, that you may be able to judge of its appearance and state of preservation.

It is in the possession of a jeweller here who has lately had more than three hundred pieces of four drachmae of the Mecedonian [sic] and Roman period. He asks two thousand francs. I have made no attempt to discuss the price but only informed him that I would write to London to try and find a purchaser if he would keep the medal for a little more than a month.

The Rt. Honbl. Thomas Wyse Her Majesty's Minister has been so kind as to consent to transmit the cast with this letter.

I requested you to deliver the cast to Colonel Leake after you have examined it and adopted your decisions.

I have the honour to be

> Sir
> your obedient servant,
> George Finlay.

~

Dear Sir,

We are much obliged to you for securing to us the offer of the rare Athenian decadrachm and we should be very glad to possess it if it is genuine, and from the cast it has every appearance of being so. But the price at present demanded (strikes?) [sic] us out of the market, being full double the fair price, and having already got one we are not disposed to give an ultra extravagant price. It is not from the same die as ours, and therefore if you could procure it for us for one thousand francs I believe the Trustees would not refuse to purchase it, but I feel sure that they would not be persuaded to exceed that amount.

The cast you were good enough to send has been forwarded as you desire to Col. Leake.

> I remain
> Yours very truly
> Edw. Hawkins

B.M.15 Jan.1851

The letter from Finlay has the following on its third page.

The British Museum having asked me to guarantee the authenticity of the coin & I having replied that I was neither a connoisseur nor a dealer of coins.

Baron Prokesch Osten purchased the coin for 1,000 drs.[4]

An electrotype of the coin is in the Leake collection. See Num. Hellenica, p. 23 of European Greece, no. 5.

Three years later, in 1854, Prokesch-Osten published some lines about his new acquisition:

> Schon Brönsted in seinen 1830 in Paris erschienenen „Reisen und Untersuchungen in Griechenland", hatte aus der Sammlung des früheren englischen Botschafters in Konstantinopel, Lord Strangford, eine Dekadrachme Athens bekannt gemacht, die Mionnet für eine Oktodrachme hielt und als solche bekannt machte (Suppl. Nr. 7), weil er sie nur aus einer Zeichnung kannte und Brönsted ihr Gewicht nicht angibt. In der Sammlung Thomas befand sich eine zweite, zu 810.6 Par. Gran Gewicht. Ich habe sie nicht gesehen, kann also über ihre Echtheit nicht urtheilen. In Athen sah ich eine ziemlich gut nachgebildete, aber etwas zu schwere, in der Hand eines Herrn Orlando. Ich erkannte sie für falsch und das sichere Auge meines Freundes Borrell bestätigte dieses Urtheil. Dagegen besass ein Mann aus Nauplia, Michel Jatros, eine, die durch Patina, Styl und Gewicht sich als unbezweifelbar echt auswies und die auch Borrell dafür erkannte. Ich habe sie vor kurzem an mich gebracht.[5]

Another, hitherto unknown account by Prokesch von Osten was recently published:

> In den Vierziger Jahren liefen in Athen drei oder vier atheniensische Dekadrachmen, vortrefflicher Arbeit, aber um ein Geringes zu schwer, was an ihrer Ächtheit zu zweifeln berechtigte. Der Zweifel war mir Gewißheit, da ich im J. 1833, auf meiner Rückreise von Alexandria nach Triest, in Nauplia in der Hand eines Arztes ein unbestreitbar ächtes Stück dieser höchst seltenen Münze gesehen hatte. Ich wollte dieses damals an mich bringen, erhielt aber von dem Besitzer nichts weiter als die Zusage daß wenn er die Münze je verkaufen wollte, er mich davon benachrichtigen würde. Er lebte noch als ich Athen zu Anfang 1849 verließ. Der Mann war etwa gleichen Alters mit mir. Mein Verlangen nach dieser Dekadrachme gab mir den Gedanken ein, einen meiner numismatischen Zubringer dort zu ermächtigen im Falle der Arzt sterben u. sein Nachlaß

4. Either Finlay was misinformed or the Cambridge copy of his letter is wrong at this point. According to Prokesch-Osten himself, the price was twice as high (see below).

5. Prokesch von Osten, *Inedita meiner Sammlung*, p. 29. Henry Borrell was an English resident of Smyrna (cf. pp. 61–62 n. 20 above) who had a part of his collection sold at Sotheby's (12 July 1852), while he sold another part to the Bank of England. Eventually the second part ended up in the British Museum together with the Bank's collection in or shortly before 1878.

verkauft werden sollte, die Münze für mich zu erstehen. Im J. 1852 trat
dieser Fall wirklich ein, u. diese Perle kam um den Preis von 2000 Drach-
men in meine Sammlung.[6]

Prokesch's hand-written catalogue of his collection (Cabinet des Médailles,
Brussels) has the entry (p. 274):

Décadrachme, 42,~~635~~/42,70 g. Tête d'Athena, à dr., à casque orné des
trois feuilles & de la spirale à palmette, les cheveux massés au front &
s'échappant en tresses perlées du bout du casque, boucle d'oreilles en deux
globules & croissant, collier en filet & en perles. (Style archaïque, noble &
grand). Rev. Ǝ-Θ-A. Chouette éployée de face, soigneusement exécutée;
pousse d'olivier dans l'angle en haut du carré creux, qui renferme le tout.
Num. Chr. 1853. p. 30. pl. VI ~~98~~ 108.

C'est la même pièce que M. Newton a vu à Athènes & dont il dit:
"I never saw any coin which appeared to me more thoroughly satisfac-
tory. The surface of the metal has that peculiar drag in places, resulting
from a slight slipping of the die at the moment of striking, which I have
never seen in a forgery. It was, farther, cracked at the edge, and slightly
oxydized in places, in a manner which could not, I should say, be coun-
terfeited, though, of course, I looked at it with every desire to convict it of
falsity, if I could, on account of its extraordinary rarity. I think it a more
satisfactory coin than Thomas's."[7] Num. Chron. 1853. 30.

J'ai rencontré cette superbe pièce la prémiere fois en 1844 ou 1845 à
Nauplia. Elle était dans les mains d'un médecin grec, Mo. Michel avec le
prénom de son métier Iatros. Mes efforts pour me la faire céder restèrent
infructueux. Tout ce que j'ai pu obtenir de lui, ce fait [sic] la promesse de
ne pas le vendre sans m'en prévenir. Obligé de quitter Athènes en fevrier
1849, j'ai chargé un de mes clients de ne pas perdre de vue cette médaille,
l'autorisant éventuellement pour le cas du décès du médecin & de la vente
alors probable de ses effets, & à l'âcheter. En 1856 [sic] le cas prévu ar-
riva—la médaille fut vendue & âcheté par mon homme au prix modique
de deux mille francs.

Obviously, Prokesch-Osten's recollection about the date of his acquisition was
blurred when he wrote the catalogue. In his 1854 publication Prokesch-Osten
said he bought the coin in 1852. He must have bought the coin before 1854,
however not long before that year, because W. S. W. Vaux while presenting C. T.

6. Bertsch, *op. cit.*, p. 658, quoting from the Prokesch family's archives. On Prokesch's
stay in Nauplia in 1833, see Bertsch, *op. cit.*, p. 230.
7. Prokesch did not cite the following words: "[... Thomas's], so far as I can recollect
it.... The coin is well known in Athens; I talked of it to Mr. Wyse, Mr. Rhangabé, and
Mr. Finlay."

Newton's report on the coin (published in 1853) mentioned it as being "at present in the hands of a jeweller at Athens".[8]

The three or four coins condemned by Borrell and Prokesch-Osten could have been specimens of the numerous "Hoffmann" fakes which are attested soon after the middle of the nineteenth century (see above, Chapter 5c).

8. W. S. W. Vaux, *NC* (1853), p. 30.

CONCORDANCES

a) to Svoronos, pls. 8 and 114:
 Svoronos, pl. 8, 8 = 2a
 Svoronos, pl. 8, 13 = 11a
 Svoronos, pl. 8, 14 = 29a
 Svoronos, pl. 8, 15 = 1a
 Svoronos, pl. 8, 16 = 7a
 Svoronos, pl. 8, 17 = 13b
 Svoronos, pl. 114, 1 = F44
 Svoronos, pl. 114, 2 = F40
 Svoronos, pl. 114, 3 = F56
 Svoronos, pl. 114, 4 = F52
 Svoronos, pl. 114, 5 = F16
 Svoronos, pl. 114, 6 = F18
 Svoronos, pl. 114, 7 = F22

b) to Seltman, pp. 211 f.:
 Seltman 445 = 2a
 Seltman 446 = 1a
 Seltman 447 = 5a
 Seltman 448 = 31a
 Seltman 449 = 7a
 Seltman 450a = 11a
 Seltman 450b = 10a
 Seltman 451 = 13b
 Seltman 452 = 29a

c) to Starr, pp. 33 f.:
 Starr 52 = 1a
 Starr 53 = 2a
 Starr 54 = 31a
 Starr 55 = 5a
 Starr 56 = 17a
 Starr 57 = 8b
 Starr 58 = 9a
 Starr 59a = 11a
 Starr 59b = 10a
 Starr 60 = 13b
 Starr 61 = 29a
 Starr 62 = 7a

Bibliography

Adelson, H. L. *The American Numismatic Society, 1858–1958*. New York: American Numismatic Society, 1958.

Alföldi, M. R. *Dekadrachmon. Ein forschungsgeschichtliches Problem.* Sitzungsberichte der Wissenschaftlichen Gesellschaft an der Johann Wolfgang Goethe-Universität Frankfurt am Main XIII, 4. Wiesbaden: F. Steiner, 1976.

Anonymous. *Médailles fausses recueillies par H. Hoffmann pour servir a l'étude de l'authenticité des monnaies antiques.* Paris: n.p., 1902.

Antiken aus dem Akademischen Kunstmuseum Bonn³. Cologne: Rheinland-Verlag, 1983.

Arias, P. E., and M. Hirmer. *A History of Greek Vase Painting,* translated and revised by B. Shefton. London: Thames & Hudson, 1962.

Ashton, R. "Forgeries of Rhodian Didrachms", in *Florilegium Numismaticum. Studia in honorem U. Westermark edita*, pp. 29–32. Stockholm: Svenska numismatisk föreningen, 1992.

―――― and S. Hurter (eds), *Studies in Greek Numismatics in Memory of Martin Jessop Price.* London: Spink, 1998.

Augé, C. "La circulation des monnaies à l'est du Jourdain à l'époque perse", *Transeuphratène* 20 (2000): 167–168.

Babelon, E. "Les origines de la monnaie à Athènes", *JIAN* 8 (1905): 7–52.

Babelon, E. "La politique monétaire d'Athènes au V. siècle avant notre ère", *RN* (1913): 457–485.

Babelon, E. *Traité des monnaies grecques et romaines, I–IV.* Paris: E. Leroux, 1901–1932.

Babelon, J. *Catalogue de la Collection de Luynes, II.* Paris: J. Florange & L. Ciani, 1925.

Balcer, J. M. "The archaic coinage of Skyros and the forgeries of Konstantinos Christodoulos", *SNR* 57 (1978): 69–101.

Berry, B. Y. *Near Eastern Excursions.* [Zurich?]: printed for the author, c. 1989.

———. *A Numismatic Biography.* Lucerne: printed for the author, 1971.

———. *Out of the Past.* New York: Arco, 1977.

Bertsch, D. *Anton Prokesch von Osten.* Munich: Oldenbourg, 2005.

Beulé, E. *Les monnaies d'Athènes.* Paris: Rollin, 1858.

Biesantz, H. *Die thessalischen Grabreliefs.* Mainz: Ph. von Zabern, 1965.

Bliss, F. J., and R. A. S. Macalister, *Excavations in Palestine during the Years 1898–1900.* London: Palestine Exploration Fund, 1902.

Boehringer, Ch. "Hierons Aitna und das Hieroneion", *JNG* 18 (1968): 67–98.

———. "Wilhelm Schwabacher (1897–1972)", *SNR* 52 (1973): 155–161.

Boehringer, E. *Die Münzen von Syrakus.* Berlin: W. de Gruyter, 1929.

Bouyon, B., G. Depeyrot, and J.-L. Desnier. *Systèmes et technologie des monnaies de bronze.* Wetteren: Moneta, 2000.

Brand, A. *Het verboden Judas-evangelie en de schat van Carchemish.* Soesterberg: Aspekt, 2006.

Brett, A. B. *Museum of Fine Arts, Boston. Catalogue of Greek Coins.* Boston: Museum of Fine Arts, 1955.

Briant, P. *L'histoire de l'empire perse.* Paris: Fayard, 1996.

Brøndsted, P. O. *Voyages dans la Grèce accompagnés de recherches archéologiques, 2ième livraison.* Paris: Firmin Didot, 1830.

Buchanan, J. J. *Theorika. A Study of Monetary Distributions to the Athenian Citizenry during the Fifth and Fourth Centuries B.C.* Locust Valley, N.Y.: J. J. Augustin, 1962.

Bunbury, E. "On Some Unpublished Coins of Athens, and One of Eleusis", *NC³* 1 (1881): 73–90.

Burdett, O., and E. H. Goddard. *Edward Perry Warren: The Biography of a Connoisseur.* London: Christophers, 1941.

Caccamo Caltabiano, M. *La monetazione di Messana.* AMuGS XIII. Berlin & New York: W. de Gruyter, 1993.

Cahn, H. A. "Asiut: Kritische Bemerkungen zu einer Schatzfundpublikation", *SNR* 56 (1977): 279–287.

———. "Dating the Early Coinage of Athens" [lecture given at the American Numismatic Society, April 1971]. In *Kleine Schriften zur Münzkunde und Archäologie,* pp. 81–97. Basel: Archäologischer Verlag, 1975

Callataÿ, F. de. "Un faux 'tétradrachme en or' de Mithridate Eupator", *SM* 57 (2007): 3–7.

Carlson, C. W. A. "Rarities 5—the Missing Athenian Dekadrachm," *SAN* 5 (1973–74): 8.

Carradice, I. (ed.) *Coinage and Administration in the Athenian and Persian Empires.* BAR international series 343. Oxford: BAR, 1987.

Christ, M. A. "Liturgy Avoidance and Antidosis in Classical Athens", *TAPhA* 120 (1990): 147–169.

Coin Hoards I–IX, edited by M. Price et al. London: Royal Numismatic Society, 1975–2002.

Comstock, M., and C. C. Vermeule. *Greek Coins, 1950 to 1963*. Boston: Museum of Fine Arts, 1963.

Cornaggia, G. "Un contemporaneo falsificatore di monete antiche", *RIN* 37 (1924): 37–46.

Curiel, R., and D. Schlumberger. *Trésors monétaires d'Afghanistan*. Paris: Impr. nationale, 1953.

Deubner, L. *Attische Feste*. Berlin: H. Keller, 1932.

Dodson, O. H. "Counterfeits I have known", *Coinage* 3.4 (April 1967): 20–23, 66, 68, 70.

Djukov, Y. L., T. N. Smekalova, A. V. Melnikon, and N. M. Vecherukhin, "Studies of Silver Coins of Alexander of Macedon from the Collection of the State Hermitage." In Gh. Moucharte et al. (eds), *Liber amicorum Tony Hackens*, pp. 87–94. Louvain-la-Neuve: Association de numismatique Marcel Hoc, 2007.

Duncan, J. "R. Ready Electrotypist", *CNG Review* 17.3 (1992): 4–5.

Dutilh, E. D. J. "Vestiges de faux monnayages antiques à Alexandrie ou ses environs", *JIAN* 5 (1902): 93–97.

Elayi, J., and A. G. Elayi, *Trésors de monnaies phéniciennes et circulation monétaire (Ve-IVe siècles avant J.-C.)*. Transeuphratène Suppl. 1. Paris: Gabalda, 1993.

Evans, A. J. "Syracusan 'Medallions' and Their Engravers", *NC* 11 (1891): 205–376.

Fava, A. S. *Il medagliere delle raccolte numismatiche torinesi*. Turin: Museo Civico d'Arte Antica, 1964.

Figueira, T. *The Power of Money. Coinage and Politics in the Athenian Empire*. Philadelphia: University of Pennsylvania Press, 1998.

Fischer-Bossert, W. "A Lead Test-Piece of a Syracusan Tetradrachm by the Engravers Euth... and Eum...", *NC* 162 (2002): 1–9.

———. "Der Hortfund vom Dipylon 1875 (*IGCH* 339)", *Athenische Mitteilungen* 114 (1999): 235–251.

———. "Zwei sizilische Bleimünzen in Münster", *Boreas* 23–24 (2000–01): 195–206.

Flament, Ch. "À propos des styles d'imitations athéniennes définis par T. V. Buttrey", *RBN* 147 (2001): 39–50.

———. *Le monnayage en argent d'Athènes*. Louvain-la-Neuve: Association de numismatique Marcel Hoc, 2007.

Fonblanque, E. B. de. *Lives of the Lords Strangford, with Their Ancestors and Contemporaries through Ten Generations*. London: Cassell, Petter, and Galpin, 1877.

Fried, S. "The Decadrachm Hoard: an introduction". In I. Carradice (ed.), *Coinage and Administration in the Athenian and Persian Empires*, pp. 1–10. Oxford: BAR, 1987.

Friedländer, J. *Ein Verzeichnis von Griechischen falschen Münzen welche aus*

modernen Stempeln geprägt sind. Berlin: W. Weber, 1883.

Froehner, W. *Monnaies grecques de la collection Photiadès Pacha*. Paris: H. Hoffmann, 1890.

Gardner, P. *A History of Ancient Coinage, 700–300 B.C.* Oxford: Clarendon Press, 1918.

Gerin, D. "Illustration de quelques faux de Caprara conservées au Cabinet de Médailles de Paris", *BNumParis* 41 (1986): 1–4.

Gitler, H., and O. Tal. *The Coinage of Philistia of the Fifth and Fourth Centuries BC*. Milan: Ennerre, 2006.

Gnecchi, F., and E. Gnecchi. *Guida Numismatica Universale*. Milan: L. F. Cogliati, 1903.

Gomme, A. W. *A Historical Commentary on Thucydides*, I. Oxford: Clarendon Press, 1945.

Gricourt, D. and D. Hollard. "Plomb et faux-monnayage en Gaule romaine: épreuves de coins et empreintes monétaires inédites", *RBN* 149 (2003): 11–42.

Hansen, M. H. "Misthos for Magistrates in Classical Athens", *Symbolae Osloenses* 54 (1979): 5–22.

Hardwick, N. "Coin Hoards," *NC* 166 (2006): 382–384.

Harris, D. *The Treasures of the Parthenon and Erechtheion*. Oxford: Oxford University Press, 1995.

Head, B. V. *A Guide to the Principal Coins of the Greeks*[2]. London: British Museum, 1932.

———. *A Guide to the Principal Coins of the Greeks*[3]. London: British Museum, 1959.

———. *Historia Numorum*[2]. London: Clarendon Press, 1911.

Hendin, D. "A Bronze Test-Strike from the Bar Kokhba Revolt", *Israel Numismatic Research* 1 (2006): 111–116.

Hill, G. F. *Becker the Counterfeiter, part I*. London: Spink, 1924.

———. *Historical Greek Coins*. London: A. Constable, 1906.

———. *Select Greek Coins*. Paris & Brussels: G. Vanoest, 1927.

Hiller, H. *Ionische Grabreliefs der 1. Hälfte des 5. Jahrhunderts v. Chr.*, Istanbuler Mitteilungen Beiheft 12. Tübingen: Wasmuth, 1975.

Himmelmann, N. *Minima Archaeologica*. Mainz: Ph. von Zabern, 1996.

Hoover, O. *Coins of the Seleucid Empire from the Collection of Arthur Houghton, Part II*, ACNAC 9. New York: American Numismatic Society, 2007.

———. "A Late Hellenistic Lead Coinage from Gaza", *Israel Numismatic Research* 1 (2006): 25–36.

———. "A Reassessment of Nabatean Lead Coinage in the Light of New Discoveries", *NC* 166 (2006): 105–120.

Houghton, A., C. Lorber, and O. Hoover, *Seleucid Coins: A Comprehensive Catalogue, Part 2*. New York & Lancaster: American Numismatic Society, Classical Numismatic Group, 2008.

Hurter, S. "The Galvano Boys – Part II", *BoC* 17.2 (1992/93): 2–10.

——. "The 'Galvano Boys' Again", *BoC* 20.2 (1995/96): 2–9.

——. "A new Caprara counterfeit", *BoC* 10, 2 (1985): 4.

——. "More Caprara Forgeries: a Chalcidic League Problem Solved", *NC* 159 (1999): 290–292.

——. "Perseus/Gortyna: A new Caprara die-link", *BoC* 22, 2 (1997): 14.

——. "A Tetradrachm of Sura by the 'Galvano Boys'", *BoC* 23, 1–2 (1998): 10.

——. "Two possible new Caprara counterfeits", *BoC* 16, 1 (1991): 30.

—— and A. Walker. "The British Museum Forgers or 'Costodoulos' and 'Gulyás'", *BoC* 17, 1 (1992): 2–49.

Ihl, H. "Eine neue Bleimünze des Polykrates. Falschgeld oder Notgeld?", in P. Berghaus (ed.), *Westfalia Numismatica 2001*, pp. 15–19. Münster: Münzfreunde Minden, 2001.

[Jameson, R.] *Collection R. Jameson, III.* Paris: Feuardent frères, 1924.

Jenkins, G. K., and M. Castro Hipólito. *A Catalogue of the Calouste Gulbenkian Collection of Greek Coins, Part II: Greece to East.* Lisbon: Fundação Calouste Gulbenkian, 1989.

Jensen, J. S. *Christian VIII & The National Museum.* Copenhagen: National Museum of Denmark, 2000.

Jongkees, J. H. "Notes on the Coinage of Athens", *Mnemosyne*[3] 12 (1945): 81–117.

Kagan, J. H. "The Decadrachm Hoard: Chronology and Consequences." In I. Carradice (ed.), *Coinage and Administration in the Athenian and Persian Empires*, pp. 21–28. Oxford: BAR, 1987.

Karouzos, Ch. "An Early Classical Disc Relief from Melos", *JHS* 71 (1951): 96–110.

Kilian-Dirlmeier, I. *Kleinfunde aus dem Itonia-Heiligtum bei Philia (Thessalien).* Mainz: Römisch-Germanisches Zentralmuseum, 2002.

Kinns, P. *The Caprara Forgeries.* London: Royal Numismatic Society, 1984.

Kosmetatou, E. "A numismatic commentary of the inventory lists of the Athenian Acropolis," *RBN* 147 (2001): 11–37.

Kovalenko, S. "Struck Lead Pieces from Tauric Chersonnesos: Coins or Tesserae?", *NC* 162 (2002): 33–58.

Kraay, C. M. *Archaic and Classical Greek Coins.* London: Methuen, 1976.

——. "The Archaic Owls of Athens: Classification and Chronology", *NC* (1956): 43–68.

——. "The Early Coinage of Athens: A Reply", *NC* (1962): 417–423.

——. "Greek Coinage and War". In W. Heckel and R. Sullivan (eds.), *Ancient Coins of the Graeco-Roman World*, pp. 3–18. The Nickle Numismatic Papers. Waterloo: Wilfrid Laurier University Press, 1984.

——. *Greek Coins and History. Some Current Problems.* London: Methuen, 1969.

—— and M. Hirmer. *Greek Coins.* London: Thames & Hudson, 1966.

────── and P. R. S. Moorey. "Two Fifth Century Hoards from the Near East", *RN* (1968): 181–210.

Krengel, E., and C. Sode. "Griechische zweiseitige Bleisiegel aus dem 4. Jahrhundert v. Chr.", *JNG* 55/56 (2005–06): 69–73.

Kroll, J. H. *The Greek Coins. The Athenian Agora XXVI.* Princeton: American School of Classical Studies at Athens, 1993.

──────. "The Piraeus 1902 Hoard of Plated Drachms and Tetradrachms (*IGCH* 64)." In *XAPAKTHP. Αφιέρωμα στη Μάντω Οικονομίδου*, pp. 139–146. Athens: Archaeological Resource Fund, 1996.

──────. "A small find of silver bullion from Egypt", *AJN* 13 (2001): 1–20.

Lanckoroński, L. M. von. *Schönes Geld der alten Welt.* Munich: Ernst Heimeran, 1935.

Lange, K. *Antike Münzen.* Berlin: Gebr. Mann, 1947.

──────. *Götter Griechenlands.* Berlin: Gebr. Mann, 1941.

Le Rider, G. *La naissance de la monnaie.* Paris: Presses universitaires de France, 2001.

Lenormant, F. *Description de médailles et antiquités composant le cabinet de M. le baron Behr.* Paris: Hoffman, 1857.

Lorber, C., and O. Hoover. "An unpublished tetradrachm issued by the artists of Dionysos", *NC* 163 (2003): 59–68.

Mainzer, F. "Das Dekadrachmon von Athen. Eine kritische Skizze", *ZfN* 36 (1926): 37–54.

Manganaro, G. "Dall'obolo alla litra e il problema del 'Damareteion'". In M. Amandry and S. Hurter (eds.), *Travaux de numismatique grecque offerts à Georges Le Rider*, pp. 239–255. London: Spink, 1999.

Mattingly, H. B. *The Athenian Empire Restored. Epigraphic and Historical Studies.* Ann Arbor: University of Michigan Press, 1996.

──────. "The Damareteion Controversy: a New Approach", *Chiron* 22 (1992): 1–12.

──────. "A New Light on the Early Silver Coinage of Teos", *SNR* 73 (1994): 5–11.

McNall, B. *Fun While It Lasted.* New York: Hyperion, 2003.

Meadows, A., and R. W. Kan. *History Re-Stored. Ancient Greek Coins from the Zhuyuetang Collection.* Hong Kong: Zhuyuetang, 2004.

Meiggs, R. *The Athenian Empire.* Oxford: Clarendon Press, 1972.

Meister, K. *Die Ungeschichtlichkeit des Kalliasfriedens und deren historische Folgen*, Palingenesia 18. Wiesbaden: F. Steiner, 1982.

Meshorer, Y., and Sh. Qedar. *Samarian Coinage.* Jerusalem: Israel Numismatic Society, 1999.

Metzler, D. "Der Adler als achämenidisches Herrschaftszeichen des Themistokles von Magnesia am Mäander (ca. 465–459 v. Chr.)". In E. Winter (ed.), *Vom Euphrat zum Bosporus. Festschrift für Elmar Schwertheim*, pp. 461–470. Asia Minor Studien 65.2. Bonn: Habelt, 2008.

Meyer, C. "A Lead Test-Piece from Histria in the Ashmolean", *NC* 166 (2006): 25–26.

Milne, J. "The History of Greek Medallions". In G. E. Mylonas and D. Raymond (eds), *Studies Presented to David Moore Robinson*, vol. II, pp. 224–232. St. Louis: Washington University Press, 1953.

Mionnet, T. E. *Description de médailles antiques grecques et romaines. Supplément III*. Paris: Testu, 1824.

Mørkholm, O. (ed.), *Den kongelige Mønt- og Medaillesamling, 1781–1981*. Copenhagen: Nationalmuseet, 1981.

Moulakis, Ch. "Christodoulou the Forger – More Dies", *Nomismatika Khronika* 13 (1994): 45–54

———. "Christodoulou the Forger: Twenty More Fakes?", *Nomismatika Khronika* 14 (1995): 71–75.

———. "Christodoulou Yet Again". In A. P. Tzamalis and M. Tzamali (eds), *Μνήμη Martin Jessop Price*, pp. 157–160. Athens: Hellenic Numismatic Society, 1996.

———. "Inexhaustible Christodoulou", *Nomismatika Khronika* 19 (2000): 131–134.

Münzen und Medaillen. Die Ausstellung des Münzkabinetts im Bode-Museum. Munich: Prestel, 2006.

Mushmov, N. Античнитъ Монети. Sofia: G. I. Gavazov, 1912.

Naster, P. *La collection Lucien de Hirsch*. Brussels: Bibliothèque royale de Belgique, 1959.

Neumann, G. *Probleme des griechischen Weihreliefs*. Tübingen: E. Wasmuth, 1979.

Nicolet-Pierre, H. "Autour du décadrachme athénien conservé à Paris." In R. Ashton and S. Hurter (eds), *Studies in Greek Numismatics in Memory of Martin Jessop Price*, pp. 293–299. London: Spink, 1998.

———. "Metrologie des monnaies grecques. La Grèce centrale et l'Egée aux époques archaïque et classique (VIᵉ–IVᵉ s.)", *AIIN* 47 (2000): 11–76.

Noe, S. *Bibliography of Greek Coin Hoards²*, NNM 78. New York: American Numismatic Society, 1937.

Oikonomidou, M., and J. Touratsoglou. *Coins & Numismatics*. Athens: Numismatic Museum, 1996.

Oreshnikov, A. V. *Collection des monnaies grecques de l'Institut archéologique de l'Université de Moscou*. Moscow: O. O. Gerbek, 1891.

Penny, N. "Exhibition Reviews: London, British Museum", *The Burlington Magazine* 132/1048 (July 1990): 505.

Pensabene, P. "Su alcune tessere plumbee di uso commerciale", *Scienze di Antichità* 11 (2001–03): 479–510.

Pfisterer, M. *Ein Silberschatz vom Schwarzen Meer*. Paris: Association pour l'avancement des études iraniennes, 2000.

Pinder, M. *Die Beckerschen falschen Münzen*. Berlin: Nicolai, 1843.

Price, M. J. "More Forgeries from the British Museum Archives", *BoC* 2.4 (1977): 89.

———. In M. Jones (ed.), *Fake? The Art of Deception*. Berkeley: University of California Press, 1990.

——— and N. M. Waggoner. *Archaic Greek Silver Coinage. The "Asyut" Hoard*. London: V. C. Vecchi, 1975.

Prokesch von Osten, A. *Inedita meiner Sammlung autonomer altgriechischer Münzen*. Vienna: Hof- und Staatsdruckerei, 1854.

Ravel, O. *Falsifications*. London: Spink, 1946.

———. "Notes techniques pour reconnaitre les monnaies grecques fausses", *RN* (1933): 1–42.

Raymond, W. *The J. Pierpont Morgan Collection*. New York: Wayte Raymond, 1953.

Regling, K. *Die antike Münze als Kunstwerk*. Berlin: Schoetz & Parrhysius, 1924.

Renner, V. von. *Catalogue de la collection des médailles grecques de M. le chevalier Léopold Walcher de Molthein*. Paris & Vienna: Rollin & Feuardent, 1895.

Ridgway, B. S. *The Severe Style in Greek Sculpture*. Princeton: Princeton University Press, 1970.

Robinson, E. S. G. "Greek Coins Acquired by the British Museum", *NC* (1948): 48–56.

———. "Some Problems in the Later Fifth Century Coinage of Athens", *ANSMN* 9 (1960): 1–15.

Roland-Marcel, P. R. (ed.), *Bibliothèque Nationale. Cabinet des Médailles et Antiques. Les Monnaies. Guide du Visiteur*. Paris: E. Leroux, 1929.

Rolley, C. *La sculpture grecque, 1. Des origines au milieu du Vᵉ siècle*. Paris: Picard, 1994.

Rutter, K. *Greek Coinages of Southern Italy and Sicily*. London: Spink, 1997.

———. "The Myth of the 'Damareteion'", *Chiron* 23 (1993): 171–188.

Sallet, A. von. *Die antiken Münzen*, revised by K. Regling. Berlin & Leipzig: W. de Gruyter, 1922.

———. "Die berühmte Sammlung des Grafen Prokesch-Osten", *ZfN* 3 (1876): 104.

Samons, L. J. II. "Kimon, Kallias and Peace with Persia", *Historia* 47 (1998): 129–149.

Savio, A. *Catalogo delle monete alessandrine della collezione dott. Christian Friedrich August Schledehaus nel Kulturgeschichtliches Museum Osnabrück*. Bramsche: Rasch, 1997.

Schultz, H. D. *Antike Münzen. Bildheft*. Berlin: Staatliche Museen zu Berlin, 1997.

Schultz, S. *Antike Münzen. Griechische Prägung.* Berlin: Staatliche Museen zu Berlin, 1984.

Seltman, C. *Athens, Its History and Coinage before the Persian Invasion* Cambridge: Cambridge University Press, 1924.

———. *Greek Coins.* London: Methuen, 1933.

———. *Masterpieces of Greek Coinage.* Oxford: B. Cassirer, 1949.

———. "On the style of early Athenian coins", *NC* (1946): 97–110.

Sestini, D. *Descrizione di molte medaglie antiche greche esistenti in più musei.* Florence: G. Piatti, 1828.

[Sestini, D.] *Sopra i moderni falsificatori.* Florence: Tofani, 1826.

Sheedy, K. *The Archaic and Early Classical Coinages of the Cyclades.* London: Royal Numismatic Society, 2006.

Shefton, B. "The White Lotus, Rogozen and Colchis: the fate of a motif". In J. Chapman and P. Dolukhanov (eds.), *Cultural Transformations and Interactions in Eastern Europe*, pp. 178–210. Aldershot: Avebury, 1993.

Smet, A. de. *Voyageurs Belges aux États-Unis du XVIIᵉ siècle à 1900.* Brussels: Bibliothèque royale de Belgique, 1959.

Smith, M. N. *The Mint of "Lete".* Ann Arbor: University Microfilms International, 1999.

Sorge, H. "Der Mond auf den Münzen von Athen", *JNG* 2 (1950/51): 7–13.

Sox, D. *Bachelors of Art: Edward Perry Warren and the Lewes House Brotherhood.* London: Fourth Estate, 1991.

Starr, C. G. *Athenian Coinage, 480–449 B.C.* Oxford: Clarendon Press, 1970.

———. "New Specimens of Athenian Coinage, 480–449 B.C.", *NC* (1982): 129–132.

Stos-Gale, Z. A. "The Impact of Natural Sciences on Studies of Hacksilber and Early Silver Coinage". In M. S. Balmuth (ed.), *Hacksilber to Coinage. New Insights into the Monetary History of the Near East and Greece*, pp. 53–76. New York: American Numismatic Society, 2001.

Svoronos, J. N. "C. Christodoulos et les faussaires d'Athènes", *JIAN* 20 (1920 [1922]): 97–107.

———. *Les monnaies d'Athènes*, completed by B. Pick. Munich: F. Bruckmann, 1923–26. Reprinted with translated text as *Corpus of the Ancient Coins of Athens.* Chicago: Ares, 1975.

———. "Synopsis de coins faux de Christodoulos (suite)", *JIAN* 21 (1927): 141–146.

Tazedakis, P. "The Medals of Christodoulou", *Nomismatika Khronika* 10 (1991): 91–102.

Theodorou, J. "Athenian Silver Coins: 6th–3rd Centuries BC; the Current Interpretation". In A. P. Tzamalis and M. Tzamali (eds), *Μνήμη Martin Jessop Price*, pp. 51–81. Athens: Hellenic Numismatic Society, 1996.

Thompson, M., C. M. Kraay, and O. Mørkholm. *An Inventory of Greek Coin*

Hoards. New York: American Numismatic Society, 1973.

Thompson, W. E. "The Functions of the Emergency Coinages of the Peloponnesian War," *Mnemosyne*[4] 19 (1966): 337–343.

Tölle-Kastenbein, R. *Frühklassische Peplosfiguren. Originale.* Mainz: Ph. von Zabern, 1980.

Tsangari, D. I. *Hellenic Coinage. The Alpha Bank Collection.* Athens: Alpha Bank, 2007.

Tudeer, L. "Die Tetradrachmenprägung von Syrakus in der Periode der signierenden Künstler", *ZfN* 30 (1913): 1–292.

Tusa Cutroni, A. In *Himera II. Campagne di scavo 1966–1973.* Rome: L'Erma di Bretschneider, 1976.

van Alfen, P. "The 'Owls' from the 1989 Syria Hoard", *AJN* 14 (2002): 1–57.

———. "Two Unpublished Hoards and Other 'Owls' from Egypt", *AJN* 14 (2002): 59–71.

Vaux, W. S. W. "Extract of a Letter...Relating to a Hoard of Coins of Alexander the Great, Discovered near Patras, in 1850", *NC* (1853): 29–37.

Vismara, N. *Ripostigli d'epoca pre-ellenistica (VI–IV sec. a.C.) con monete della Lycia antica.* Milan: Ennerre, 1999.

Wallace, W. P. "The Early Coinages of Athens and Euboia", *NC* (1962): 23–42.

Warren, J. *The Bronze Coinage of the Achaian Koinon.* London: Royal Numismatic Society, 2007.

Wealth of the Ancient World. Fort Worth, Beverly Hills: Kimbell Art Museum & Summa Galleries, 1983.

Weil, R. "Das Münzrecht der Symmachoi im Ersten Attischen Seebund", *ZfN* 28 (1910): 351.

Weiser, W. "Die Eulen von Kyros dem Jüngeren", *Zeitschrift für Papyrologie und Epigraphik* 76 (1989): 267–296.

Wesenberg, B. "Kunst und Lohn am Erechtheion", *Archäologischer Anzeiger* (1985): 55–65.

Whitehead, D. "From Smyrna to Stewartstown: A Numismatist's Epigraphic Notebook", *Proceedings of the Royal Irish Academy* 99 (1999): 73–113.

Williams, R. T. *The Confederate Coinage of the Arcadians in the Fifth Century B.C.* NNM 155. New York: American Numismatic Society, 1965.

———. Review of Starr, *Athenian Coinage. Phoenix* 26 (1972): 411–412.

LIST OF PLATES

Plates 1–8 contain illustrations of comparanda mentioned in the text, listed below. Plates 9–41 illustrate the catalogues of genuine specimens, lead trial pieces, and ancient and modern forgeries. All specimens of which a photograph has been available to the author have been illustrated. Although in the case of some of the modern forgeries these illustrations are of less than optimal quality, it is hoped that their reproduction will be of some service.

Plate 1.A. Athens, decadrachm. Staatliche Museen Berlin, Münzkabinett. Prokesch-Osten Collection.

Plate 1.B. Syracuse, decadrachm. Staatliche Museen Berlin, Münzkabinett. Löbbecke Collection. Photo Lutz-Jürgen Lübke.

Plate 1.C. Becker's dies. Staatliche Museen Berlin, Münzkabinett. Photo Reinhard Saczewski.

Plate 2.D. Reverse die taken from the de Luynes specimen. Private collection, United States. Photographs of the cast.

Plate 2.E. Christodoulou's dies. Νομισματικό Μουσείο, Athens.

Plate 3.F. Relief from the island Ikaria. Kataphygion, school. After H. Hiller, *Ionische Grabreliefs der 1. Hälfte des 5. Jahrhunderts v. Chr.*, Istanbuler Mitteilungen Beiheft 12 (Tübingen: Wasmuth, 1975), pl. 16, 1. Photo N. M. Kontoleon.

Plate 4.G. Ludovisi throne. Rome, Museo Nazionale Romano 8570. Plaster cast Bonn, Akademisches Kunstmuseum. Photo Forschungsarchiv für Antike Plastik, Cologne FA-S8234-08 3000419,07.

Plate 5.H. Melos disc. Athens, National Museum 3990. Photo H.R. Goette.

Plate 6.I. Giustiniani stele (detail). Staatliche Museen Berlin, K 19. Photo H. R. Goette.

Plate 7.K. "Mourning Athena" (detail). Athens, Acropolis Museum 695. Photo H. R. Goette.

Plate 8.L. Banquet relief from Thasos (detail). Istanbul, Arkeoloji Müzeleri 1947. Plaster cast Deutsches Archäologisches Institut, Berlin. Photo H. R. Goette.

Plates

Plate 1

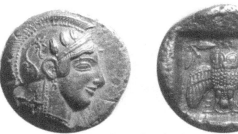

A. Athens, decadrachm

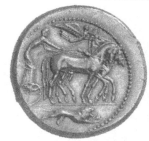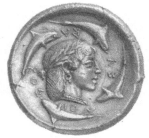

B. Syracuse, decadrachm

C. Becker's dies

Plate 2

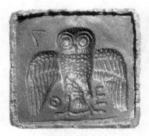

D. Reverse die taken from the de Luynes specimen

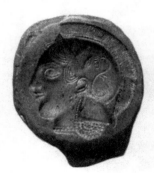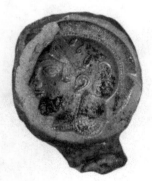

E. Christodoulou's dies

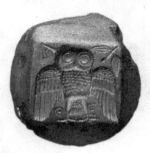

Plate 3

F. Relief from the island of Ikaria

Plate 4

G. Ludovisi throne

Plate 5

H. Melos disc

Plate 6

I. Giustiniani stele (detail)

Plate 7

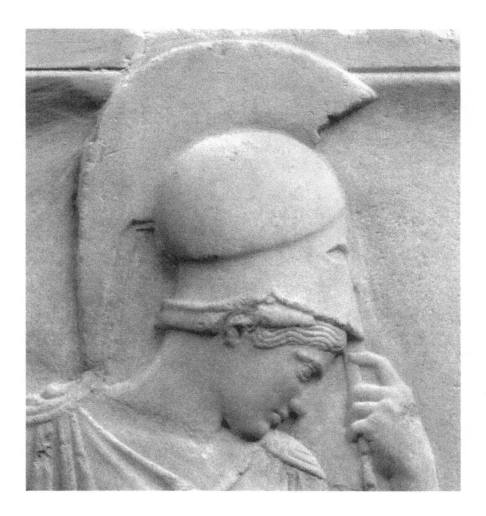

K. Mourning Athena (detail)

Plate 8

L. Banquet relief from Thasos (detail)

Plate 9

Die Study

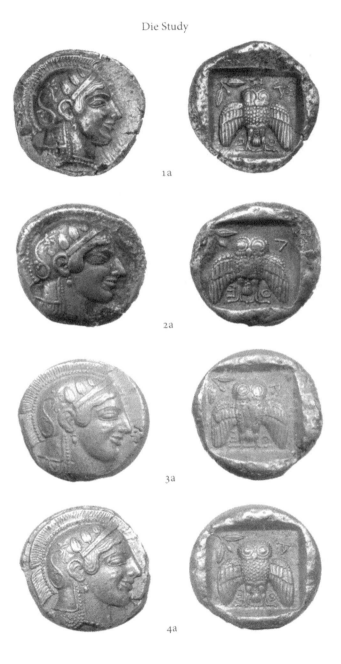

1a

2a

3a

4a

Plate 10

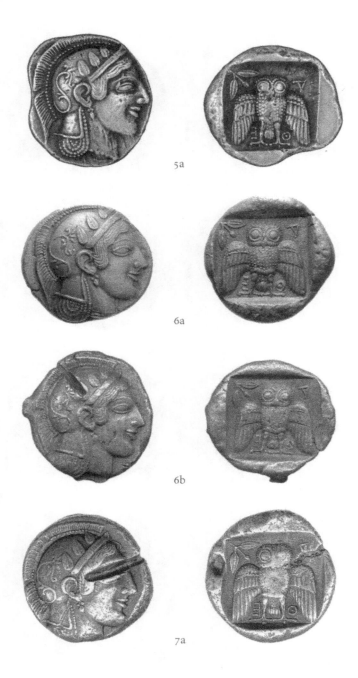

5a

6a

6b

7a

Plate 11

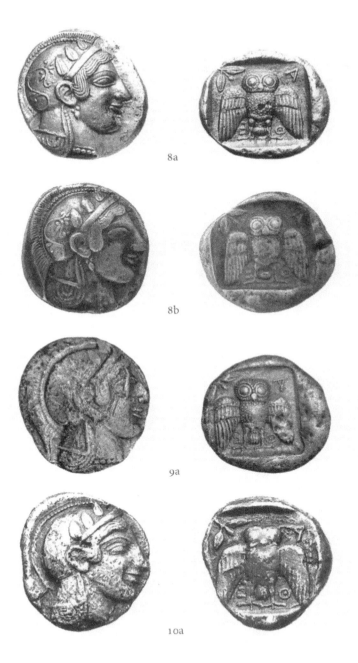

8a

8b

9a

10a

Plate 12

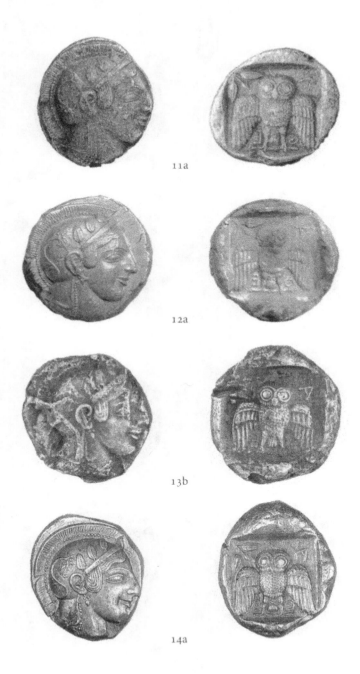

11a

12a

13b

14a

Plate 13

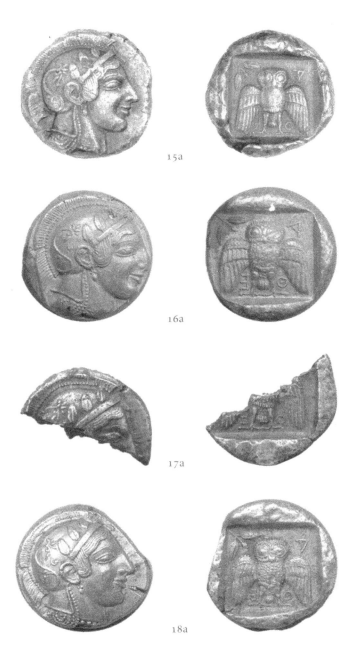

15a

16a

17a

18a

Plate 14

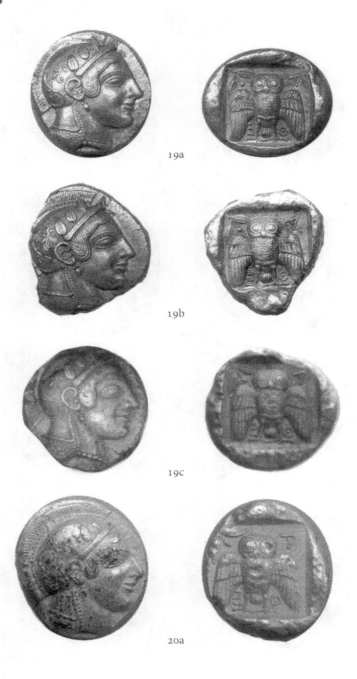

19a

19b

19c

20a

Plate 15

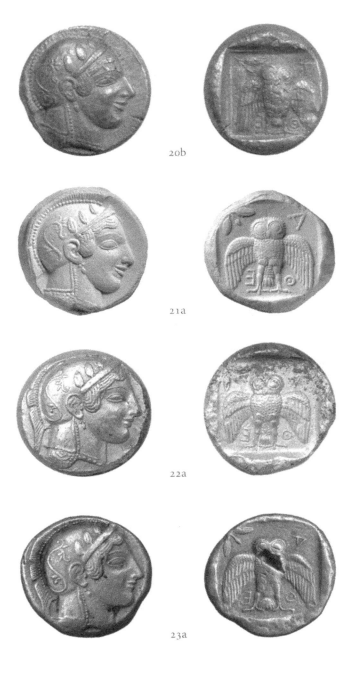

20b

21a

22a

23a

Plate 16

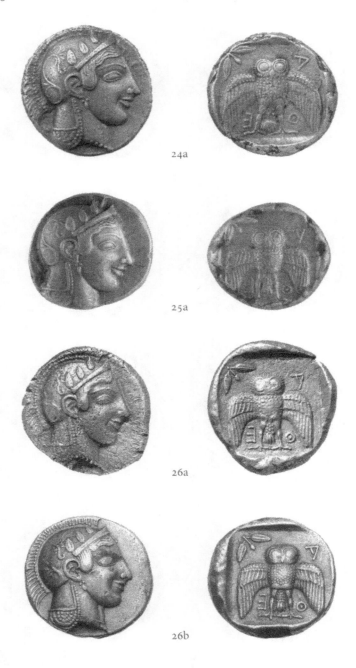

24a

25a

26a

26b

Plate 17

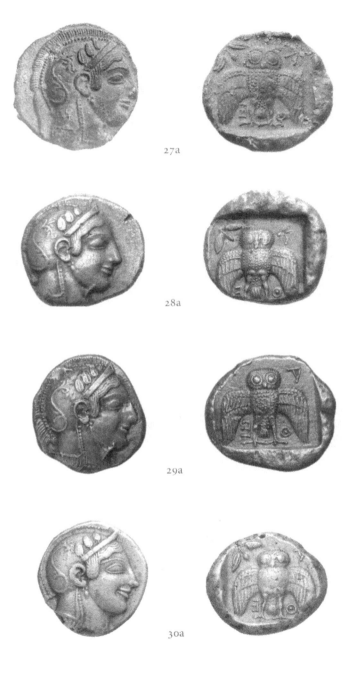

27a

28a

29a

30a

Plate 18

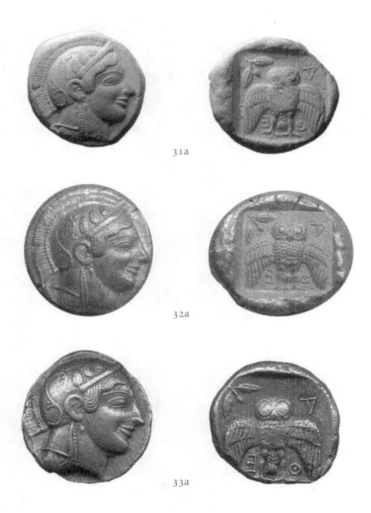

31a

32a

33a

Plate 19

Lead Trial Pieces

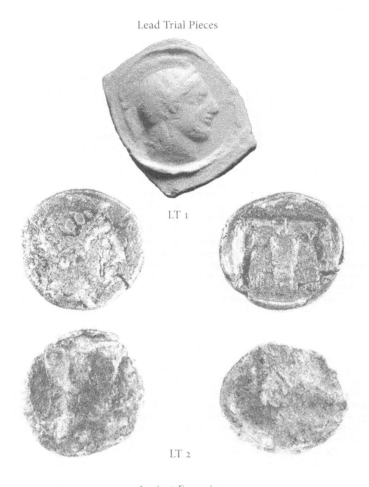

LT 1

LT 2

Ancient Forgeries

AF 1

Plate 20

Modern Forgeries

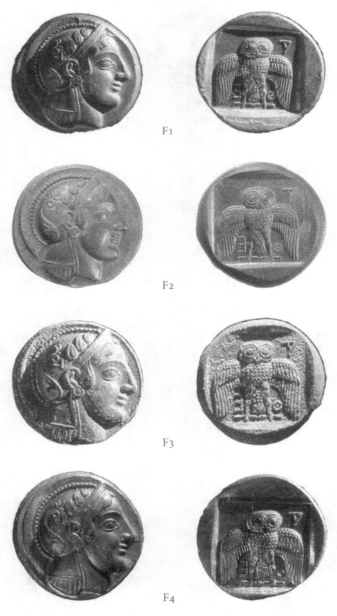

F1

F2

F3

F4

Plate 21

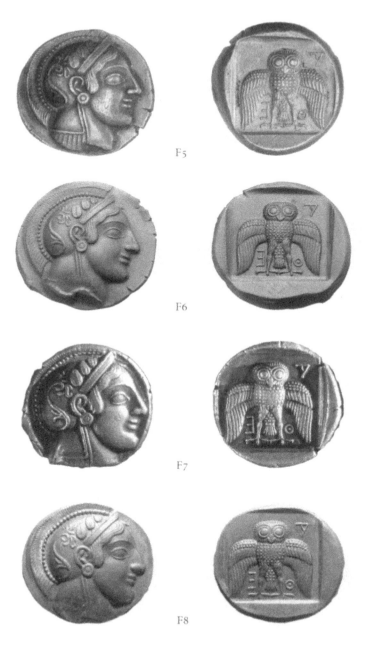

F5

F6

F7

F8

Plate 22

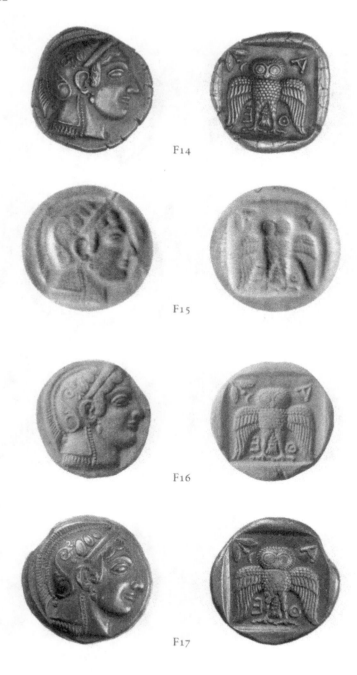

F14

F15

F16

F17

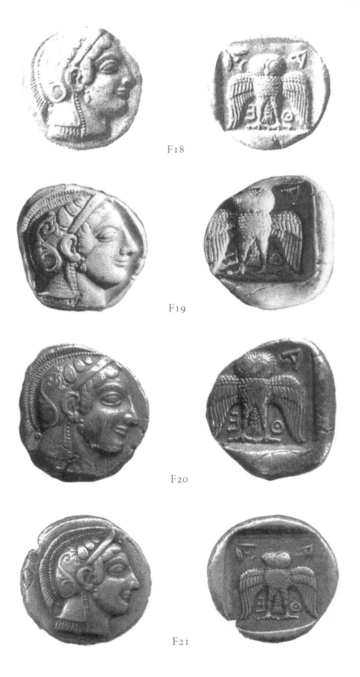

Plate 23

F18

F19

F20

F21

Plate 24

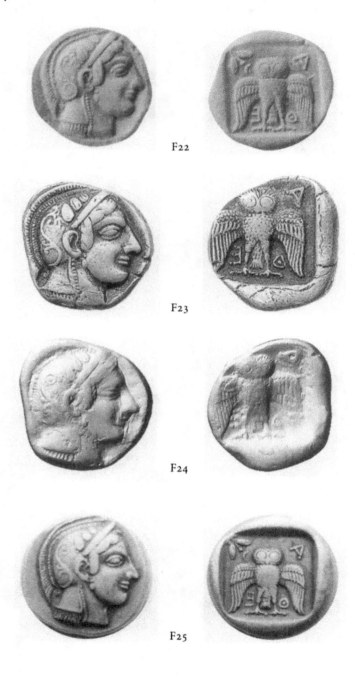

F22

F23

F24

F25

Plate 25

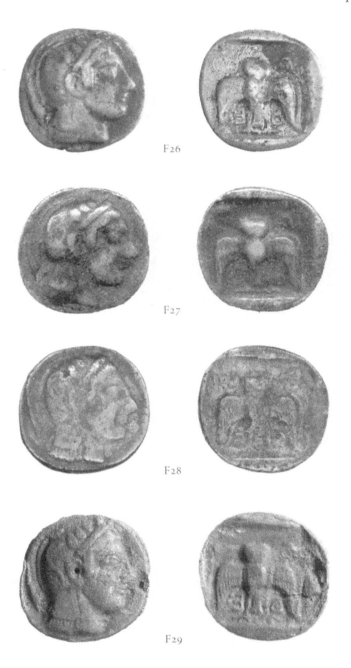

F26

F27

F28

F29

Plate 26

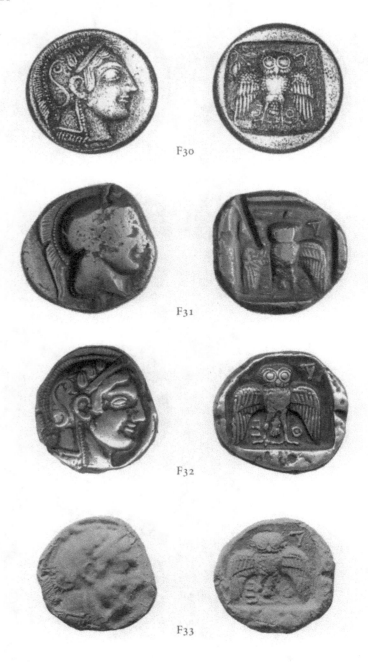

F30

F31

F32

F33

Plate 27

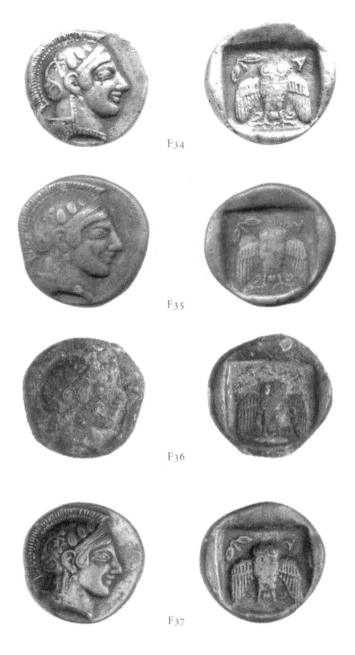

F34

F35

F36

F37

Plate 28

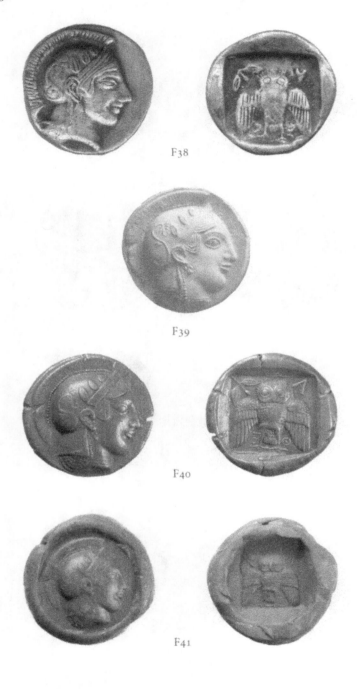

F38

F39

F40

F41

Plate 29

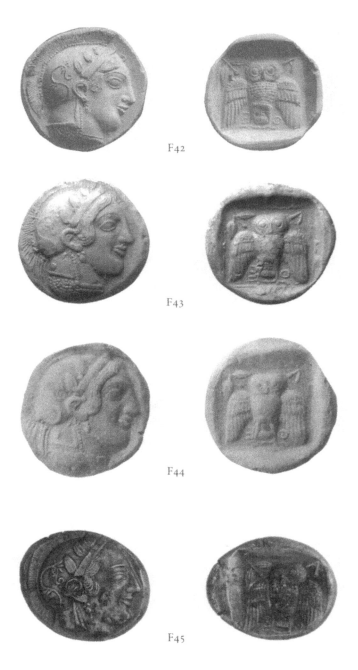

F42

F43

F44

F45

Plate 30

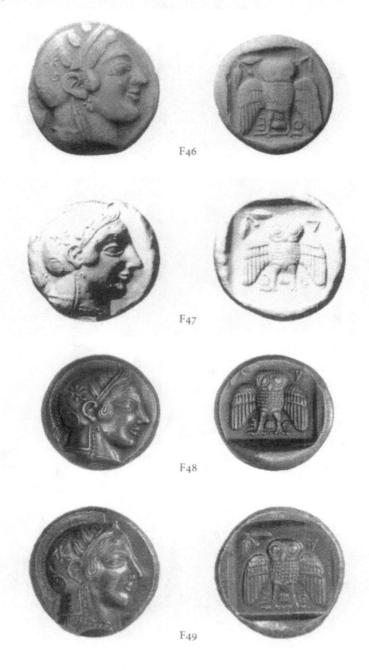

F46

F47

F48

F49

Plate 31

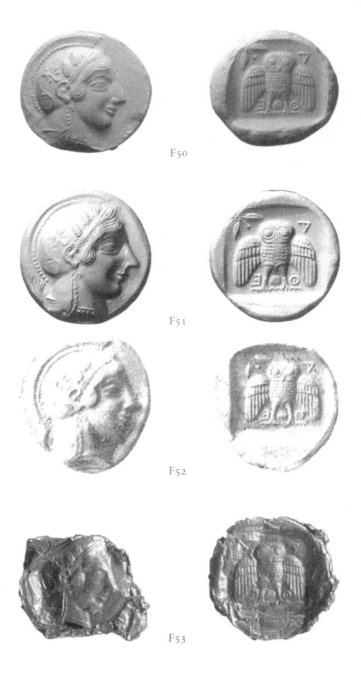

F50

F51

F52

F53

Plate 32

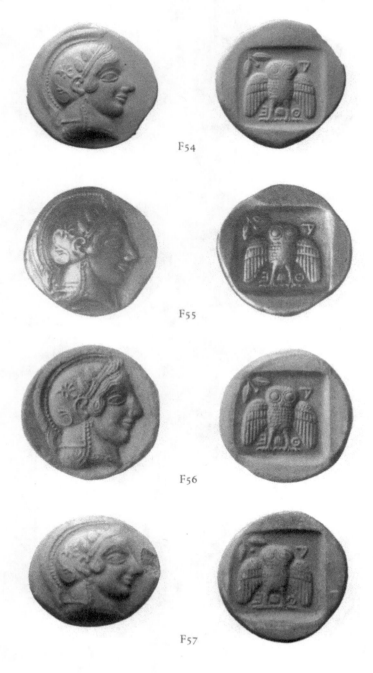

F54

F55

F56

F57

Plate 33

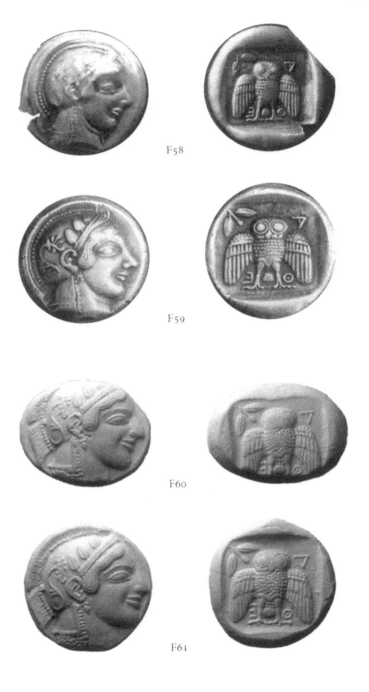

F58

F59

F60

F61

Plate 34

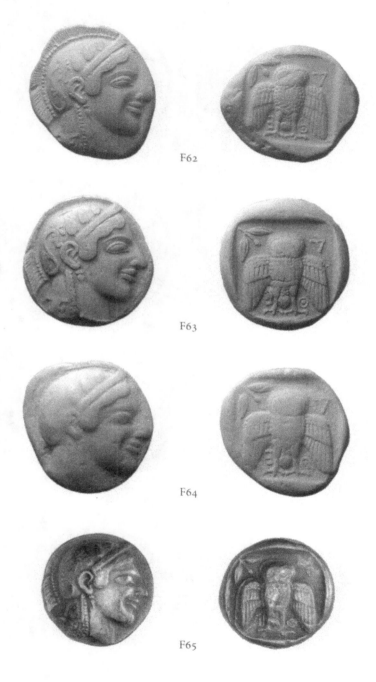

F62

F63

F64

F65

Plate 35

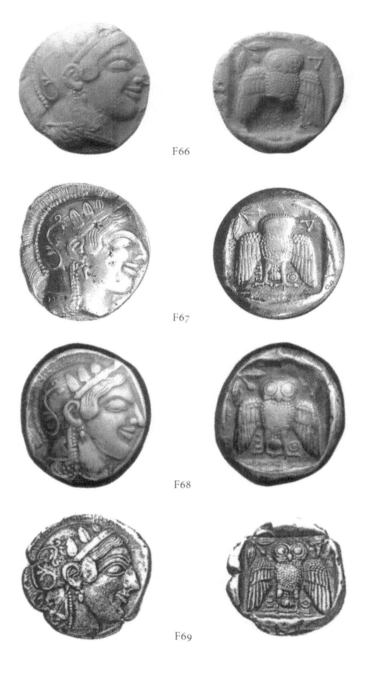

F66

F67

F68

F69

Plate 36

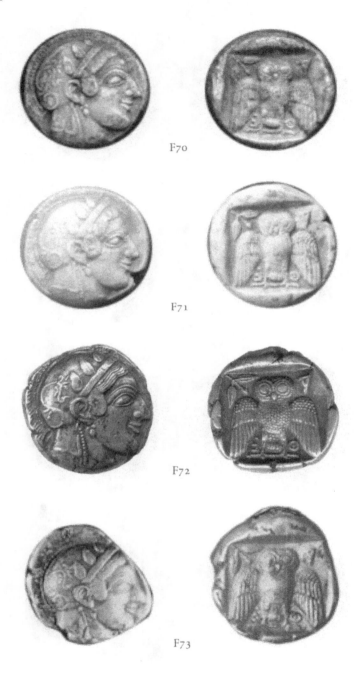

F70

F71

F72

F73

Plate 37

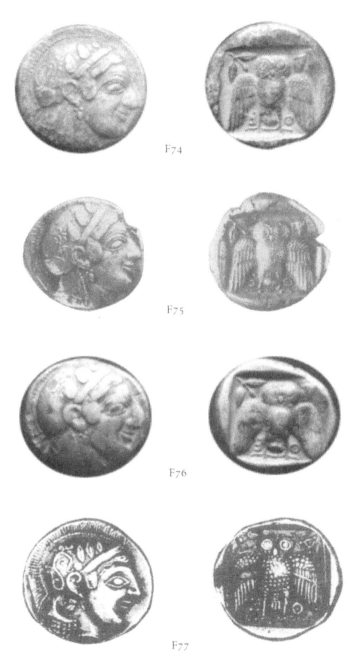

F74

F75

F76

F77

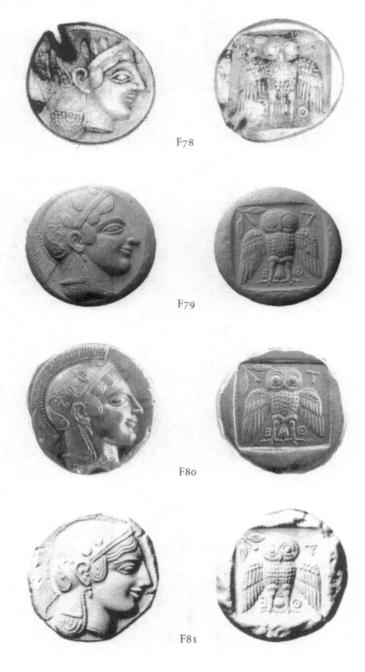

Plate 38

F78

F79

F80

F81

Plate 39

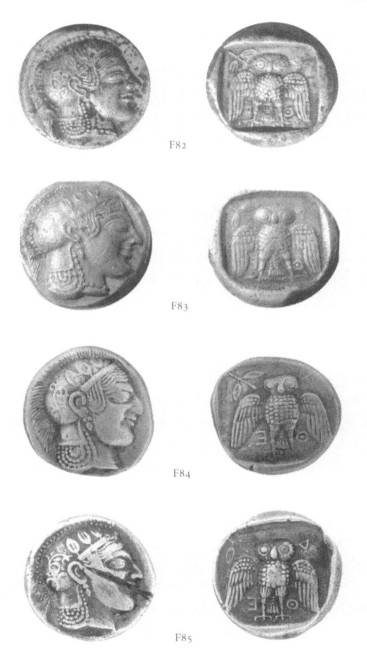

F82

F83

F84

F85

Plate 40

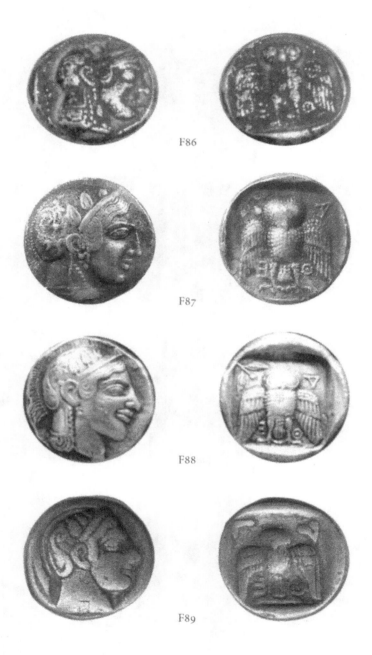

F86

F87

F88

F89

Plate 41

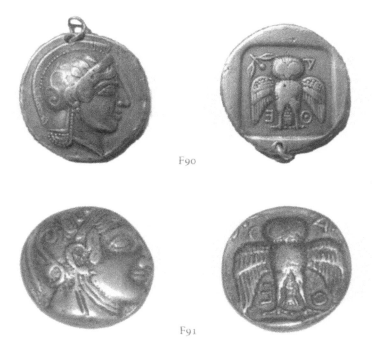

F90

F91

Printed in the USA
CPSIA information can be obtained
at www.ICGtesting.com
LVHW011931041023
760167LV00005B/20